The Photoshop Lightroom Workbook

The Photoshop Lightroom Workbook

Workflow not Workslow in Lightroom 2

Seth Resnick

Jamie Spritzer

ELSEVIER

AMSTERDAM • BOSTON • HEIDELBERG • LONDON • NEW YORK • OXFORD
PARIS • SAN DIEGO • SAN FRANCISCO • SYDNEY • TOKYO

Focal Press is an imprint of Elsevier

Focal Press is an imprint of Elsevier
Linacre House, Jordan Hill, Oxford OX2 8DP, UK
80 Corporate Drive, Suite 400, Burlington, MA 01803, USA

First published 2009

British Library Cataloguing in Publication Data
Resnick, Seth
 The Photoshop Lightroom workbook : workflow not workslow in
 Lightroom 2
 1. Adobe Photoshop lightroom
 I. Title II. Spritzer, Jamie
 775'. 0285668

Library of Congress Control Number: 2008935933

ISBN: 978-0-240-81067-6

For information on all Focal Press publications
visit our website at www.focalpress.com

Printed and bound in Canada

09 10 11 12 12 11 10 9 8 7 6 5 4 3 2 1

*This book is dedicated to the loving memory of
Shirley C. Resnick, who gave us tremendous
support and inspiration.*

Contents

Acknowledgments .ix

Foreword by George Jardine .xi

Introduction . xiii

Chapter 1 Before You Shoot . 1

Chapter 2 Understanding File Formats and Shooting RAW 23

Chapter 3 Color Spaces for Digital . 33

Chapter 4 The Lightroom Catalog . 43

Chapter 5 Lightroom's Preferences . 53

Chapter 6 Lightroom's Architecture . 73

Chapter 7 The Lightroom Library Module . 83

Chapter 8 The Develop Module .145

Chapter 9 Global Corrections and Synchronizing
 Develop Settings .209

Chapter 10 The Slideshow Module .217

Chapter 11 The Print Module .231

Chapter 12 The Web Module .251

Chapter 13 D-65's Lightroom Workflow .261

Chapter 14 Archiving .291

Chapter 15 Importing and Exporting Catalogs and Synchronizing
 Your Laptop and Desktop .303

Chapter 16 Taking It Up a Notch – Advanced Lightroom317

Digital Dictionary .335

Index .351

Acknowledgments

There are so many folks who helped make this project a reality. First, we must thank both past and current people at Focal Press who all aided in bringing life to an idea – Emma Baxter, Asma Palmeiro, Hayley Salter, Ben Denne, Kate Iannotti, David Albon, Marissa Del Fierro and Lisa Jones. Thanks….

The photographic inspirations come from mentors and friends Jay Maisel, Susan Meiselas and Eric Meola.

None of this would have been possible without the support of a core group of friends and colleagues of the Pixel Mafia and especially the close support and friendship of some of the most intelligent digital minds in the world, Seth's fellow partners in PixelGenius: Jeff Schewe, Martin Evening, Andrew Rodney, Mac Holbert, the late Mike Skurski and Bruce Fraser.

There is of course the entire Adobe family as well. Never have we worked with a company where we truly feel like family. There are so many brilliant minds and wonderful people, including Addy Roff, Jennifer Stern, George Jardine, Kevin Connor, Frederick Johnson, Tom Hogarty, Mark Hamburg, Troy Gaul, Melissa Gaul, Eric Scouten, Zalman Stern, Thomas Knoll, Julieanne Kost, Ben Zibble, Wade Henniger, Jon Steinmetz, Kevin Tieskoetter, Andrew Rahn, Dan Gerber, Melissa Itamura, Craig Marble, Phil Clevenger, Brian Kruse, Bill Stozner, Dan Tull, Dustin Bruzenak, Shoji Kumagai, Kelly Castro, Julie Kmoch, Jeff Van de Walker, Mark Soderberg, Becky Sowada, Peter Merrill, Eric Chan, Hendrik Kueck and John Nack. A very special thanks to Donna Powell, who acted as our technical editor on this project.

We could never have done this without the loving support of each other and the support from our family.

Seth & Jamie

Foreword

Workflow. Now where in the world do you suppose a word like *workflow* came from?

Thinking back to my early days in digital color prepress, I guess, I remember that operators and managers in the color shops liked to use the term *workflow*. Jobs came in, and parts of these jobs might be digitized from analog artwork, while other parts might be created from scratch in the virtual world of the computer. Various types of files would then go back and forth between composition, output and proofing, between various types of computers, across various types of media, until the job was finally finished.

Each color shop would define and create its own workflow, based on Its hardware, software and its particular expertise or product. So each workflow was completely unique. Some were haphazard, while others were quite refined.

And that is where the similarities with a digital *photographic workflow* end. Photographers have a unique problem that is quite different from the one that prepress shops face. In the color shop, final films were delivered to the client, and the computer files that generated those films would then be 'archived' … probably never to be opened again. The job was done. On the other hand, a successful photographer *builds* a *library* of photographs over time. It's the library that is interesting here; the archive of that library is probably secondary. Another way of putting it is to say that building a successful lifetime's library is the primary goal. Preserving it for posterity – while nonetheless important – by its very nature must be secondary to the process of actually building it.

Crafting a library is a continual process that will last the entire working lifetime for the photographer. Successful photographers are continually adding to and refining their libraries. After all, the more salable pictures your library contains, and the easier it is for you to find those pictures and then keep getting them in front of the folks who actually *buy* pictures, the more successful you will be. And so, successful photographers are constantly growing their libraries and improving them.

Although these libraries are by necessity shot on today's formats and built on today's hardware, photographers must move their libraries forward from format to format, from computer to computer and from storage device to storage device.

So the photographer's library is not the static and dead storage area of the prepress archive, but rather it is an organic, living, and growing thing. Or, at least it should be. This situation forces photographers to face the dual problem of having to keep shooting and building the library, while at the same time attempting to do their best to take the long view on how it should be best preserved. In fact, it is the extent to which photographers are able to step back and take in the big picture of their life's work and then set about structuring a library that is coherent to the direction in which they will be successful.

And therein lies the rub. Do you know where you are going as a photographer? Are you able to take a broader perspective of your life's work? And even if you can, where do you start? You've already got a big pile of pixels, and it's growing with every click of the shutter.

Unfortunately, there is simply no way to teach photographers how to see the big picture. The big picture will be slightly different for every photographer anyway. And in the end, that part is really up to you. But as authors and educators, what Seth and Jamie have done in this book is build a road map for you. Rare amongst photographers, Seth and Jamie get the big picture. And, even more rare, they have mastered the details in their own professional work. Add to that the knowledge gained from having taught over 60 D-65 workshops (remember, the teacher always learns more than the student, grasshopper) in more than 25 cities, and you have the insight required to guide other professionals in learning how to manage their digital libraries.

The details are not difficult, and Seth and Jamie lay them out for you step-by-step. As you read through the book, you'll quickly find that there's plenty of room for you to tweak things to suit your own personal style. In no time at all, you'll have the confidence and knowledge to begin reshaping your own library into one that is both efficient for today's business and built for the long-haul requirements of *the archive*.

George Jardine
Pro Photography Evangelist
Adobe Systems, Inc.

Introduction

Why did Adobe developed Lightroom as a new product? Photoshop's core engine really wasn't designed for raw image processing or digital asset management. To answer the needs of photographers, Adobe introduced Bridge, which was first featured in Photoshop CS2. For the past several years however, Adobe or rather Mark Hamburg has been working on an entirely new idea for dealing with the needs of today's photographer. This idea was finally given the go ahead, and what was once a secret known as Shadowland, turned into Lightroom. Lightroom was introduced as a public beta meaning quite simply that it was a work in progress being tweaked daily from the input provided by the public. The first release of Lightroom 1.0 was in February 2007.

The heart of Lightroom is a one-stop solution for digital workflow. It utilizes the power behind Adobe Camera Raw, combining image processing and a digital asset management system under one roof. The aim of Lightroom is to be simple and to streamline workflow. The software is very well-suited to the professional photographer or the advanced amateur. It is not designed to replace Photoshop or Bridge, but rather to work alongside those applications. It was built from the ground up, and optimized to accomplish the tasks with speed and efficiency.

One fundamental difference between Lightroom and other digital asset management programs is that navigation, searching and developing are based on metadata. It is further important to know that adjustments made in the Develop Module to raw files are non-destructive because you are making the changes to the metadata that describes the image, as opposed to altering pixels. This is the way of the future. D-65 has always preached about the importance of metadata in files. In fact, there was a great deal of time spent to come up with a term for developing images based on metadata and not pixels. While the term metadata editing seemed to make sense, many thought that would be confusing because we are not talking about IPTC metadata. The new buzzword for Lightroom is parametric editing. Isn't that cool!

The design of Lightroom is unique because it is modular in nature. Currently Lightroom 2.0 has five modules that include: Library, Develop, Slideshow, Print and Web. This modular system allows for additional modules at a later date, not only from Adobe. It is rather unique for any software developer to encourage third parties to create 'hacks' for the software. Adobe has opened this door to allow the needs of individuals or corporations to be tailored to this application.

Now how does this all fit in with digital workflow? When photographers shot film, a lab developed it. The photographer then edited the results and forwarded the selects to the client. Photographers had done their work and were onto the next job. In the realm of digital capture, the photographer takes on the responsibility of being both the photographer and the lab. You may need to process and refine hundreds of images in a day. What was once at hour and a half wait for processed film has become a beleaguered task for most photographers who have thousands of digital files to 'work on'. Then you have to upload the images via FTP to a web site, create a PDF or burn a CD to deliver to the client. Most photographers are surprised by the amount of work they have taken on without knowing it. They quickly find that they are spending more time at the computer, and less time shooting. This was not part of their plan for moving to digital capture. This means that for many, they are continually playing catch up and getting further and further behind. But your success as a corporate, editorial, wedding/event or advertising photographer is directly related to your ability to process hundreds of superior quality images a day in a timely and efficient manner.

As the cameras produce larger and larger files, it is more critical than ever to have an efficient workflow that allows a photographer to take pictures instead of being glued to a keyboard. The workflow that D-65 suggests can be tailored to meet your specific needs for any job or client. It will also help to insure proper color management and cross platform digital standards. Our workflow should greatly increase your efficiency and organization allowing you to easily manage digital.

This book will present a well-tested workflow that photographers can implement exactly as taught here, or can be easily modified to a specific photographer's job requirements. The best part about the D-65 workflow is that it can be easily changed on a per job basis to meet the delivery specs of a client. As you learn more

about digital, you will find that one of the issues is that many of your clients are not as educated as you. Their specifications for digital files may be very different from the way you process your files. One of the fundamental concepts of the D-65 workflow is to accommodate all of your own needs as well as your client needs with the press of a button. No need to reinvent the wheel. The key parts of the D-65 workflow are:

- Capturing the highest quality digital files.
- Creating keywords and metadata to manage digital files.
- Automating the processing of digital files while optimizing them for reproduction.
- Displaying and delivery of digital files.
- Printing digital files.
- Archiving digital files.

Requirements to Run Lightroom

Lightroom is an image-processing application and as such it should be no surprise that the performance is greatly enhanced with sufficient RAM and processing power. The minimum specs are as below but please keep in mind that these are bare minimums.

Macintosh

- Macintosh OS 10.4.1 or higher (Lightroom will not run on any version earlier than 10.4.1).
- G4, G5 or Intel processor.
- 768 MB RAM (1 GB or more is HIGHLY recommended).
- 1 GB free HD space (10 GB or more is HIGHLY recommended).

Windows

- Windows XP SP2
- Pentium 4 processor
- 768 MB RAM (1 GB or more is HIGHLY recommended)
- 1 GB free HD space but (10 GB or more is HIGHLY recommended).

As a side note, 'SHOULD YOU BUY A MAC PRO?' Lightroom will run significantly faster on a Mac Pro. When running any universal binary application, you should not run a non-universal binary application at the same time. Programs like Lightroom CS4, iMovie will all run significantly faster if they are not running at the same time as non-universal binary applications. There's no doubt that the Mac Pro is faster running Universal Binary applications like

iMovie, Final Cut Pro, etc. The Mac Pro 2.66 GHz was from 16 to 62% faster than the Quad-Core G5/2.5 GHz.

Here is the issue. Photoshop CS2 will run faster on a G4 than on a Mac Pro, because it is a non-universal binary application. Lightroom and CS4 and will run considerably faster on the Mac Pro. This was one reason why Adobe released CS4 as a beta to the public. When CS4 was available to the public, Apple released the 3.0 GHZ Quad-Core Intel Xeon processor. Loading up this machine with 16 gigs of RAM makes Lightroom and CS4 absolutely fly. The only downside is the price, which can rapidly approach 10 K if the machine is maxed out.

Upgrading from Lightroom 1.4.1 to 2.0

If you were working in Lightroom 1.4.1, you will need to upgrade your Lightroom 1.4.1, you have a catalog (.lrcat file). If you have a single catalog, Lightroom 2.0 will automatically open that file and upgrade it, see **Figures 1A** and **B** below.

FIG 1A

FIG 1B

If you have multiple catalogs, you will need to upgrade each one on your own. The time this process will take is dependent on the size of your existing catalog. This operation CANNOT be cancelled.

Do not force quit this operation or Lightroom will become corrupted. Any catalog that is updated in 2.0 will no longer be able to open in 1.4.1. During the upgrade process, Lightroom will automatically check the integrity of the new catalog.

& All keyboard shortcuts and screen shots in this tutorial are Macintosh. If you are using the Windows version substitute the PC Control Key in place of the Macintosh Command Key. You also will substitute a Right Mouse Click for the Control key on a Mac.

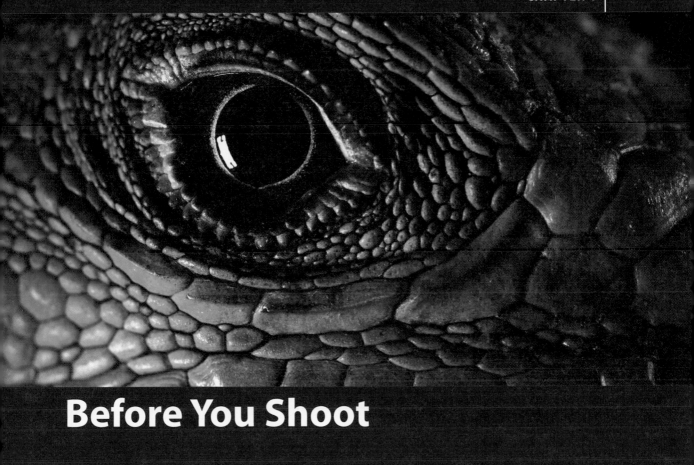

Before You Shoot

Before we get into the fundamentals of Lightroom, it is important to get a grasp on some of the key elements of shooting digital. When you learn math, it is vital to understand how to add and subtract before you learn how to multiply. This same principle applies to digital. Digital workflow begins even before the camera shutter clicks. In order to truly perfect your digital workflow, you need to understand all the concepts that govern the world of digital.

Memory Cards

Memory cards are an overlooked but a very important part of digital workflow. After all, the memory card is the modern day equivalent of your film. In the same way that you didn't use just any film, even though they were all color or black and white,

all memory cards are not created equal. Some of the important criteria are speed, data verification, technical support, warranty and size. SanDisk, Toshiba and Samsung are among the largest flash memory chip suppliers. Toshiba is actually a partner with SanDisk.

There is also a second component within a memory card known as the controller. SanDisk and Lexar produce the majority of the controllers. Technically, it is the combination of the controller and the flash memory that ultimately determine the efficiency and performance of the card.

If the memory card physically holds data, it is a miniature hard drive. These are known as microdrives, originally perfected by IBM. They are still available from Hitachi and Seagate. While these were very popular early on, they have largely been replaced by compact flash cards or flash memory. Memory cards enable your ones and zeros (digital data) to be stored in a cell known as a memory cell, as opposed to the rotating platter of a hard drive. Flash memory cards are more durable than the older microdrives in part because microdrives contain moving parts and are susceptible to jarring and rough handling.

Memory Card Speed

The speed itself is dependent on more than just the card. The architecture of the camera is also a factor. A card that is superfast in one camera could be slow in another camera. This all depends on how the controller interchanges data with the specific camera.

Choosing the Right Size Memory Card

Flash memory cards have been increasing in size, and are now available up to 32 gigs. D-65 still advocates using 2–8-gig cards. Why? The memory card is likely to be the first place where you can encounter a problem. Any glitch or failure with the memory card can wreck a shoot. For this reason, D-65 chooses to match the memory card to the RAW file size produced by the camera. Don't fall into the trap of believing that more storage on a card is better. You would never shoot film-based job on only one really long roll of film just in case the lab ran into problems. For this reason, D-65 recommends using multiple cards per job. You can size the card specifically for a camera. While a 32-gig card may seem like a great convenience, you are putting all of your 'digital eggs' in one

basket. The key is not to have too many images on one card in case of failure.

How Long Will My Memory Card Last?

All cards have a lifespan, as is the case with all digital products. While the manufacturers are reluctant to post specific numbers, all cards will eventually die, as the cells in the card start to expire. Do not assume that a card will last for 300,000 erase and write cycles. It is a good idea to introduce new cards using your existing cards as backup on regular intervals. D-65 buys new cards generally when the card size jumps to the next level. We don't buy the largest, but we do go up in size.

Always Format the Memory Card in Your Camera…Every Time

Whether you choose flash cards or microdrives, you must format these media in the camera. Do not just remove or delete the images using the computer or camera software. This may lead to data loss – why?

All cards and microdrives run with their own operating system and have their own native file structure. These media typically need to be formatted to a FAT16 file structure while many computers use a FAT32 file structure. If you manipulate the images on a card using a FAT32 computer, this information will be written to the card/microdrive. So, you will have a FAT16 device with FAT32 information – not a desired result, and such an easy problem to avoid.

Always format compact flash cards and microdrives in your camera. Also you should reformat the card every time you remove it from the camera. And most importantly, do not take the card out of your camera, check the images on a computer and then put the card back in the camera and continue shooting. You risk data loss.

Also, as a general rule, **never fill a memory card or microdrive**. If there is not enough space to write the last file, the entire card may get corrupted. Leave a few shots (three or four) at the end of each card. This greatly reduces the risk of card failure.

Editing in Camera

While it is generally safe to delete files as you shoot in the camera, there is an exception to this rule that can lead to data loss. **Do not**

delete files at the end of the card to create extra space for more shooting. The data is very vulnerable when the cards are close to filled. It is almost a guarantee that you will encounter data loss if you delete files at the end of the card. It is acceptable to do a rough edit while you are shooting, using the LCD on the camera back. Do not be overzealous with your editing; remember the limitations of the LCD display. However, it is a good idea to delete obvious 'out takes' from the camera to reduce editing time later.

Shooting at the Optimum ISO

Every digital camera has an optimum ISO setting. The best capture quality will be obtained using that ISO. In fact, the only camera setting that will significantly impact the quality of the RAW capture is the ISO. The nomenclature on the menus of cameras tends to confuse photographers. We all ask the questions, 'Should I shoot on Adobe RGB, Turn on Noise Reduction? Sharpening?' The reality is that none of these apply when shooting in RAW mode. The only settings that apply when shooting RAW are shutter speed, f-stop and ISO.

When shooting film, photographers typically pick a higher ISO when they need speed or when the light is reduced. In the world of digital capture, D-65 suggests shooting at the optimum ISO whenever possible because there is a direct correlation between digital noise and higher ISO. **The higher the ISO, the more potential there is to generate noise.** Noise is a level of electronic error usually resulting from amplification of the signal from the sensor. While there are various ways to mask noise, the best solution is to try and prevent it before it occurs. Up until recently, D-65 was adamant to try to shoot at the optimum ISO for the camera, the reason being that although camera manufacturers claimed excellent results at higher ISOs, we found that most of the cameras produced less than optimal quality at ISO 400 or above. Recently, because of better insulators in microcomponents and overall better technology, both Nikon and Canon have changed our way of thinking with the high-end cameras. While we still believe that the best quality is at the optimum ISO, we have seen spectacular results at ISOs above 1000. As time goes on, ISO may become less and less of an issue.

There is only one place to eliminate noise, and that is at the sensor level. Reducing noise after capture is a mask or band-aid; it is

not truly eliminating the problem. While noise can be reduced in Lightroom and Photoshop, if you need further noise reduction, D-65 recommends a great product called Noiseware (see http://www.imagenomic.com).

White Balance

The white balance indicates the color of the light in which an image was captured. Our eyes automatically adjust to changes in white balance by making the brightest area of the scene white. As you can recall, film shot under fluorescent lighting looked green, while to the human eye, it never appeared green. While no camera is capable of the white balancing accomplished in the human brain, digital cameras do an admirable job. Digital cameras have sensors with red, green and blue filters. There are twice as many green filters as red and blue filters in digital cameras because our eyes are most sensitive to green wavelengths. Digital is trying to mimic the way our eyes see.

Unlike film, a digital camera gives you full control over white balance. Obtaining a specific white balance value can be accomplished in many ways. Some cameras allow you to set custom white balance values. While it is true that you can always adjust the white balance of a raw file after the fact, having to do this will slow down your workflow. Achieving the correct white balance in a camera will speed up your workflow.

Many cameras have an AWB mode. In our minds, this stands for Average White Band, and not average white balance. The photographer should take control and determine the desired color temperature, and not a computer chip. For example, many of us like to shoot at sunrise and sunset. The light at these times, known as golden light or National Geographic light, is exceedingly warm. Setting your camera to AWB at these times will correct this light to look more like light at high noon.

On the following page we have an example of the same image shot with two different white balance settings. The scene is a vendor selling squid in an outdoor market. It is a cloudy day, and there are fluorescent tubes and a red incandescent light bulb hanging over the squid, along with a green and white awning. It is the type of image that in the days of film, would be nearly impossible to

FIG 1.1 As Shot

FIG 1.2 Custom White Balance Done in Camera

correct. In **Figure 1.1**, the camera is set to daylight. In **Figure 1.2**, we have done an in-camera custom white balance to achieve the correct white balance that we wanted.

X-Rite ColorChecker

If custom white balance isn't an option for you, another way to obtain an accurate white balance is to place an X-Rite ColorChecker in the scene.

To do this, place the X-Rite ColorChecker in the frame and capture the image. When you process the file in Lightroom, use the White Balance tool in the Develop Module and click on the second patch from the left in the bottom row. The white balance will be corrected instantly (**Figure 1.3**).

To use the custom white balance in the camera, focus on an area of the image that has white with detail (the underbelly of the squid in the upper left-hand corner of the image).

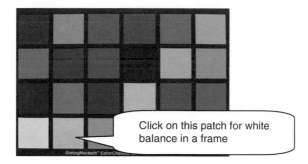

Click on this patch for white balance in a frame

FIG 1.3

While white with detail will not give exactly the same reading as an X-Rite ColorChecker, it will be very close in most situations.

Color balance is very subjective. We all see color differently. It is technically determined in our brain. No two people see the exact same shade of red in a red ball. If you were shooting clothing for a clothing manufacturer, then we would always recommend using an X-Rite ColorChecker. The manufacturer will want the yellow sweater to look exactly or as close to the real thing as possible. Going to a beach at sunset and shooting a portrait for an editorial piece is another story. You would likely want the warm light on your subject, which is not 'technically' white balanced at all. In the days of film, we used an 81A filter on the lens or a sun CTO filter on the strobes to warm up the scene and make it look like afternoon sunlight. Many editors hired us specifically for this look, while other editors didn't like the look of our warm portraits at all, thinking the skin tones were too orange. Neither look is right or wrong; it is just personal preference.

Understanding Histograms

One similarity between film and digital is that whether you are shooting with a digital camera or on film, getting correct exposure is essential for getting great results. Your creativity and composition may be great, but unless it is exposed correctly you have nothing at all. With film it is pretty easy to simply look at transparency and judge whether it was exposed correctly or not. Some photographers and photo editors assume that exposure is not a problem with digital, because you see your results immediately. Although this is a great advantage, it doesn't actually solve all the problems. Once you start looking at and understanding the technical merits of a digital file, the world that you thought you knew changes very quickly.

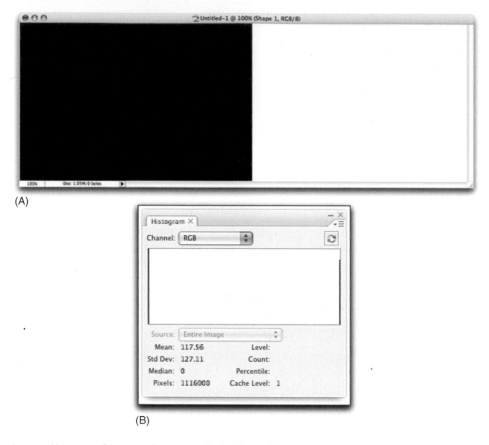

(A)

(B)

FIG 1.4 Image and histogram of the image showing pure black and pure white

Figure 1.4 above cont ains only pure black and pure white. The histogram for this image looks like a pair of goalposts.

While many folks would complain that the histogram above is a 'poor' histogram, it is actually a perfect histogram for this particular image. This is a very important concept to understand. **There is no such thing as a 'perfect' histogram**. An image cannot be judged on its histogram alone, as illustrated above.

Every image has a histogram that represents the tonal values in that particular image. Judging an image solely on the histogram is a mistake that many people, photo editors and stock agencies make. You must evaluate the image and its histogram together.

Figure 1.5 contains values from black (0) to white (255) and the histogram below it clearly shows that. However, the histogram shown below is not technically superior to the histogram shown

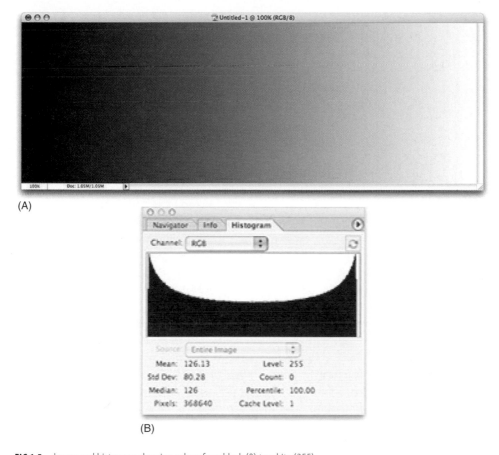

(A)

(B)

FIG 1.5 Image and histogram showing values from black (0) to white (255)

above. They each represent the tonal values of their associated image.

In Lightroom, the left side of the histogram represents 0% luminance while the right side represents 100% luminance.

Now that you've grasped these concepts, things start getting more complicated!

We will try and keep this simple and in ENGLISH. There is a conflict of sorts with digital and it is based on whether you come from a school of photography based on aesthetics or technical value. Let us explain. We grew up shooting transparency film, and when we wanted certain colors to saturate, we underexposed them. Our mentor was and still is Jay Maisel, who typically hit an electric shade of red known for its vibrancy that was about

two stops underexposed. Many of Jay's strong saturated colors were achieved with underexposure as much as two or even three stops. He shot for years on film that many came to love known as Kodachrome. Today, with a digital camera one can still underexpose and the color will look similar to that of film but the quality of the file will be poor. WHY?

The basic digital camera of today has a dynamic range of about six stops. The majority of cameras offer capture in 12 bits, meaning technically that they can capture (2^12) power or 4096 tonal values. If you divided the 4096 tonal values among the potentials of six stops and if each stop is looked at as a zone, it would be logical to assume that each stop has an equal amount of data. That logical assumption is wrong and accounts for one of the biggest misunderstandings when it comes to exposing for digital.

Most digital cameras today use a sensor that simply counts photons. They produce a charge that's directly proportional to the amount of light that strikes them. The cameras for the most part use a series of array filters. The red-filtered elements produce a grayscale value proportional to the amount of red light reaching the sensor, the green-filtered elements produce a grayscale value proportional to the amount of green light reaching the sensor and the blue-filtered elements produce a grayscale value proportional to the amount of blue light reaching the sensor.

A raw digital file is truly a linear file and, ironically, the capture of data is very much the same way as traditional f-stops work with film. F 2.8 allows twice the light, as F 4.0 and 4.0 is twice 5.6 and so on. So without getting too geeky here, one half of the data of a 12-bit capture (4096 levels) or 2048 levels is in the brightest stop (highlights), 1024 in the next stop, 512 in the next stop and so on until one gets to the shadows that contain only 64 levels. The darkest stop of the digital file has the least amount of data and thus shows the greatest amount of digital problems, mainly noise that looks static on a television screen (**Figure 1.6**).

Since most of the information in a digital capture is in the first brightest stop, the very act of underexposure reduces the quality of a digital file. From a pure technical position you should expose digital capture so that most of the data is present. As a general rule, this means that a properly exposed digital file is slightly overexposed. Then bring down the exposure during processing.

THE DARKEST TONES	THE DARK TONES	THE DARK MIDDLE TONES	THE LIGHT MIDDLE TONES	THE BRIGHT TONES	THE BRIGHTEST TONES
FIVE STOPS DOWN	FOUR STOPS DOWN	THREE STOPS DOWN	TWO STOPS DOWN	ONE STOP DOWN	2048
64	128	256	512	1024	LEVELS
LEVELS AVAILABLE	LEVELS AVAILABLE	LEVELS AVAILABLE	LEVELS AVAILABLE	LEVELS AVAILABLE	AVAILABLE

FIG 1.6 One half of the data of a12-bit capture (4096 levels) or 2048 levels is in the brightest stop (highlights), 1024 in the next stop, 512 in the next stop and so on until one gets to the shadows that contain only 64 levels.

Let's think about film for a moment. When shooting transparencies, we typically underexposed to increase saturation and color. The problem here is that if we simply underexpose in camera, we will lose valuable data in our RAW files. Essentially, digital exposure is exactly the opposite of transparency film. In digital we need to make a judgment call on the overexposure, rather than the underexposure. It is during processing that we can achieve rich, saturated color, rather than during exposure where we would sacrifice the quality of the file.

D-65 does not recommend to *always* slightly overexpose in digital. With film, the 'correct exposure' is the correct exposure. However, many times 'correct exposure' is a slight underexposure in order to achieve the desired saturation and color. We don't however always underexpose film. Similarly, we don't always overexpose digital files.

Warning: Using the Histogram Displayed on the Back of Your Camera

Not to further confuse the issue, but there is also a lesson here for the photographer. Many cameras have a histogram display on the back of the LCD on the cameras that warn when a highlight is about to be blown out and many photographers adhere strictly to the histogram, but the LCD preview and the histogram on the back of the camera do not represent any real information regarding how your raw capture will look. The camera does an 'on the fly' conversion to sRGB. The histogram is a luminance histogram of the sRGB preview, not a true representation of your file; most importantly, as a general rule for some of the most widely used professional cameras, the overexposure warning is off by at least one stop.

11

This prevents you from blowing out the highlight, but it typically eliminates the brightest stop with the most information. The camera manufacturers set the threshold for this display too low, which will lead you to underexposure of your image. If you look at **Figure 1.6**, and realize that the histogram on the back of the camera is blinking at level 1024 instead of 2048 (one stop early), and if you are like most photographers, you are worried by the blinking histogram. So you back off one more stop. You are now at level 512. You have successfully eliminated two-thirds of the information in this image. The blinking light is useful in that it really means you have at least one stop to the right before you are blowing out any highlights. One amazing quality about Lightroom is the ability to recover almost two stops of blown-out highlight detail captured by the sensor, but not visible in the camera LCD. Beware of the camera's histogram!

Exposing for Digital

Determining exposure for digital capture is quite different than exposing for film. Digital camera sensors have a wider dynamic range than many films and are much more sensitive to light than many films. You can use less created or strobe light with digital than you would with film. Lighting digital capture the same way you would light film will generally result in an image that looks overly lit.

Another common exposure problem is that people will base their exposure on a gray card and as a result shoot at that ambient light value. A light meter reading taken off of a subject of known reflectance like an 18% gray surface is only giving you a base exposure. With digital it is vital to actually expose for the color as well as the ambient light. Colors change and vibrate depending on the exposure. Our best suggestion is to shoot at the same ISO value so that your brain gets used to the colors produced under similar light conditions. Ideally, shoot on manual so that you learn the light instead of letting the camera make the decision for you. D-65 determines what color in a scene we want to accentuate. Our exposure is based on that particular color. For example, an image with bright, vibrant yellow and very dark blue will have a different exposure value depending on whether you are accentuating the yellow or the blue, regardless of the ambient light that is constant throughout the frame.

The key to getting a digital file that is technically good is essentially to shoot in a RAW mode and overexpose slightly and then bring it

down during the processing phase. In the end you can still end up with a red that looks like the Jay Maisel red, and in fact with a good raw processor, you can actually achieve a better quality image with more detail and even more vibrant colors and saturation, but getting there is essentially the opposite of what we did when exposing transparency film.

One thing that a photo editor must keep in mind is that if a photographer delivers a raw file and it is exposed correctly for the greatest amount of data, the file will most likely be overexposed. A photo editor may naturally think that the photographer should learn how to expose if his own knowledge is based on working with film, but the slightly overexposed digital file is actually the best one.

16 vs. 8: Is There a Bit of Difference?

Understanding the difference between 8 and 16 bits is a critical part of digital. Lightroom and Photoshop are all about 16-bit corrections and yet printing is all about 8 bit. Why do you need to care about bits especially if you are ending printing in 8 bit and know that 16-bit images are twice as big as 8-bit ones?

Let's start with some basics:

In digital imaging, the number zero is the complete absence of color while the number 255 represents the maximum level of a color. 8-bit RGB images use 0–255 to represent each channel of red, green and blue.

So, (255,0,0) is equal to red and (0,255,0) is equal to pure green, while (0,0,0) equals black and (255,255,255) equals white. Numbers 0–255 give 256 total distinct values that each of these three channels can have, and $256 \times 256 \times 256$ gives 16.7 million different combinations for an 8-bit image.

Now with 16-bit images, we get 65,536 values for each channel instead of only 256. So $65,536 \times 65,536 \times 65,536$ gives us 281 *trillion* total possible colors. It's confusing if we make it so technical huh…

So let's put all this in simple English and use fruits to describe 8 to 16 bits. Fruits and Lightroom go hand in hand and will actually make total sense.

Before we explain it is important to understand that altering pixel data is a destructive process. Quite simply, everything we do in Photoshop hurts the pixels. In fact, the best way of using Photoshop is the method that produces the least amount of destruction.

FIG 1.7 8 bit representation

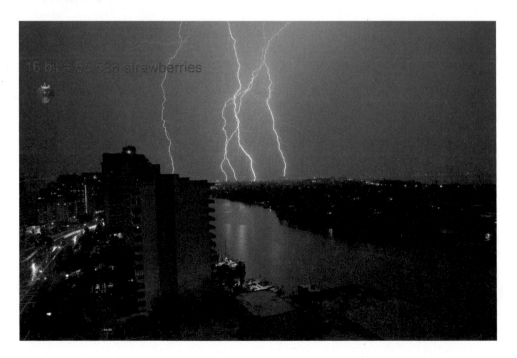

FIG 1.8 16 bit representation

To make this easy, we are going to use the concept of 256 (8 bits) and 65,536 (16 bits). Imagine that instead of pixels we had fruit deriving the images in **Figures 1.7** and **1.8.** Apples represent 8-bit, and strawberries represent 16-bit. Conceptually, we are making rows of fruits instead of pixels; so we have 256 apples making up the image in the 8-bit model and 65,536 strawberries making up the 16-bit model. Knowing that Photoshop is destructive if we went ahead and did a levels adjustment on the 8-bit model, we would have a hole, or in pixel terms a gap in data, in the image the size of one apple. Making the same adjustment on the 16-bit model, we would have a hole, or gap in data, the size of one strawberry. We could do many more adjustments on the 16-bit model, with each adjustment causing another strawberry-sized hole before we had a hole the size of one apple.

So as we edit in 16-bit mode, we will still lose data, but much less than we would in 8-bit mode. (It takes a lot of strawberries to make a hole the size of one apple.)

Can you see the difference between 16 and 8 bit? Yes and No. First, let's look at the histogram of the image with no changes (**Figure 1.9**).

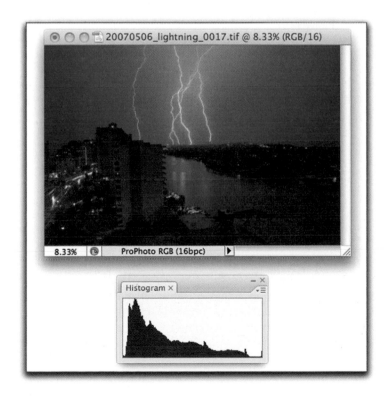

FIG 1.9 Histogram of the 16 bit image

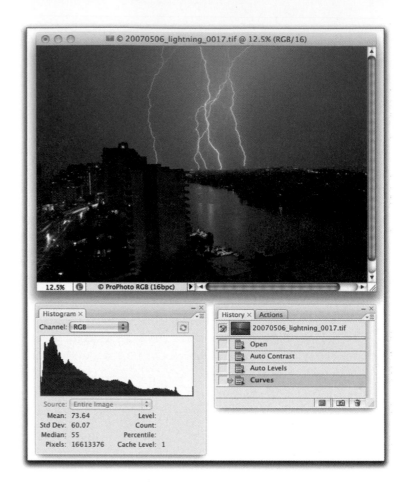

FIG 1.10 Histogram of image with adjustments done in 16 bit

In the histograms, choosing Auto Contrast, Auto Levels and a Curves adjustment on both a 16-bit (**Figure 1.10**) and an 8-bit (**Figure 1.11**) file will show a drastically different histogram. The histogram with the 8-bit file clearly shows gaps of data (apples vs. strawberries).

However, if someone were to show you a printed image, it may be very tough to decide whether it was 16 or 8 bits. There is one good example that is many times a telltale sign. In places like Miami where we have a nice blue sky, the sky in a print should go from a nice light blue to a much darker blue at higher altitude. In a print you may notice that the sky goes from light blue and then there is a line or what looks like banding going to a darker blue. Typically what you are seeing is an image that the adjustments were done in

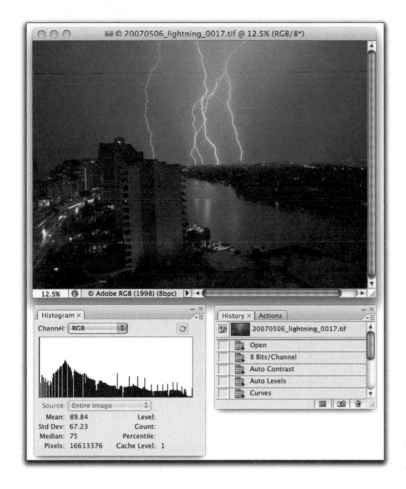

FIG 1.11 Histogram of image with adjustments done in 8 bit

8 bits instead of 16. The stripes or banding are missing gradations of tone, so instead of a nice even light to dark blue it appears as light blue and then a much darker blue.

So the bottom line is to work in 16 bits whenever possible.

Filters

While many photographers used all kinds of filters with film-based cameras, it is generally not a good idea to use them with digital. Why?

The glass in a lens is not flat and the lens is composed of many different elements and element groups. This glass has a meniscus curve. A meniscus curve is similar to the shape of a kneecap.

The idea of using glass with a meniscus curve is that light will pass through the lens and hit the sensor and then bounce straight out through the lens. Putting a filter, like a skylight filter that is generally a screw mount, can wreak havoc. The glass on the filter is most likely not a meniscus curve and light will pass through the filter, hit the sensor and then reflect back on the sensor instead of passing through the filter. Skylight and UV filters are also altering the wavelength of light that hits your sensor. The conversion of photons to pixels by the sensor is based on calculations from pure, natural light. In simple English, changing the light with a UV filter will affect contrast in the final image because the sensor has no way of knowing there is a UV filter on top of the lens. A polarizing filter is the only filter that is acceptable for digital, because achieving the effects of a polarizer in Lightroom or Photoshop is nearly impossible.

So how do you protect your lens? Use the lens cap! Jay Maisel uses Velcro strips to keep the lens cap attached to each lens. Otherwise, you may find them in your washing machine after they fall out of your back pocket ☺

Your Physical Work Environment

The room that houses your computer is an important part of digital workflow that is frequently overlooked. Your physical working environment must be considered part of your color management system. Following are some suggestions for maximizing the impact of your workspace.

- Control ambient light when correcting color: While many people will only work in totally dark rooms when correcting colors, it is difficult to work in total darkness for long time periods. In reality, total darkness isn't practical and too much ambient light competes with the light emitted from the monitor. So you will need to find a balance that works for you in your environment.
- Use a monitor hood: Shield the monitor from ambient light by using a hood on its top and sides. These two areas should be shielded to a distance of 12". The inside of the monitor hood should be of matt black color. These hoods can be purchased from stores catering to the graphics design trade or made using directions found on the internet.
- Configure a neutral computer desktop: Your desktop should be as neutral a color as possible. A solid gray is optimum. Your

desktop should not be configured to display an image of your child or favorite travel destination.

- Neutral walls reduce color cast: The visible walls around your monitor should be a neutral color; gray is ideal.
- Keep CPUs and monitors away from sources of direct heat or cold.

Working Backups

The most popular means of storing data is on hard drives. It is not a matter of if they die or fail. It is only a matter of when they will die. All data must be backed up regularly. For workflow, D-65 suggests a secondary hard drive to be used as a backup, and performing backups of what you're working on, on a regular basis.

Tip for Canon Camera Users

Some camera manufacturers allow you to put information into a metadata field called 'Owners Name'. By placing the proper copyright information into this field, you are embedding your name and copyright into all files created by that camera (Figure 1.12).

For Canon cameras: connect the camera to the computer with a Firewire or USB cable. Using the Canon software you can add and store your copyright information in the camera. This is an incredible asset and saves you a step during file processing.

FIG 1.12 Inserting copyright information in Canon cameras

Summary

- Not all memory cards are created equal, and bigger isn't necessarily better. Choose the correct memory card for your camera and for your needs. Don't forget to format your memory card every time you take it out of the camera.
- Only edit in camera when your memory card is not close to being full.
- The best image quality will be obtained when shooting at the optimum ISO for your camera. Noise is inherent at higher ISOs.
- The only filter acceptable for digital is a polarizer.
- Achieving the correct white balance may be subjective.
- X-Rite ColorCheckers can give a photographer the technically correct white balance.
- Your work environment is a critical component to your overall workflow and image quality.

- The histogram of an image shows the range of tone within an image. There is no such thing as a good or bad histogram. It simply reflects the tonal range of the image.
- Digital is linear capture, meaning we are capturing degrees of brightness. Twice the light or brightness equals twice the data or information.
- With digital capture, it is better to make a judgment call to overexpose, rather than underexpose.
- The histogram on the back of the camera is an sRGB histogram representing luminance only, and is typically off by one stop.
- It is essential to have a backup for digital imaging.

Discussion Questions

(1) Q. You have a job that requires you to shoot 500 images. Should you go out and buy a 16-gig card?

A. No, it is far better off to split the job among multiple cards. The greatest risk of data loss during the entire workflow process is with the cards themselves. Although there is recovery software available, it doesn't always work. Duplicating the data from the card multiple times and using multiple cards reduces the risk of loss.

(2) Q. Why do you want to try to shoot at the optimum ISO for your camera?

A. Grain and noise are two different things. While grain was desirable as an aesthetic quality in film, noise is always seen as a defect in digital. As ISO increases, noise becomes an inherent problem in digital capture. While it can be masked using software after the fact, it can only be eliminated at the sensor level upon capture. Shooting at the optimum ISO for your camera reduces the noise and increases the overall image quality.

(3) Q. Should I use a skylight or UV filter to keep my lens protected?

A. No, the glass element in your lens has a meniscus curve. This curve allows light to hit the sensor and bounce out through the glass. The filters do have a meniscus curve, and allow light to reflect off the sensor, back to the filter, and then back on the sensor, creating undesirable halos and ghost-like effects on the image.

(4) Q. Shouldn't I underexpose my digital files, just like I did with film to make the colors 'pop'? I love the look of Velvia.

A. No, digital is linear capture. Twice the amount of light is equal to twice the amount of information. Half of all the information in your digital file occurs in the first brightest stop and decreases by half with each additional stop. The reason noise occurs in the shadows of an image is that the shadows contain 1/64th of the information than the highlights. When exposing for digital, you will achieve a better quality file by exposing to the right (overexposing a bit) and bringing the image down in processing. Underexposing in camera, while it may achieve your desired effect, will increase noise and block up shadow detail.

(5) Q. Since I can always change the white balance of my digital file with software, does it really matter what I shoot it at?

A. It is critical to understand white balance so that you, and not the camera, can decide on the color and characteristics of the image. You may want to warm up or cool down an image, and all of that is achievable in camera. While you can make corrections after the fact, those corrections will reduce your efficiency and increase your time spent during processing. It makes more sense to get it right in camera to start.

(6) Q. When shooting RAW, is it a good idea to judge exposure of an image by looking at the histogram on the back of the camera?

A. The histogram on the back of the camera is in the sRGB color space only, and shows a very small gamut. It is also a luminance histogram only, and not representative of the raw data you are shooting. Additionally, the camera manufacturers generally tweak the histogram so that it is off by at least one stop. This is done to keep photographers from blowing out highlights, which was thought to be non-recoverable information in a file. With Lightroom and other imaging software, up to two or three stops of highlight detail can be recovered. Also, one half of all your digital data for the file is in the first brightest stop.

Understanding File Formats and Shooting RAW

Shooting in RAW Mode

RAW is the digital capture format that provides photographers with ultimate flexibility and allows them to produce the optimum file for delivery to clients and reproduction. The RAW format provides the most data, which is the basis for generating the best final image. This format contains all of the actual data captured by the camera's CCD or CMOS sensor. Finally and most importantly, capturing RAW format files gives you a true original, a digital negative. You can always return to your original and process it differently.

In the world of film-based shooting, once the film was processed there were very limited options to fix a poorly processed or improperly exposed roll. However, with digital capture in RAW format, the photographer can manipulate the actual pixel data

after the fact to achieve the desired results. This could be as simple as adjusting white balance or increasing contrast in the image, or as complex as manipulating individual color channels to improve hue and saturation. You do not have the ability to make these types of changes to JPEG or other file types without negatively impacting image quality.

Some photographers choose to capture JPEG format files because it is faster. Yes, shooting JPEG files is faster, but has some inherent problems. The JPEG format uses a lossy compression technique that results in pixel data being thrown away even during image captures. This loss of original pixel data lessens the quality of the image. The JPEG algorithm throws away approximately 3800 values of brightness from the image and uses destructive compression to shrink an image into a smaller size at the expense of quality. In fact, a JPEG has one-third of its luminance data discarded. Unfortunately, the most commonly implemented capture format for digital cameras is JPEG. Although appropriate, in limited circumstances the difference in quality is very noticeable at higher ISOs where increased noise and hue problems are clearly visible. Most importantly, every time you capture in JPEG format, you have lost your ability to have a real original, and restricted your color space.

The differences between capturing all the data as in shooting raw or capturing just some of the data as in shooting jpg are pretty dramatic. Figure 2.1 below reveals an image that was shot in RAW and processed as a TIFF. Notice the intense and rich color. This is what we would want the image to look like if we were showing it

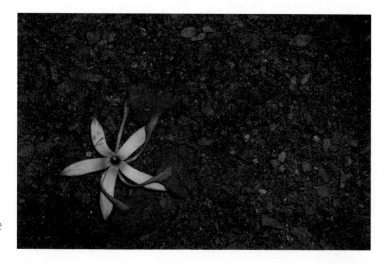

FIG 2.1 An image that was shot in RAW and processed as a TIFF. Notice the intense and rich color

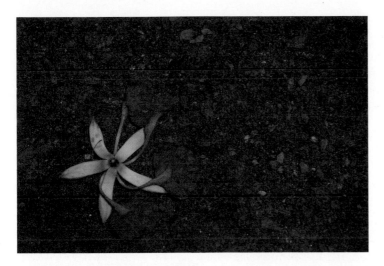

FIG 2.2 This image was shot in the highest jpg mode in camera. The colors are severely muted

to a client or a teacher. Next, take a look at Figure 2.2 and notice the difference in color and tone. This image was shot in the highest jpg mode in camera. The colors are severely muted. If you were to shoot both jpg and raw and were going to send your teacher or client the jpg files as an example of what you shot, you would see that they look very different from the version you shot as raw. For this reason, D-65 stresses to shoot raw and then, if required, convert to profile in Photoshop or Lightroom so that the color of the final image even in a jpg will look the same as the master file.

The differences between an image with all the data and a compressed file like a jpg go far beyond just the color. Look at Figures 2.3 and 2.4 and notice the jagged edges revealed in the jpg

(A)

(B)

FIG 2.3

(A)

(B)

FIG 2.4

file compared to the full-size tiff file. Also notice the histogram for each file. You can clearly see data loss in Figure 2.4, which is the histogram from the jpg file.

The importance of DNG

Shooting digitally allows a photographer to combine editing with shooting – providing the power to see in real time and improve the image. Personally, we haven't shot any film in more than 7 years, and doubt we will ever shoot film again. For what we do, digital is simply better.

But our intellectual property – and the intellectual property of all photographers – is at risk. Why? Almost every digital camera today creates a file, which is a proprietary RAW format. A RAW file contains all of the data and information the chip in the camera is capable of capturing. Unlike JPG, which is a lossy compression throwing out data and only available as an 8-bit file, RAW preserves all of the color data and metadata. Using RAW format, you can always go back and reprocess to different specs without losing any quality.

In the old film-based world, when the film is processed, right or wrong, there was no going back. With the RAW format, however,

the photographer is able to act as the 'lab technician' and tweak the pixel data to achieve both tonal control and white balance. You simply can't do this with JPG or other compressed formats without a loss of image quality. Simply put, RAW is the format that is needed to produce the optimum file for delivery to clients and reproduction.

The many faces of RAW

Here, however, is the problem: There are many different and proprietary RAW formats. Each digital camera manufacturer has created one or more proprietary formats for RAW files; some manufacturers even change those proprietary formats between their individual camera models. We have .NEF, .TIF, and .CRW, and .CR2 – just to name a few as RAW file extensions. And each camera company has created converters to change these RAW file formats into usable files such as JPGs, PSDs, and TIFFs.

An additional factor is the evolution of operating systems. As these operating systems change – Mac 9.2 to OS X to Tiger, Panther, and Leopard, for instance – software that's compatible with those systems at the very minimum needs updating. Suppose you have a 4-year-old camera that you used to photograph the greatest project of your life. Of course, you shot RAW because the RAW format is superior to all others. And you did everything right; you even backed up those files to all the media types several times. You now turn on your new computer and find that your camera manufacturer's converter has not been updated to the new operating system and won't run. Your greatest job can no longer be accessed. As operating systems change and as the world of digital capture grows, the potential for disaster increases.

Other problems can also arise. For instance:

- The photographic world is experiencing mergers and acquisitions as are many other sectors of our economy. Suppose your camera manufacturer merges with another company – as with Hasselblad and Imacon – or simply changes like Polaroid. Suppose they simply go out of business due to tough economic times. You may indeed own the copyright to those files, but it could become a classic case of having no software to open them.
- Currently, to open RAW files, you can use the camera manufacturer's converter or a third-party software such as

Lightroom, Capture One by Phase One, or Adobe's Camera Raw. From the perspective of digital photographers, the third-party manufacturers are typically the crème de la crème. Every time a new camera comes out, an engineer from the third-party manufacturer is required to reverse engineer the camera and try to adapt it to their software and then create an update for all their users. The lag time waiting for an update, however, can easily be 6 months. With all the new cameras coming out at such a rapid pace, you could have the latest camera, but your software of choice may not be updated.

As a photographer, you own the copyright to your work, which is granted at the moment of creation. You may own the copyright to your intellectual property, but if you can't access the intellectual property you create, you have nothing. To D-65, the greatest concern for a digital photographer today is not how many times you archive, but will you be able to open your archive? Photographers are currently being held hostage because our ability to open these files is controlled by third parties. The need for a universal RAW format is imperative.

Universal .dng?

With this in mind, Thomas Knoll – the guy who wrote the Photoshop program – and a group of other engineers from Adobe have produced a format designed to be universal – Digital Negative, or .dng.

Officially released in September 2004, .dng preserves all of the needed proprietary metadata and color information from the camera manufacturers, and also provides a universal means of archiving the data for all future generations. It does not replace the proprietary file, but rather creates a new file as a .dng, so that you wind up with your original RAW file as well as a copy of the RAW as a .dng. The long-term goal is that the camera manufacturers will utilize .dng as their RAW format, and do away with all the proprietary formats – so that all RAW files coming out of digital cameras are .dng.

Even Capture One, Adobe's biggest competitor for RAW processing, has announced that it would support .dng. This is a very positive step forward. We urge all photographers to embrace .dng as a means of preserving the very integrity of digital

photography – it is absolutely a necessity in guaranteeing the long-term viability of our digital files.

The ability for us to create art is based on licensing and re-licensing our creations for future generations. If future generations can't even open our creations, digital photography itself is at a risk of demise. In the D-65 workflow, we always archive a DNG.

File Formats

While there are many file formats including JPEG2000 and PDF, Lightroom supports the following file formats. What follows below is a basic description of each format.

RAW

RAW formats contain unprocessed data from a digital camera's sensor. Most camera manufacturers save image data in a proprietary raw format.

DNG

Digital Negative (DNG) is a publicly available archival format for raw files. By addressing the lack of an open standard for the raw files created by individual camera models, DNG helps ensure that photographers will be able to access their files in the future. You can convert proprietary raw files to DNG from within Lightroom and Photoshop and with the standalone free application DNG Converter.

TIFF

Tagged-Image File Format (TIFF, TIF) is used to exchange files between applications and computer platforms. TIFF is supported by virtually all paint, image-editing, and page-layout applications. However, most other applications, including older versions of Photoshop (pre-Photoshop CS), do not support documents with file sizes greater than 2 GB. Most image-editing applications will also recognize all the metadata contained in a TIFF file, making it the industry standard. The TIFF format provides greater compression and industry compatibility than PSD, but has several save options and takes longer to save than a PSD. In Lightroom, you can export TIFF image files with a bit depth of 8 or 16 bits per channel.

PSD

Photoshop format (PSD) is the standard Photoshop file format. To import and work with a multilayered PSD file in Lightroom, the file must have been saved in Photoshop with the Maximize PSD and PSB File Compatibility preference turned on. You'll find the option in the Photoshop file handling preferences. Lightroom saves PSD files with a bit depth or 8 or 16 bits per channel. Adobe applications all recognize PSD. Most other image-editing applications will also recognize PSD, but in some cases those applications may not be able to read all of the metadata within the file.

JPEG

Joint Photographic Experts Group (JPEG) format is commonly used to display photographs and other continuous-tone images in web photo galleries, slideshows, presentations, online services, and on the camera LCD. JPEG is an 8-bit RGB image but compresses file size by selectively discarding data. When shooting the JPEG format in camera, there is a loss of about 20% of the data on capture. And every time a JPEG is saved, there is additional loss. Making changes to the JPEG file and saving over and over again will eventually lead to a file that can no longer be opened in Lightroom or Photoshop, because each time you save a JPEG, random pixels are thrown away.

XMP

Extensible Metadata Platform (XMP) is a type of metadata. Metadata is a set of standardized information about a photo, such as the author's name, resolution, color space, copyright, and keywords applied to it. Most digital cameras contain information about a file, such as height, width, file format, and the time the image was taken. Lightroom supports this standard known as International Press Telecommunications Council (IPTC). This standard was originally developed for the wire services to identify transmitted text and images. IPTC includes entries for descriptions, categories, credits, and origins. You can use metadata to streamline your workflow and organize your files.

File information is stored using the XMP standard. In the case of camera, raw files that have a proprietary file format, XMP isn't written into the original files. To avoid file corruption, XMP

metadata is stored in a separate file called a sidecar file. For all other file formats supported by Lightroom (JPEG, TIFF, PSD, and DNG), XMP metadata is written directly into the files. XMP facilitates the exchange of metadata between Adobe applications and across publishing workflows. For example, you can save metadata from one file as a template, and then import the metadata into other files.

Summary

- There are six file formats that we discuss in Lightroom: RAW, DNG, TIFF, PSD, JPEG, and XMP.
- RAW and DNG are the only formats that contain all of the information the sensor is capable of capturing.
- There is currently no standard RAW format. This creates standardization and archiving issues.
- DNG is an open source solution to proprietary RAW formats.

Discussion Questions

(1) Q. Since JPEG takes up less space and you can fit more images on a memory card, isn't it wise to conserve space and to shoot in JPEG mode?

A. JPEG is a compressed format. It is smaller because random pixels are thrown out starting with capture, and every time a JPEG is saved. Almost one-third of the information that the sensor is capable of capturing is lost in JPEG mode. JPEG is fine for small files sent via e-mail or for posting to the web. It is not fine for your master files. All masters should be shot in RAW or DNG.

(2) Q. What is the one standardized format for processed files generally accepted by all imaging applications?

A. TIFF

(3) Q. My camera manufacturer always makes software to open my proprietary raw files. Why should I worry about a standardized raw format like DNG?

A. While your camera manufacturer may be here today, there is no guarantee that they will be here tomorrow. Look at Polaroid as an example. At one time they were the largest employer in the state of Massachusetts,

and every photographer used Polaroid film on a shoot. Operating systems continually change. On the MAC side, we have gone from Panther to Tiger to Leopard in less than 5 years. No camera manufacturer has guaranteed that all current software will be backward compatible. Files that opened up on your OS 9 system may not open up today. Digital needs to be as stable as film. Only a standard file format can assure this for the future.

Color Spaces for Digital

The Four Color Spaces for Digital

There are four color spaces that we will discuss: sRGB, Adobe98, ColorMatch and ProPhoto. First, think about color spaces as boxes of Crayola crayons. sRGB is the smallest box of crayons. It has 256 tones. The large box that many people choose can be thought of as Adobe98. It is like the big box of crayons with many shades of the same color. The ColorMatch space can be thought of as a much bigger box than sRGB but not as big as Adobe98. Finally, there is the ProPhoto color space, which is **so big** that not all the colors can even fit in the box.

Understanding Raw Digital Capture

Raw files contain no color profile upon capture. Once you bring those raw files into an image-processing software such as Lightroom, a color space needs to be designated. ProPhoto is D-65's choice for processing raw files. We also set up our color settings in Photoshop with ProPhoto as our working RGB. Why?

Digital cameras today have come a long way in a very short time. The sensors today are capable of capturing a very wide tonal range, but unfortunately, the majority of photographers simply don't take advantage of the capabilities of their camera sensors and inadvertently throw out very important color information without even realizing it.

Your camera captures a wider range of colors than you can see. The profile associated with the camera determines the colors available to be processed. Your camera captures a wider range of colors than your monitor can display. The profile associated with the monitor determines what colors presented to it are actually to be displayed. Your camera captures a wider range of colors than your printer can print. The profile associated with the printer determines which of the colors presented to it will be printed.

Let's start with how most cameras actually capture color or rather don't capture color. The camera sensor doesn't actually capture color at all. The sensor captures in grayscale only. It captures the intensity of the light in grayscale. There are colored filters on the sensor such that a given pixel only sees light through a single colored filter: either red or green or blue. Assuming you are shooting RAW, the job of the converter such as Lightroom, Adobe Camera Raw or Capture One is to interpolate data and render it as color. If the pixel being interpolated is a 'red' pixel, that value is assigned red. If the pixel being interpolated is a 'green' pixel, that value is assigned green, and if the pixel being interpolated is a 'blue' pixel, the value being assigned is blue. With these three values, a color equivalent number can be calculated.

Every camera requires a profile or formula that can be used to translate the 'zeros and ones' that become color equivalent numbers. Monitors and printers must recognize those numbers. This translation is essentially the goal of your working space.

Okay, so in a more basic English, the color world we perceive with our eyes is captured by our cameras as light intensity in grayscale,

translated into color by a special translator such as Lightroom and then passed on to our monitors, printers and all other devices.

Working Space for Digital

The majority of photographers use Adobe98 as their working space. While delivery in Adobe98 may be the so-called standard for delivery, it is not necessarily the ideal working space for digital photographers shooting RAW. Why?

ProPhoto can hold all the color the camera can capture plus more. As cameras improve, they capture even more colors. Every other color space, including Adobe98, will clip color from today's cameras. So that leads to the obvious question: What is clipping? In digital imaging, when a color falls outside the gamut or range, then we say that the color has been 'clipped'. If we did nothing about the color, then it would be left out of the final image. If we left these lost colors unattended, then our final image would come out, looking flat, due to the missing hues. One of the biggest complaints of digital photographers is the loss of reds. Well, when colors clip, red is the first to go. ProPhoto preserves the widest range of reds. A monitor can display colors that cannot be printed. As well, paper can render colors the monitor cannot display. Why would you want to limit printed colors just because your monitor can't display them? Epson & Canon printers can print colors that are outside the Adobe98 space. Using a ProPhoto space will obtain a greater range of tones and colors. The bottom line is that Adobe98, or any color space except ProPhoto, does not preserve all the colors you get from the camera. Once the file is converted, the extra shades are gone forever. We must also look towards the future. While your monitor of today can't typically display all of the color in Adobe98, the monitors of tomorrow, and some of the more expensive monitors of today, display the full range of Adobe98 if not more. For anyone using Adobe98, you must ask yourself the question: 'Why would you want to eliminate extra color and tone just because your monitor of today can't show it?'

Color Space for the Web

The standard color space for the web for most monitors is sRGB. The reason for this is because when the standards were defined,

sRGB was the largest space for any monitor. As monitors get better, there may be less of a need for sRGB.

ColorMatch Color Space

Another color space that is worth paying attention to is ColorMatch. ColorMatch was defined by the old Radius Pressview monitors, which were an industry standard quite some time ago. ColorMatch is very close to the gamut of CMYK. Many photographers have difficulty converting to CMYK and complain about the correct color when the client does the CMYK conversions from Adobe98 for press. Since ColorMatch is very close to CMYK, it makes a lot of sense to deliver in ColorMatch if CMYK is out of the question.

There is a problem delivering in Adobe98 for most client/ photographer relationships. Here's why…In the old days, when we delivered film, the art director or pre-press house scanned the film and made a proof. Today, most art directors will receive a digital file in Adobe98 from a photographer. This is where the problem starts. Delivering in Adobe98 is sort of like saying 'See all this color, well you can't have it'. CMYK is a much smaller color space than Adobe98. Delivery in Adobe98 just about guarantees that the proof will not look like the image on the art director's monitor. The blame then falls on the photographer shooting digital. If delivery occurred in ColorMatch, which is smaller than Adobe98 and very similar to CMYK, the proof will look very much like what is on the art director's monitor. The digital photographer will definitely be hired again.

Using Color Spaces and Profiles in Workflow

With this in mind, it makes sense for digital photographers shooting RAW to make their Photoshop working space ProPhoto, to process their raw files as 16-bit ProPhoto and to store their archive files as ProPhoto. ProPhoto is perfect for the digital photographer but not ready for prime-time TV for the rest of the world. Because the majority of the world is in Adobe98, you certainly don't want to deliver file to clients in ProPhoto. For client delivery, you may want to convert into a color space that the client can handle. Most clients are used to Adobe98. D-65's

recommendation is to convert the raw file using the ProPhoto color space during raw conversion and deliver in Adobe98 or ColorMatch. This will allow the photographer to gain greater tonal range and color and preserve it achieving a better file. Converting the file to Adobe or ColorMatch will preserve the greater tonal range and color while allowing the client to use the color space that they are used to.

Why ProPhoto?

- ProPhoto can hold all the colors that the camera can capture.
- As cameras improve, they capture even more colors. When colors clip, red is the first to go. ProPhoto preserves the widest range of reds.
- A monitor can display colors that cannot be printed. Paper can render colors that the monitor cannot display. Why would you want to limit printed colors just because your monitor can't display them?
- Epson & Canon printers can print colors that are outside the Adobe98 space. Using a ProPhoto space will obtain a greater range of tones.
- The bottom line is that Adobe98 or any color space, except ProPhoto, does not preserve all the colors you get from the camera. Once the file is converted, the extra shades are gone forever.

Color Spaces for Client Delivery

Ideally, we would deliver images in CMYK using the ICC profile supplied by the client or printer. Having the actual CMYK profile when we do our color conversions will produce the best results. However, much of the world disregards color profiles and/or doesn't understand color management. D-65 has a solution for these people too.

If we are going to deliver RGB images, D-65 will deliver files in ColorMatch. ColorMatch most closely resembles what will be produced by CMYK output. Delivering files in Adobe98 may look better on the screen but may contain more colors than can be printed. So what you see is not going to be what your client will get in print.

For images being used on the web or in multimedia presentations, D-65 will deliver files in the sRGB color space. This limited space is the de facto standard for the web.

Demonstration on ProPhoto

This is an image shot in ProPhoto and a graph of the image in the color analysis program, Chomix ColorThink (Figures 3.1, 3.2 and 3.3).

(A)

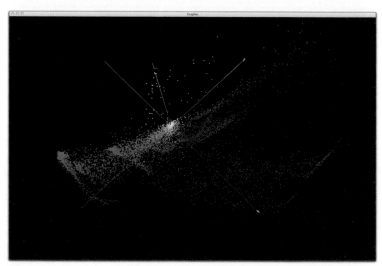

FIG 3.1 Map of the Image Color (B)

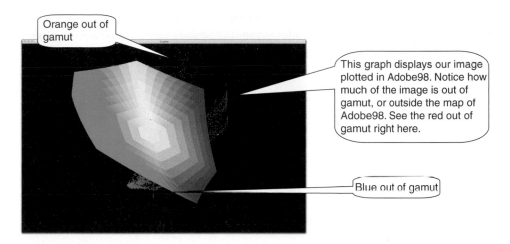

FIG 3.2

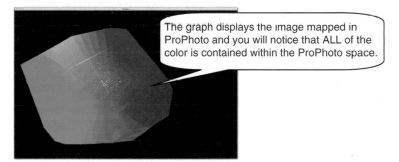

FIG 3.3

One big problem with color management that always surfaces is how to handle files with different tagged color profiles or without any color profile.

When to Assign or Convert Profiles

- When opening a file, always assign a profile to an untagged (missing a profile) file. If a file comes in without a profile, use your working RGB.
- Convert from a source color profile to a destination color profile when you want to retain the color in a file but need it in a different color space. For example, you would convert a ProPhoto file to sRGB when it is being used on the web. It will still look like the ProPhoto file but will be tagged sRGB.

- A big misconception is that you can 'go up' or increase the color space of a file. Photoshop will allow you to convert from sRGB (a smaller space) to ProPhoto (a larger one); however, the effect will be one NOT of additional colors but only of more tones of the same colors.

To summarize, Lightroom has really simplified many of the tough choices associated with processing. For one, Lightroom uses a very wide color space, essentially ProPhoto RGB, but a gamma of 1.0 instead of 1.8. A gamma of 1.0 matches the native gamma of raw camera files, and ProPhoto is able to contain all of the colors that your camera is able to capture. Since ProPhoto is really a 16-bit space, Lightroom uses a native bit depth of 16 bits per channel.

It makes sense to process your raw files in ProPhoto and to store your archive file as ProPhoto. For client delivery, you will want to convert to the client-provided CMYK profile or, for a web press, U.S. Web Coated (SWOP)v2 is a good default if you can't get the ICC profile from the printer. Use ColorMatch RGB for print or sRGB for the web. D-65 does not deliver images in the ProPhoto color space because most clients would not know how to handle it.

Images in Lightroom can be in any color space and will be color managed, provided the image has an embedded profile. If the image(s) you are working on does not have an imbedded profile, Lightroom will automatically assign sRGB without a warning dialog box.

Summary

- There are four important color spaces for digital photographers. They are from smallest to largest: sRGB, ColorMatch, Adobe98 and ProPhoto.
- It makes sense to work in ProPhoto for digital imaging but deliver in ColorMatch or convert to CMYK for print.
- If your images are going onto the web, sRGB is the correct color space.
- Lightroom's native color space is 16-bit ProPhoto.
- Assign a profile when an image is not tagged with one.
- Convert to profile when going from a larger color space to a smaller color space.
- While Adobe98 may be the so-called standard, it isn't necessarily the best color space for digital photographers capturing in RAW.

Discussion Questions

(1) Q. What are the four major color spaces for digital photographers?

A. sRGB, ColorMatch, Adobe98 and ProPhoto.

(2) Q. Why would you use ProPhoto as your working space if your monitor can't display it?

A. While it is true that the monitors of today cannot typically display ProPhoto, monitors of the future will be able to display color spaces wider than Adobe98. Certain paper and ink combinations can already print a wider gamut than Adobe98.

(3) Q. What is the best color space for delivering to a client?

A. It all depends on the final use of the image. If the image is going on the web, then sRGB is the correct space. If the image is going to print, then ColorMatch is the best choice if you are delivering in RGB or to get the ICC profile from the printer and convert to CMYK.

The Lightroom Catalog

Lightroom is a true digital asset management system, and
much more powerful than a simple or even advanced browser.
An image browser allows you to simply browse folder structures
and see thumbnails, while Lightroom stores information directly
into a database. One of the key differences here is that with
Lightroom all of your information about your images is available
even if the image collection is not online or connected to your
computer. This means that you can take Lightroom on a laptop
and still see 20 years worth of images and all accompanying
metadata, without physically having those images with you. You
cannot do this with an image browser.

Let's make this really simple. You have your images on an external
hard drive. With Adobe Bridge for example, in order to see those
images, the hard drive has to be connected to your computer to see

them. With Lightroom, your external hard drive can be a thousand miles away and you still can see your images on your computer.

There are pros and cons to each of these approaches. The biggest pro for Lightroom is that the majority of the information about your images is available regardless of whether the images are with you or not (online or offline). The downside or the con to Lightroom is that in order to achieve the above, the images must be imported into Lightroom's database. The biggest pro and con of Bridge in comparison to Lightroom is that you do not have to import anything into Bridge to view it. You simply scroll through a hierarchy and can view your images. The downside is that anything you want to view must be connected to your computer or on your connected hard drive.

Lightroom will not replace Bridge. They are intended to complement each other. If you need to deal with files like PDFs and Quicktime movies, and you want to place files from one Adobe application to another, you will likely find that Bridge is good for your workflow needs. If you are a digital photographer and looking for a true digital asset management system, where you can even take your entire image collection on the road with you, then Lightroom is your answer.

Lightroom's Catalog

To fully understand how Lightroom works, we will need to examine its structure. Lightroom has three basic components.

(1) There is the application itself, Adobe Lightroom, which resides in your application folder.

(2) There is also a Lightroom folder containing two very important files: The Lightroom_Catalog.lrcat and the Lightroom_CatalogPreviews.lrdata. These two files are the heart that makes Lightroom breathe. The default location for this Lightroom folder is in your User>Pictures folder. The Lightroom_CatalogPreviews.lrdata file contains the thumbnail previews for each of your image files. There are several types of previews available to you, and we will cover them later. The Lightroom_Catalog.lrcat file contains all of the database information related to your images.

(3) There is one more folder which is stored in your User>Library>Application Support>Adobe>Lightroom folder which contains all of the presets that come with Lightroom,

as well as any custom presets that you may create. The Windows path for this information is Documents and Settings/ [username]/Application Data>Adobe>Lightroom folder.

When you open Lightroom for the first time on a clean system without Lightroom ever on the system, the user is not prompted to select a catalog, it is automatically placed in the Pictures folder. If you already have Lightroom installed, you can option click when starting Lightroom and select the location for your catalog. This is where your digital asset management system begins.

Let's explain the concept of the Lightroom catalog using a visit to your local public library as an analogy. When you walk into your local public library, there are thousands of books on many shelves and possibly on multiple floors. You've come to the library today to find one book. You can ask the librarian for help, or you can go to the card catalog for all kinds of specific information about every book in the library. It would be impossible to walk through the aisles looking at every book to find the title you are seeking. Instead, you go to the card catalog and find the location of your book and simply walk directly to the right location. Similarly, it is not efficient to browse through a million thumbnails to find one image. So Lightroom uses a catalog (Lightroom_Catalog.lrcat) as its card catalog for your images, the same as the card catalog in your public library.

Now let's add to this concept. Your public library doesn't exist with only a card catalog. There is a physical building that holds all the books within it, along with the card catalog. In Lightroom, your images are also stored in a physical place. D-65 prefers this image library to be an external drive, or a secondary internal hard drive. This hard drive is your 'public library' and all the images that reside in it are your 'books'. You may have thousands of images, just like a library has thousands of books. These images become your Lightroom library. To find a specific image, you will use the power of Lightroom's catalog, exactly like the card catalog at your local public library.

Lightroom's Catalog Location

Here is the critical part. The default location for the catalog created by Lightroom and your images is in your User>Pictures. This is fine for a few images, but keep in mind that with today's cameras, like a Canon 1DS Mark III, each file can be close to 100mg. As your computer's internal hard drive becomes more than 50% full, it rapidly loses efficiency. For this reason, we prefer not to use the default location, and instead use large dedicated drives (internal or

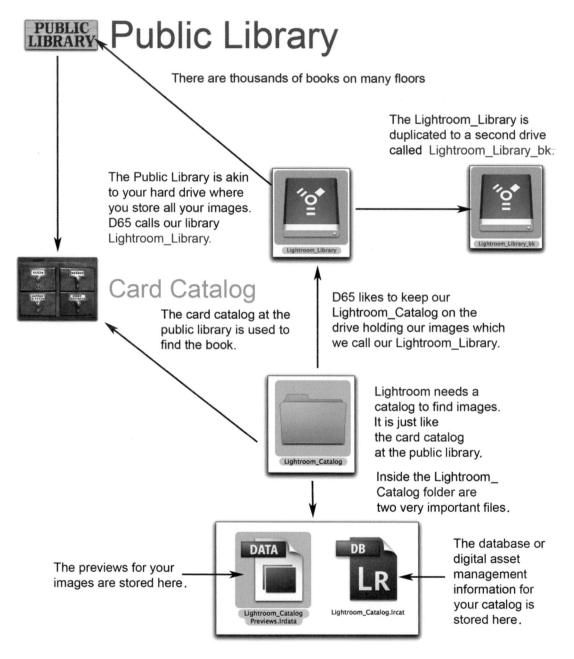

Public Library

There are thousands of books on many floors

The Lightroom_Library is duplicated to a second drive called Lightroom_Library_bk.

The Public Library is akin to your hard drive where you store all your images. D65 calls our library Lightroom_Library.

Card Catalog

The card catalog at the public library is used to find the book.

D65 likes to keep our Lightroom_Catalog on the drive holding our images which we call our Lightroom_Library.

Lightroom needs a catalog to find images. It is just like the card catalog at the public library.

Inside the Lightroom_ Catalog folder are two very important files.

The database or digital asset management information for your catalog is stored here.

The previews for your images are stored here.

FIG 4.1

external) to hold our Lightroom library and Lightroom catalog. D-65 is currently using a terabyte drive to hold the Lightroom catalog and the Lightroom library.

To setup your new Lightroom library and catalog, we suggest using two large dedicated hard drives. One is for holding your Lightroom library and catalog, and the other as a backup holding the exact same information. We call the drives Lightroom_Library and Lightroom_Library_bk. We call our dedicated drive Lightroom_Library because by doing this we, regardless of how many hard drives we have, we always know which one holds our images and catalog for Lightroom. Naming the hard drives in this way keeps things organized right from the start (Figure 4.1).

We use an internal drive to store our Lightroom catalog and our raw files. There is nothing else on this drive. It is dedicated to Lightroom only. Using an internal drive we are able to have the fastest possible connection. We maintain an exact duplicate of this drive on a second drive just for safety and we call this drive Lightroom_Library_bk. The 'bk' stands for backup (Figure 4.2).

FIG 4.2 Icons of Lightroom_Library
hard drive and backup drive

What is The Lightroom Catalog?

In order for Lightroom's catalog to 'see' or recognize an image, the file itself must be physically imported into Lightroom. The Lightroom_Library hard drive contains all of those imported files. We also create a new folder on our Lightroom_Library hard drive to hold our catalog. We call this folder Lightroom_Catalog. It contains the Lightroom_Catalog.lrcat and the Lightroom_CatalogPreviews. lrdata files. We choose to use a terabyte drive so that we can hold all of our imported files and the Lightroom catalog on one dedicated hard drive that is always loaded as Lightroom's default.

D-65's Lightroom_Library contains only RAW files. These can be RAWs or DNGs. We are only holding only our RAW files and none of

our processed files in the Lightroom_Library for one specific reason. Lightroom may slow down if there are more than 100,000 files in the Library. Eventually, the goal is to hold at least 1,000,000 files.

D-65 has taken all of its RAW files going back to 2000, and imported them into the Lightroom_Library. Our dedicated terabyte drive contains folders of RAW files, each designated with a job name (year, month, day, underscore job name). Also on this terabyte drive is our Lightroom_Catalog folder. It is held within the Library (see Figure 4.3).

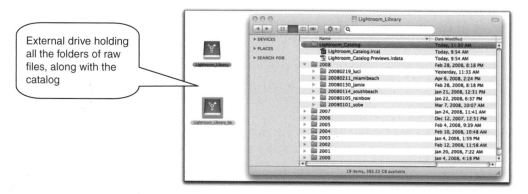

External drive holding all the folders of raw files, along with the catalog

FIG 4.3

The default location when you start Lightroom for your catalog is in your User>Pictures in a folder called Lightroom (Figure 4.4).

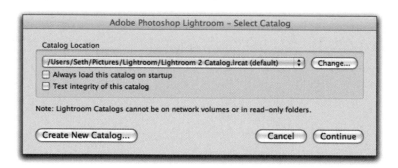

FIG 4.4 Default catalog location

As you can see in Figures 4.5 and 4.6, D-65's catalog folder is very large. This is our primary reason for a large, dedicated drive holding all of our Lightroom files. If our catalog alone was in Lightroom's default location, we would have crashed and run out of space long ago.

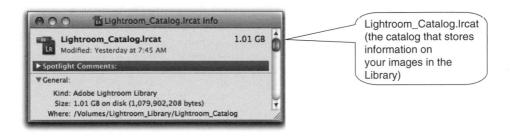

Lightroom_Catalog.lrcat
(the catalog that stores
information on
your images in the
Library)

FIG 4.5

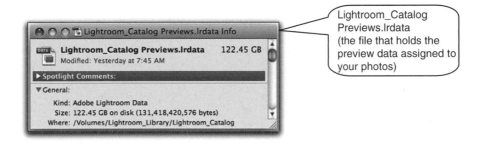

Lightroom_Catalog
Previews.lrdata
(the file that holds the
preview data assigned to
your photos)

FIG 4.6

To Create a New Catalog

1. Start Lightroom while holding down the option key.
2. The Select Catalog window will pop up with your default catalog location.
3. Choose 'Create New Catalog'.
4. Choose the drive that you named Lightroom_Library.
5. Under 'Save As', type in Lightroom_Catalog.
6. Choose 'Create'.
7. Lightroom will open with your new catalog loaded (Figure 4.7).

FIG 4.7

The next time you start Lightroom with the option key down, you will see your new catalog listed. We suggest checking 'Always load this catalog on startup' so that it will always load as your default (Figure 4.8).

FIG 4.8 Select catalog to always load on startup

Catalog Tips

- If you ever lose your library or catalog, you have to physically choose the catalog file (.lrcat) within the Lighroom_Catalog folder.
- To create a new catalog, hold down the Alt key on Windows or the Options key on MAC when starting Lightroom.
- Lightoom's performance will decrease significantly if virus software is turned on.

Using More Than One Catalog in Lightroom

You can create more than one Lightroom catalog in order to aid with organization and digital asset management. The downside is that you can only have one catalog open at the same time.

There is no right or wrong answer as to how many catalogs you have in Lightroom. It is a matter of philosophy. George Jardine, Adobe's Lightroom Evangelist, loves to have catalogs for every place he travels. For him, this makes total sense because he simply looks at the title of the catalog and loads the catalog he is trying to find. A photographer who shoots weddings, bar mitzvahs and social events may very well want a separate catalog for each type of event listed above. Since you can only view images from one catalog at a time, D-65 prefers to have one large catalog holding all

the information on our images, and using extensive metadata and keywords to describe each image. In this way, we can cull down and find anything we are looking for. For example, we will always have keywords or metadata describing the location we shot; so if we wanted to find all of our Miami Beach images, we would simply search the entire catalog for Miami Beach and find those images. Alternatively, George Jardine would just load the one Miami Beach catalog. Thus, we have two ways to do the same thing.

Summary

- Lightroom is a digital asset management system, not just a browser. Lightroom needs a catalog to find images. It is just like the card catalog at the public library. Inside the Lightroom _Catalog folder are two very important files, Catalog.lrcat and Previews. lrdata.
- D-65 chooses to change the default location of the catalog because of its size.
- D-65 creates its own dedicated Lightroom_Library that holds all RAW files and the Lightroom_Catalog folder.
- You can create a new Lightroom catalog by following the steps discussed.
- You can create more than one catalog but can open only one at a time.

Discussion Questions

(1) Q. What is the difference between Lightroom and Bridge?
 A. Lightroom and Bridge behave differently. To view images in Bridge, your images must be on your hard drive(s) or connected to an external storage device. This defines Bridge as a file browser. Lightroom is a true database that catalogs the images you import. You can view all images whether or not your hard drive or external drives contain the actual photos once they are imported. They are being viewed as reference files in your Lightroom_ Catalog.

(2) Q. Why would you want to use a large internal or external drive for Lightroom instead of the default location?
 A. The files from the previews and catalog can grow very large. It is doubtful that the user Picture folder has enough room to provide all the needed space for Lightroom.

(3) Q. What are the two files in the Lightroom catalog and what do they do?

A. The Lightroom_Catalog.lrcat and the Lightroom_CatalogPreviews.lrdata. The Lightroom_CatalogPreviews.lrdata file contains the thumbnail previews for each of your image files. There are several types of previews available to you, and we will cover them later. The Lightroom_Catalog.lrcat file contains all of the database information related to your images.

(4) Q. Why would some photographers want one catalog and others want many catalogs?

A. A photographer who shoots weddings, bar mitzvahs and social events may very well want a separate catalog for each type of event listed above. Since you can only view images from one catalog at a time, some photographers prefer to have one large catalog holding all the information on their images, and using extensive metadata and keywords to describe each image. In this way, they can cull down and find anything they are looking for.

Lightroom's Preferences

All software come with preconfigured default preferences. Many of us just assume that the defaults are correct and start using the software. The defaults may be fine for some but disastrous for others. In order to truly streamline your workflow, it makes sense to configure your preferences so that they best suit your needs and to do so before you start using the software. With this in mind, this chapter will cover all of Lightroom's preferences and catalog settings so that your Lightroom will really fly.

Lightroom's Preferences

Now let's setup Lightroom's preferences. Go to the Lightroom main menu bar to Lightroom>Preferences. We will go through each of the preferences panes (Figure 5.1).

FIG 5.1 To set up Lightroom's preferences, go to the Lightroom main menu bar to Lightroom > Preferences.

General Preferences

By default, Lightroom will load your most recent catalog. Although D-65 suggests it, you don't have to keep all your photos in one catalog. You may want to create more than one catalog if you'd like to organize your system differently. You can choose to load another Lightroom catalog at any time from this general preferences menu or by starting Lightroom by holding down the option key and choosing which catalog to load (Figure 5.2).

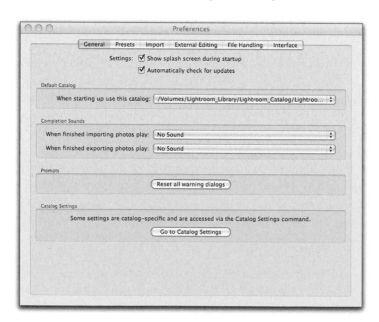

FIG 5.2 D-65's suggested setup for Lightroom's General Preferences

Presets Preferences

D-65 chooses not to apply auto tone or auto grayscale mix. While we may use auto at times, we prefer to start out with our images 'as shot', and manually decide how to process them. The reason we do choose 'Make defaults specific to camera serial number and ISO setting' is that we might choose to apply a develop preset on import, which is camera and ISO specific. If this camera model or ISO should change, with these checked, the develop preset would not be applied. If you have more than one catalog, you might want to choose to store presets with catalog under Presets. We like to have our presets available all the time, no matter what catalog we choose or if we create a new one, so D-65 does not check 'Store presets with catalog'. Restoring any of the presets listed above will restore them to the way Lightroom is configured out of the box. This is useful if you have deleted or made changes to some of the default presets in Lightroom. A great way to move custom presets from one computer to another is by using the 'Show Lightroom Presets Folder' option (Figure 5.3).

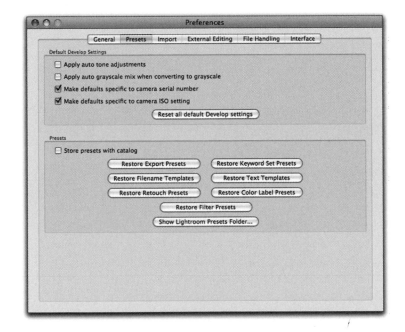

FIG 5.3 D-65's suggested setup Lightroom's Presets Preferences

Import Preferences

D-65 chooses 'Show import dialog when a memory card is detected' option. This is the first step of our workflow. We will check 'Ignore camera-generated folder names when naming folders'

because we will designate our own file naming convention. We do not check 'Treat JPEG files next to raw files as separate photos' because D-65 does not shoot RAW + JPEG. We shoot raw and create our own jpegs from the tweaked raw files. If you do shoot RAW + JPEG, then it would be a good idea to check this box, so that you can differentiate between your raws and jpegs (Figure 5.4).

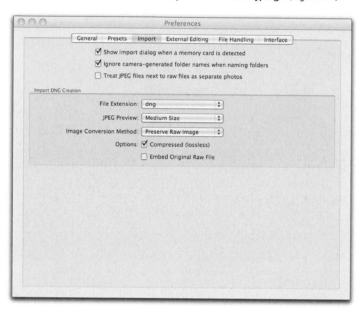

FIG 5.4 D-65's suggested setup Lightroom's Import Preferences

If you choose to import as a DNG, instead of copying or moving the camera proprietary raw, we suggest the preferences listed above.

External Editors Preferences

One of the totally cool features of Lightroom is the ability to open a file from Lightroom directly into Photoshop. This can be done from using Lightroom's Photo Menu>Edit in Adobe Photoshop CS3, or keyboard shortcut, command E. You can then save that same file directly back into Lightroom next to or stacked with the original. You even have the ability to pick a second application for editing as well. For example, maybe you have a plug-in that only works in CS2. You can pick CS2 as your second application. You will have the choice to open a file in Lightroom directly into CS3 or CS2 from Lightroom's Photo Menu.

Why would you use this feature? Suppose you shot a skyline of seven frames and they are all in Lightroom. You want to use CS3's stitching capability to create a panoramic. You would select all the images in Lightroom, choose command E and create your panoramic in CS3. When you close the file, it automatically stores within Lightroom.

Without this feature, you would have had to export each file individually from Lightroom and then open each file in Photoshop, and import the new panoramic file back into Lightroom. This is a huge timesaver because you are basically able to bypass the import dialog.

This preference is for the files you are going to create in Photoshop or your designated application. D-65 chooses a 16-bit ProPhoto RGB PSD or TIFF because these are the type of files we create for working in Photoshop.

TIFF maybe more compatible with keeping up with changes in metadata in all applications. This is recommended for best preserving metadata in Lightroom. The first thing any application is going to update is to a TIFF standard.

So why would you want a second editor? One reason is if you want to use Photoshop plug-ins. All plug-ins needed to be rewritten for CS3 and many developers still have not updated some of the plug-ins. So if you wanted to use a plug-in that hasn't been updated, you may want to choose CS2 as a second editor. If you work on images in several applications, you even have the ability to create a preset for additional editors, specifying the file type, color space, bit depth, etc. per application preset.

We do not apply an export naming convention because we rename during our Lightroom workflow, and we like to keep those same names for our exported files (Figure 5.5).

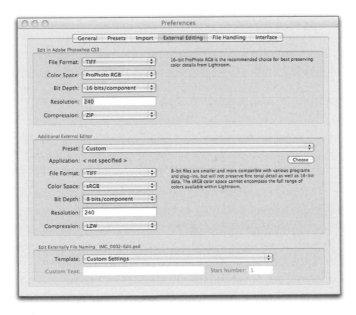

FIG 5.5 D-65's suggested setup Lightroom's External Editing Preferences

File Handling Preferences
Reading Metadata

If you are using other applications or have used applications in the past that separate keywords with a period or slash, then you should check the options – Treat '.' and treat '/' as a keyword separator (Figure 5.6).

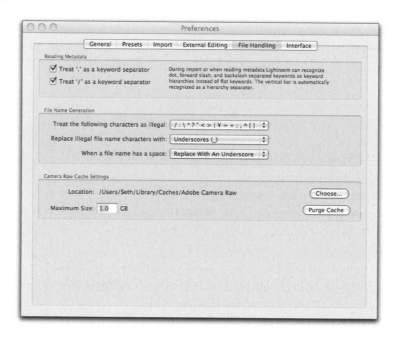

FIG 5.6 D-65's suggested setup Lightroom's File Handling Preferences

Lightroom uses commas ',' to separate keywords. This preference makes it very easy to import and utilize keywords applied to images even if the keywords are not separated by a comma.

File Name Generation

D-65 uses underscores in our file naming convention. Many photographers and other applications use all kinds of characters, including spaces, which are known as illegal characters in their filenames. Use of illegal characters in filenames can cause applications to substitute randomly generated characters or they may have difficulty reading the filename. Spaces are particularly notorious for causing problems between computers. To insure cross platform compatibility, Lightroom provides few very cool options. Even if your filename contains illegal characters or spaces, Lightroom will substitute legal characters for the illegal ones. D-65 chooses to 'Replace With An Underscore' when a file name has a

space or an illegal character. Without this powerful feature, you would have to rename all your files that had illegal characters. Now it can be done automatically upon import for you!

Camera Raw Cache Settings

Camera Raw Cache is used for caching raw data for processing. This will speed things up in the Develop Module if the image is cached. You may find that older camera profiles identified in the Calibrate panel may have displayed poor results at extreme ends of the temperature and tint ranges. There are new camera profiles for Lightroom. Clearing the Camera Raw cache will clear any older profiles from the thumbnails. The thumbnails can then use the latest version to generate new thumbnails. This option is only necessary if you experience thumbnails not generating correctly or generating poor results.

Interface Preferences

Feel free to play with the Interface until you find a look that you like. These preferences allow you customization on the visual look and feel of Lightroom. You can see what engineers do late a night for kicks by trying some of the different Panel End Markers (Figure 5.7). For fun, try Yin Yang or Atom. And you thought that engineering was all work and no play ☺ (Figure 5.8, on page 60).

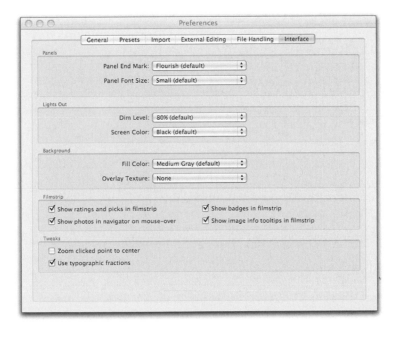

FIG 5.7 D-65's suggested setup Lightroom's Interface Preferences

FIG 5.8 Options for Panel End Marks

In the Filmstrip you can choose to 'Show ratings and picks in the filmstrip as well as badges'. The other useful choices here are to 'Show photos in the navigator on mouse-over' and 'Show image info tooltips in the filmstrip'.

Some folks like the 'Zoom clicked point to center' option as well. This option always centers the area that is zoomed. Choosing 'Use typographic fractions' will display fractions in metadata fields using fraction characters, superscript or subscript.

Catalog Settings

General Catalog Settings

Click back on the General Preferences Window and click on **Go to Catalog Settings** at the bottom. You can also get to the Catalog Settings under Lightroom's Main Menu>Lightroom>Catalog Settings (Figure 5.9).

The General Catalog Setting shows what catalog you are working on, and information on that specific catalog, such as the size, when it was created, backed up and optimized.

Under Backup, D-65 chooses to automatically Back up catalog: Never.

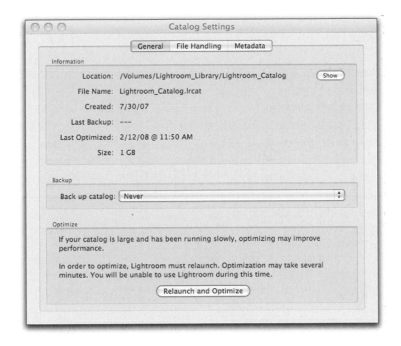

FIG 5.9 Lightroom's Catalog Settings dialog box

The choice to backup every time Lightroom quits is not available, but we think that it might be a better option because we preach to always backup after we make changes. The backup here is just a backup of the catalog. It will not backup all of your actual files. We want a complete backup of everything on our Lightroom_Library drive including the raw files. For this reason, we backup or rather duplicate the entire drive twice a day. To accomplish this, we use a software program called Retrospect from EMC.

Depending upon the preference you choose for backup, you will see the following dialog box when Lightroom starts up. The only time you will not get this window is if you choose to Back up Catalog 'Never' (Figure 5.10).

FIG 5.10 Catalog Backup prompt

Optimize

If your catalog is running extremely slow and producing a lot of spinning beach balls, or have any other problems, selecting 'Relaunch and Optimize' will quit Lightroom, and the application itself will go through a series of steps to optimize the catalog. This is like an oil change for Lightroom. Should Lightroom be unable to repair the catalog, the application will be unable to launch the catalog. For this reason, D-65 always suggests having a backup of your catalog prior to choosing 'Relaunch and Optimize'. Optimizing your catalog will work about 95% of the time. It's 5% that ends up being Murphy's Law, and will no doubt affect you if you do not have a backup (Figures 5.11 and 5.12).

FIG 5.11 Catalog Under Repair

FIG 5.12 Catalog Unable to be Repaired

File Handling Catalog Settings

Embedded previews, which are created on the fly by cameras, are not correctly color managed. These previews will not match Lightroom's interpretation of the proprietary raw file. Previews rendered by Lightroom are fully color managed (Figure 5.13).

Lightroom can create three types of previews. It can create thumbnails, screen resolution images and full 1:1 previews. All of these previews are stored in the Lightroom_Catalog Previews.lrdata.

Standard Preview Size

It designates the maximum dimensions for the rendered preview. Ideally, you would choose a size appropriate for your monitor. Adobe suggests 1.5× the monitor resolution. The problem here is that many of you will use both a laptop and a desktop monitor.

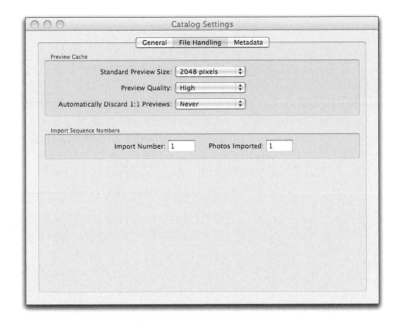

FIG 5.13 D-65's suggested File Handling setup under Catalog Settings

At some point in the future, it may be possible for Lightroom to build two different file sizes based on the size of the screen you are using. Currently, D-65 suggests setting the preview to the computer monitor you use the majority of the time.

Preview Quality

It designates the quality of the thumbnail. Low, Medium and High, similar to the quality of the jpg dialog box. You can see the image better with a high-quality jpg, although it will take up more space. If you choose a Low-res preview, it will take up very little space and will load very fast. However, should the file not be online, Lightroom will be unable to build very clear slideshows, web galleries or previews in the Library without them appearing jaggy. Medium previews will work well for many people except they only display using the color space of Adobe98, and thus they will not match the previews in the Develop Module, which always generate full-size, High-res previews in the ProPhoto color space. High-res previews have only one downside. They take up a lot of space, and take time to build. But they allow for full-size slideshows, web galleries and every feature except the Develop Module, even when the images are not online. High-res previews will also look exactly the same in the Library Module as in the Develop Module. If the High-res previews are saved and stored, then as you scroll through

images in your Library, rendering occurs instantaneously. There is no lag time at all. D-65 chooses High for our workflow.

Automatically Discard 1:1 Previews

The choice to discard previews depends on your workflow. For example, a photographer who shoots a job, works on it, delivers it and never needs to go back to that job again probably never has to keep these High-res previews. Whereas a photographer who is routinely moving between shoots, would be more likely to keep the High-res previews for an extended or indefinite period of time.

Ideally, we would never want to lose the 1:1 preview, and wait for them to be regenerated the next time we are in that folder in our Library. Let's discuss a couple of basic considerations depending upon your philosophy…

Lightroom grabs the smallest thumbnail it can in order to keep up speed. With a Low-res preview, Lightroom will load the thumbnails very quickly, but when you scroll through the images they will take time to generate. If you choose a higher quality to begin with, the import process will slow down, but when it is done, the previews are fully generated.

Lightroom will start by loading the embedded or sidecar thumbnail. NEF files are particularly slow because many of them have full-resolution previews.

D-65's workflow sacrifices the time and speed in order to get the highest quality thumbnail preloaded. Processing power and RAM may play a significant role in your choice. If you're fortunate enough to have an 8-core or quad-core Mac Pro Workstation, you will find that you can gain both speed and quality.

Metadata Catalog Settings

Including Develop settings in metadata is great idea as it allows us to move between Lightroom and Camera Raw without having to export a new file. Go to Lightroom>Catalog Settings>Metadata and include a check in the box to 'Include Develop settings in metadata inside JPEG, TIFF and PSD files'. This is a great option. Lightroom handles JPEG, TIFF and PSD in a nondestructive fashion. When you make changes to these files in the Develop module, it's only changing a preview of the image on screen, which is why it looks like you're changing the photo permanently but you're not. Just like a raw file, if you ever want to get back to the original

JPEG, just click the Reset button in the Develop Module and it's like nothing happened at all. The file can retain all the settings just like copyright in File Info. By checking this box, the changes are written as metadata to the file, which is really quite cool (Figure 5.14).

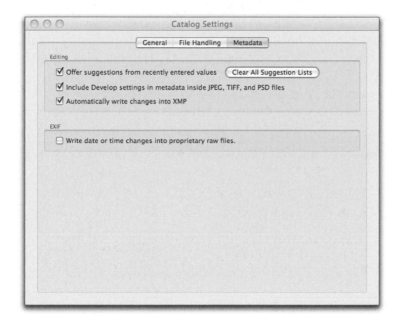

FIG 5.14 D-65's suggested Metadata setup under Catalog Settings

The 'Automatically write changes into XMP' is a choice of great debate. If you do not choose this, all changes to the .xmp are written to the internal database. This really allows Lightroom to fly. The problem with this is that if something were to happen to the database, such as corruption, there is no way to extricate this information from the corrupted database. So in plain English, you might lose all the changes you have made to your images. The other problem with this is that if you use more than one computer and move files around you won't have the .xmp files next to the originals. This means the only way to move files between computers is by exporting and importing a catalog that can be a tedious task. We advocate automatically writing changes into XMP sidecar files. Every time you make a change, the information is written to the internal database as well as to a sidecar .xmp. If the database ever crashes, you will not have lost any information. Doing so will also allow Lightroom and other programs, such as Bridge, to work seamlessly by synchronizing the .xmp settings. By doing this, the .xmp files will always be located in the sidecar .xmp with the raw files. So to summarize, we feel it is safer to always

write the .xmp, but Lightroom will take a speed hit. For those who want to write the .xmp and not suffer a speed hit, there is one other option. You could uncheck automatically write changes to .xmp and when you are done working on images either select the individual images or the entire folder of images and choose command S or Lightroom>Metadata>Save Metadata to Files. This means rather than saving each and every step you wait to the end of your working session and then write the .xmp all at once. Many folks like this option. We still prefer automatically writing changes to .xmp so that we never have to worry about it, but we also have very fast and powerful computers (Figure 5.15).

FIG 5.15 Manually saving Metadata to Files

The last option in this dialog box is one we don't check. We never want to change our proprietary raw files. Choosing this option will write time or date changes directly to the file as opposed to writing them to the sidecar .xmp file (Figure 5.14).

Identity Plate Setup

Listed right under Preferences in Lightroom's Main Menu is the Identity Plate Setup (Figure 5.16).

Think of the Lightroom Identity Plate literally as a vanity license plate. You can custom create an Identity Plate that can be placed at the top left section of the Lightroom interface and in specific modules such as the Web Gallery. In a Web Gallery, the Identity Plate can be a live link. So for D65, the logo is not only a vanity

FIG 5.16 Location of the Identity Plate Setup

plate but it will also bring folks to D65.com in a web gallery. This can be your logo or any graphic. You can save multiple identity plates. In our example below, we have saved an identity plate with the name, D-65 (Figure 5.17).

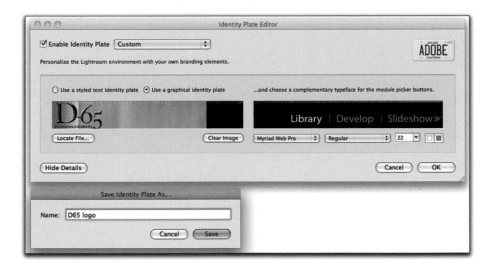

FIG 5.17 Identity Plate Editor dialog box

64-Bit Processing in Lightroom

Currently, most commercial software is built as 32-bit code, not 64-bit code. Lightroom 2.0 ships with 64-bit potential. The 64-bit version of Lightroom will give a performance kick of about 8–12% compared with the 32-bit version. For one particular task – opening up a large file on a system with a lot of memory – the 64-bit version is 10 times faster because it doesn't have to write the data that won't fit in memory onto a relatively slow hard drive. 64-bit can utilize as much RAM as you have, leaving some available for the operating system.

The Mac version of Lightroom is both 32-bit and 64-bit. The Windows version is available as a 64-bit separate download. To

enable 64-bit version, find and select the Application, Get Info on the app and uncheck Open in 32 Bit Mode (see **Figure 5.18**). In our opinion, it is worthwhile because every little speed boost makes a difference. If this checkbox isn't there, your Mac isn't 64-bit compatible. This feature applies to Intel Macs only (**Figure 5.19**).

FIG 5.18

FIG 5.19

Summary

- Lightroom's Preferences can be configured to streamline workflow.
- Using an External Editor in Lightroom allows for images to be worked on in another application and brought directly back into Lightroom without importing the images.
- The Lightroom catalog also has settings to streamline workflow.
- If your Lightroom catalog is running slowly, you can optimize and repair it under Catalog Settings.
- Choosing Lightroom preview quality really depends upon what your needs are as a photographer. D-65 chooses high-quality previews all the time because it is the only preview that loads in the ProPhoto color space.
- The Identity Plate in Lightroom is not only a vanity plate, but also can be used in slideshows and web galleries as a direct link to your website.

Discussion Questions

(1) Q. Why would we choose not to always apply auto tone adjustments in Lightroom?

A. While we may use auto at times, we prefer to start out with our images 'as shot', and manually decide how to process them. Also if one brackets when shooting, auto will correct all the brackets to look like the same exposure.

(2) Q. Why would you want to open a file directly in Photoshop from Lightroom?

A. One of the totally cool features of Lightroom is the ability to open a file from Lightroom directly into Photoshop. This can be done by using Lightroom's Photo Menu>Edit in Adobe Photoshop CS3, or keyboard shortcut, command E. You can then save that same file directly back into Lightroom next to or stacked with the original. The biggest benefit here is that you are bypassing the import module.

(3) Q. Since spaces are illegal in file names, is there anything someone can do if they are importing into Lightroom

and have spaces other than manually changing all the names?

A. Yes, even if your filename contains illegal characters or spaces, Lightroom can substitute legal characters for the illegal ones. D-65 chooses to 'Replace With An Underscore' when a file name has a space or an illegal character. Without this powerful feature, you would have to rename all your files that had illegal characters. Now it can be done automatically upon import for you by configuring File Handling in the general preferences.

(4) Q. What does Optimize and Relaunch accomplish?

A. If Lightroom starts to run slow and produces the spinning beach ball for no apparent reason, choosing this option provides an 'oil change and tune up' for Lightroom. About 90% of the time problems can be fixed with this feature.

(5) Q. What are the basic differences between Low-, Medium- and High-res previews?

A. Low-res previews take up very little space and will load very fast. However, should the file not be online, Lightroom will be unable to build very clear slideshows, web galleries or previews in the Library without them appearing jaggy. Medium previews will work well for many people except they only display using the color space of Adobe98, and thus they will not match the previews in the Develop Module, which always generate as full-size, High-res previews in the ProPhoto color space. High res previews have only one downside. They take up a lot of space, and take time to build. But they allow for full-size slideshows, web galleries and every feature except the Develop Module, even when the images are not online. High-res previews will also look exactly the same in the Library Module as in the Develop Module.

(6) Q. What are the pros and cons of choosing to automatically write changes to XMP?

A. If you do not choose this, all changes to the .xmp is written to the internal database. This really allows Lightroom to fly. The problem with this is that if something were to happen to the database like corruption, there is no way to extricate this information from the corrupted database. So in plain English, you might lose all the changes you have made

to your images. The benefit of automatically writing the .xmp is every time you make a change the information is written to the internal database as well as to a sidecar .xmp. If the database ever crashes, you will not have lost any information. The only downside is a potential loss of speed.

(7) Q. Is there any benefit to creating an identity plate besides just looking cool?

A. Yes, the identity plate can be an active web link or e-mail link so that one can go directly to a web address from the identity plate.

Lightroom's Architecture

The basic architecture of Lightroom brings a rather unique concept to software development. While Lightroom itself is an application, its construction is modular in nature. Lightroom is currently built with five modules: Library, Develop, Slideshow, Print and Web. Lightroom's modules are like five separate applications working in a nested together fashion. Each module comes with its own set of tools, templates and panels. One of the neat things about the architecture of Lightroom is the possibility of third-party developers to construct additional modules to enhance Lightroom even further (Figure 6.1).

Modules

The modules are located on the top right corner of the Lightroom window. Clicking on the name of the module allows you to move between the modules (Figure 6.2).

FIG 6.1 Lightroom's Library Module

FIG 6.2 Lightroom's Five Modules

Panels

On the left and right sides of each screen are panels. Each panel contains functions specific for the tasks with that module. Generally, the panel on the left side contains content (Figure 6.3A) and templates, and the panel on the right (Figure 6.3B) contains the tools for each module.

Toolbar

The toolbar is located underneath the grid or loupe view of your image(s). It contains controls specific to each module and can be customized by the dropdown menu located at the right side of the toolbar. Your screen size will depend on how many tools can be seen on your toolbar. To view more tools, you can collapse the side panels with the Tab key. The Library Module toolbar is shown in Figure 6.4. If you think your version of Lightroom doesn't have a toolbar, try hitting the T key. The T key is the keyboard shortcut for revealing and hiding the toolbar.

(A) (B)

FIG 6.3 Slideshow Module Left Side Panel and Right Side Panel

FIG 6.4 Library Module Toolbar

Filmstrip

The filmstrip at the bottom of the screen is a view of the current selection in the Library. A specific shoot or collection will also be shown in the filmstrip. Other modules use the filmstrip as the source. To change the contents of the filmstrip, select new images from the Library or use Filter (Figure 6.5).

FIG. 6.5 The Lightroom Filmstrip

Lightroom Keyboard Shortcuts

There are some terrific keyboard shortcuts that will definitely speed up your workflow in Lightroom. We have outlined some below (Figure 6.6).

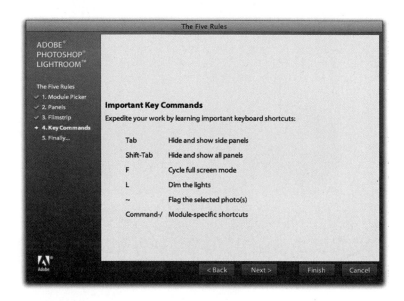

FIG 6.6 Some Important Keyboard Shortcuts

- Tab will hide and show side panels (Figures 6.7A and B).

(A)

(B)

FIG 6.7 (A) Library Module Grid view with Panels showing; (B) Library Module Grid view with Panels hiding or collapsed

- Shift-Tab cycles to full screen (**Figures** 6.8**A** and **B**).

(A)

(B)

FIG 6.8 (A) Library Module normal Grid View; (B) Library Module Grid view expanded to full screen view

- Pressing the F key will switch to full-screen mode, and pressing it again will switch to absolute full-screen mode, hiding the system bar and the Dock (**Figures** 6.9**A–C**).

(A)

(B)

(C)

FIG 6.9 Cycling through full screen mode using the F key

- Double click to go between the loupe and grid modes in the Library Module (**Figures** 6.10**A** and **B**).

(A)

(B)

FIG 6.10 Cycling through Grid and Loupe View in the Library Module

- Lightroom can turn out the lights, meaning that it can dim the screen highlighting sections of Lightroom and hiding others. Pressing the L key once will dim the lights, darkening the interface. Pressing the L key again will turn the screen black, and pressing it again will take you back to the default (see Figures 6.11A–C below). Under Lightroom Preferences, you can set the shade of gray and the opacity.

(A)

(B)

(C)

FIG 6.11 Cycling through Lights Out Mode by using the L Key

Additional Library Keyboard Shortcuts in Lightroom

- Using + and control and − and control will reduce and increase the size of the thumbnails in the grid.
- The spacebar toggles between Fit and user set zoom views in the loupe mode. If in the grid view, it will change to loupe.
- The D key takes you from the Library Module grid view into the Develop Module.
- The G key returns you back to the Library Module grid.
- Command / takes you to the keyboard shortcuts for each module – these are GREAT!

Creating Custom Workspaces in Lightroom

You can create custom workspaces allowing you to display only the panels you want, when you want to see them, to maximize your image size or screen real estate. You can manually extend panels, making the sliders larger or smaller. To do this, mouse down on the edge of the panel, and a crosshatch will appear. Drag the crosshatch to the right or left to expand your image size. This is particularly useful in the Develop Module because it allows you to extend the length of the sliders, which provides you more accuracy and finesse (Figure 6.12A). Note the extended panels on the right in Figure 6.12B.

Mouse down and drag to extend a panel.

(A) (B)

FIG 6.12 Extending the right side panel in the Develop Module

Creating a Full-Screen Workspace

D-65 likes to use the F key and the Tab key to create a full-screen workspace. We sometimes find it annoying, however, that the panels on the right and left roll over when you don't want them to. An option that we find useful to correct this is to press down the Control key (or right click with a mouse) and, at the same time, click on the panel group icon (designated by the little gray triangle pointing to the left and right of the panels). Choose Manuel or Auto Hide. Both allow the control to show the panels instead of having them roll over.

Auto Hide & Show: Displays the panel as you move your mouse to the edge of the application window. Hides the panel as you move the mouse away from the panel – this is the default.

Auto Hide: Hides the panel as you move the mouse away from the panel, but to open the panel, you must use the Tab key or click on the little gray triangle.

Manual: You must open the panel manually by using the Tab key or clicking on the little gray triangle.

Sync with Opposite Panel: This syncs both panels so that you do not have to configure each panel separately (Figure 6.13, on page 80).

Lightroom Presets

Lightroom comes with preconfigured presets, and users can also create their own presets. Presets are settings that can be

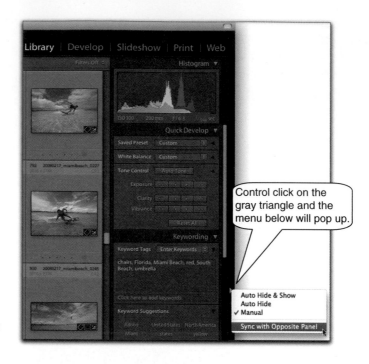

Control click on the gray triangle and the menu below will pop up.

FIG 6.13 Use this menu to sync with opposite panel

created and saved to accomplish various tasks in each module of Lightroom. Creating and using presets is an excellent way of speeding up your workflow.

Where Presets are Stored in Lightroom

If you have created any presets in Lightroom and would like to move them to another computer, they are stored in: **User Library>Application Support>Adobe>Lightroom** (Figure 6.14).

FIG 6.14 Path where Lightroom's presets are stored

Preset Locations for Adobe Photoshop Lightroom in Windows XP

Presets are stored on Windows machines in: Documents and Settings/[username]/Application Data/Adobe/Lightroom folder.

For easy access, you can get to this folder by going to the Preferences menu and choosing Show Lightroom Presets Folder. On vista, the path is: Application Data>Roaming>Adobe (Figure 6.15).

FIG 6.15 Easy access to Lightroom's Presets

Moving Presets from One Computer to Another

It is easy to create a preset on one computer and use it on another computer. Copy the preset that you would like to move to another computer and place it within the corresponding folder on your second machine. Make sure never to delete any of the folders that hold the presets. You can also select a preset, right click and export that preset. That preset can then be imported into another computer.

Summary

Lightroom comprises five modules, each designed for a specific task. The functionality of each module is controlled by a toolbar, panels and templates. There are many useful keyboard shortcuts and presets to boost workflow.

Discussion Questions

(1) Q. Name four useful keyboard shortcuts to control how Lightroom displays images.

A. Tab, Shift-Tab, spacebar and F key.

(2) Q. Why would the Lights Out mode be useful?

A. The Lights Out mode is a perfect way of showing a client or teacher your work without seeing the application.

The Lightroom Library Module

Let's start by talking about Lightroom's first Module, the Library. The Library Module is command central for Lightroom. This is your digital asset management system. It is where you view, sort, search, manage, organize, rank, compare and browse through your images.

The Lightroom Library Module is a true database that catalogs all imported images so you can view previews and data whether the images are online or not. All images must be imported into Lightroom to view them. The process of importing photos, imports the image and also creates a metadata record in Lightroom's catalog. This record contains all the data about the image including location, editing instructions and previews. As discussed in Chapter 4, the catalog can be thought of as the authoritative source of information.

It is important to understand the distinction between the Lightroom Library Module, and the Lightroom_Library hard drive that you created to hold your image files and the

Lightroom_Catalog folder. The Lightroom_Library hard drive is simply a physical place that holds yours images and Lightroom's catalog. We've discussed the importance of this Lightroom_Library hard drive in Chapter 4, now let's talk about the features of the Lightroom Library Module.

The Library Module Window

Following is the Lightroom Library Window. The left side holds the Navigator, Catalog, Folders and Collections panel as well as the Import and Export buttons. The right-hand panel holds Histogram, Quick Develop, Keywording, Keyword List and Metadata panels as well as the Sync Settings and Sync Metadata buttons. The Library Filter is located above the Grid, which resides in the middle of the main window and displays your images. At the bottom of the grid is the Toolbar. The Filmstrip is located underneath the Toolbar.

When you import images into Lightroom, they will be organized in the Folder panel, and appear in the center Grid View of the window (**Figure 7.1**).

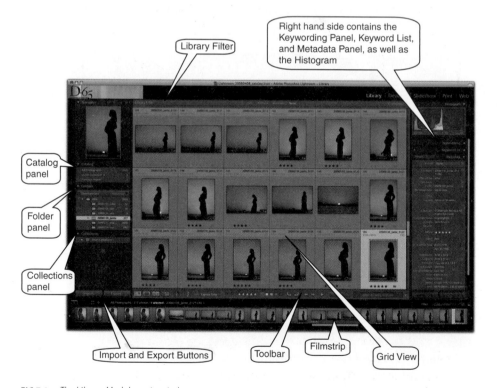

FIG 7.1 The Library Module main window

Now we'll go over how all the panels in the Library Module function. We'll start with the left-hand panels.

Navigator Panel

The Navigator is located on the top left. This gives you a preview of the selected image. Clicking on the image in the Navigator will go to Loupe Mode that displays the image in a large view.

There are four views in the Navigator. The last view has a drop-down menu with eight choices ranging from 1:4 to 11:1.

- Fit
- Fill
- 1:1
- 11:1

The Navigator also has a drop-down menu which allows you to go up to 11:1. A great shortcut for the Navigator is by using Command + and Command −, you can zoom in and zoom out. The spacebar also can be used to zoom as well as Z (**Figure 7.2A**).

Move through the image using the Navigator.

(A) FIG 7.2A

Using the Navigator in Workflow

The Navigator is great for checking critical focus or pixel defects. Clicking on any of these choices will enlarge the image accordingly. One very neat feature is that you can move through the image using the Navigator similar to the one in Photoshop. It works the best in the 1:1 or 4:1 ratio. Typically, you are going to

want to see the entire image and then zoom in for a 1:1 view to check for sharpness. If you click on Fit and then click on 1:1, you will be able to cycle between those two views by using the space bar, or clicking on the image in loupe view. **Figure 7.2B** displays 1:1.

FIG 7.2B Cycle between two views by using the space bar, or clicking on the image in loupe view

(B)

The Catalog Panel

The Catalog panel displays the number of photographs in your Library under All Photographs. When you highlight All Photographs, you will see all the images in your catalog displayed in the grid. It also displays any quick collection you may have, as well as your previous import and previous export as a catalog or any missing files (**Figure 7.3**).

FIG 7.3 The Catalog Panel

What are Quick Collections?

A Quick Collection is a temporary culling of images. To create a quick collection you can click on the circle on the top right of the cell around the image when going through the shoot. A dialog box will pop up and ask you if you'd like to add this image to a

quick collection. You can also use the keyboard shortcut B, and simply hit the B key while you have an image selected and this will automatically add it to the quick collection. This is not meant to be a permanent place to group images, just a temporary culling from a shoot to use in any module. You can only have one quick collection at a time. When you add an image to the quick collection, it does not move the image; it just makes a reference file using the metadata. Think of a quick collection as a 'shelf' that culls images temporarily.

Using Quick Collections in Workflow

Think about going through a group of folders and finding portfolio images. You create a Quick Collection of your portfolio. Quick Collections are great for making web galleries and slideshows of selected images that do exist within the same folder. The advantage of having a quick collection is that you are not moving those images out of the folder(s) they exist. You are only moving the metadata that identifies those files. You can export from a quick collection, even though it is just a reference file. You can always convert a quick collection to a permanent collection by choosing File>Save Quick Collection. You can clear a quick collection by choosing Clear Quick Collection from the File Menu (**Figure 7.4A**).

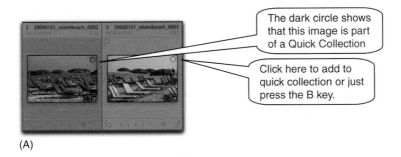

The dark circle shows that this image is part of a Quick Collection

Click here to add to quick collection or just press the B key.

(A)

FIG 7.4A

Target Collections

There is a + next to Quick Collection when you first open Lightroom 2.0. The + sign signifies that Quick Collection is designated as your Target Collection. Any collection can be deemed a Target Collection. A target is simply the location that the image(s) will be referenced to when using the keyboard shortcut B. By default, Quick Collection is your target collection. You can only have one Target Collection at a time. To change your target

collection, control or right click on the new collection you want to be deemed as your target, and choose Set as Target Collection.

In **Figure 7.4B**, we have set our Portfolio Collection as our Target Collection, so anytime we hit the B key on an image, we are adding a reference file of that image to our Portfolio Collection.

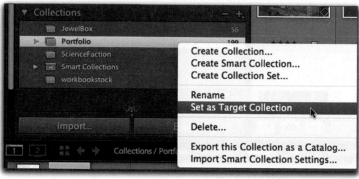

FIG 7.4B Setting a Target Collection (B)

Workflow Tips for Quick Collections
- Command B toggles you between the folder you are browsing and a quick collection you already have created.
- D-65 prefers to use the B key to add/delete from Quick Collections. It is too easy to accidentally click on the little circle when double clicking on an image to go to Loupe View, thus adding it to a quick collection when you don't really want to. You can turn off the quick collection circle under View Options.

Previous Import in the Catalog Panel
Previous Import displays the number of images of your last import. This is the field that will be selected first by default after you import images into Lightroom. D-65 suggests moving off Previous Import and going directly to the folder of images you are working on.

The Folder Panel

When you import images into Lightroom, the folders containing those images are displayed in the Folder panel. The number of imported images within that folder is shown to the right of the folder name. The folders within the folder panel can also have subfolders for further organization. Simply click on the + icon next to Folders, while you have a folder selected and it will prompt you to create a subfolder name.

The Volume Browser

The volume browser (**Figure 7.4C**) shows you where the images are located and how much disk space is used/avail (or photo count). Alt-clicking on the volume browser will select all the folders on that volume.

(C)

FIG 7.4C The Volume Browser

Workflow in the Folder Panel

D-65 uses a specific file-naming convention for all the imported folders of images, as well as to the images themselves. We import into a folder with a naming convention of Year, Month, Day and Job Name. All of our image folders line up in a hierarchical order based on year, month, day making it is easy to browse through the jobs in a logical progression. The images inside those folders are also named with the same convention, adding on a sequence number. More details on this once we begin importing images (**Figures 7.5A** and **B**).

FIG 7.5 The Folders Panel

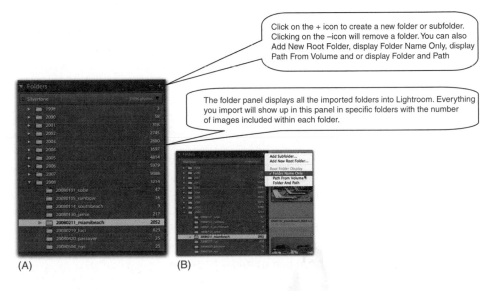

Click on the + icon to create a new folder or subfolder. Clicking on the −icon will remove a folder. You can also Add New Root Folder, display Folder Name Only, display Path From Volume and or display Folder and Path

The folder panel displays all the imported folders into Lightroom. Everything you import will show up in this panel in specific folders with the number of images included within each folder.

(A) (B)

You can move images within folders by dragging and dropping them. To move images, select the images you want to move in the grid mode, and drag them to the new folder location. You will see an icon, which looks like a stack of slides. The original location is shaded in light gray and the new location is shaded in light blue. Note that the light blue shading is only available with Intel Macs. These are the actual images that are moving, not reference files. The files will physically move in the hard drive that they reside as well (**Figure 7.6**).

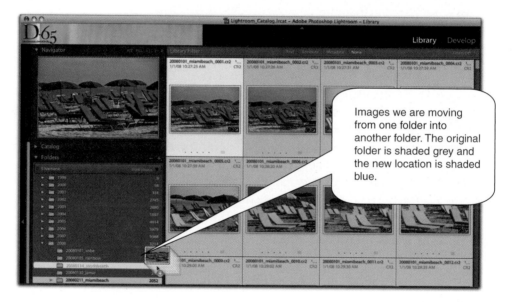

FIG 7.6 Moving images between folders

More Folder Panel Options
To rename a folder, control click or right click on the folder and choose rename. The folder name will be changed in the Folder panel, and also in the physical location that the folder resides. You will also notice that you can create subfolders, Show in Finder, Save Metadata, Synchronize, Update Folder Location and Export the Folder as a Catalog. Depending on where the folder is located you can also add the parent folder or promote subfolders.

The Synchronize Folders is useful as you have the option of adding files that have been added to the folder but not imported into the catalog, and removing files which have been deleted. The Save Metadata option will update and save any changed metadata to either the catalog or to sidecar .xmp files as determined by your preferences. Lastly, Update Folder Location allows you to change the folder links without having to first remove the existing folder (**Figure 7.7**).

FIG 7.7 Options in the Folders Panel

Lightroom as a DAM

Lightroom is a true digital asset management system. The catalog can display folders and images even if they are not currently physically present. In the example on the next page D-65 is on the road using a laptop computer. We have taken our Lightroom_Catalog folder with us but we have only taken a few folders of images from our Lightroom_Library hard drive. We have taken these folders of images because we want to work on these files while we are on location. The folders in the light gray shade with the ? designate folders with images inside the folder that are not physically present on the external hard drive associated with our laptop's Lightroom_Location_Library. The folders in WHITE are physically present on our external hard drive that we use as our Lightroom_Location_Library.

Shown below in **Figure 7.8** are folders with question marks and a light shade of gray. These files are not physically present. However, Lightroom still has the power to browse these files, search for these files and perform other database activities, with the exclusion of actual developing (**Figure 7.9**).

FIG 7.8 Images that are on online, but are in Lightroom's catalog

The folders with the question marks are not physically on the laptop or the Lightroom_Location_Library hard drive. They are still 'at home or at the studio', in the Lightroom_Library hard drive. The folders of images in White are on the external hard drive that we take on location for our Lightroom_Location Library.

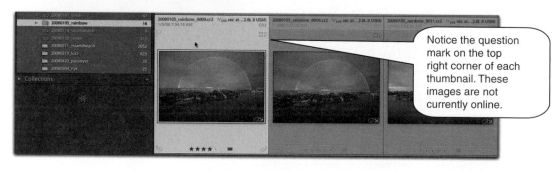

Notice the question mark on the top right corner of each thumbnail. These images are not currently online.

FIG 7.9

Using the Library Module in Workflow while 'On the Road'

Because we have built high-res 1:1 previews, we can even zoom in on these files without any artifacting. This is one large plus for generating 1:1 previews. You can take them on the road without having the files and still make web galleries and slideshows and view the images at 100%. The only downside is that these previews do take up considerable space. In **Figure 7.10A**, we have a file that is off-line, but has a high-res preview. This allows us to zoom into 100%, and use the file for all purposes in Lightroom with the exception of the Develop Module, even without having the image with us. **Figure 7.10B** is an example of an off-line file which only has the low-res preview generated. It reveals artifacting at 100%, rendering it useless for any other purpose than reference within Lightroom.

The Collections Panel

The last panel on the left side is called Collections, and it is located under the Folder panel. Collections are similar to Quick Collections,

(A)

(B)

FIG 7.10 (A) Highres preview of an offline image (B) Low res preview of an offline image

but they are permanent and you can have as many Collections as you would like in Lightroom.

Why Use a Collection?

Here is the real power of Lightroom. You have an image in one folder. It's of some pink flippers on a dock in Belize (like the one on the next page). You want to place this image with a group of other images called Portfolio and you also want to use this for a stock submission for your agency. In the old days, you would

have to duplicate the file and place it in different folders. If you changed something in the file, you would then have to change it in all the files. Because Lightroom is entirely based on metadata, you can create Collections based on the metadata. In this case, we created a collection called Portfolio and placed this image into that folder. This image is also in a collection called WorkbookStock. The beauty of Lightroom is that the master file remains in its original location which is a folder named 20050831_belize. We do not need to duplicate the file, instead Lightroom creates a reference file that will go into one or more collections. While you will see the image in thumbnail and full size when you view a collection, the actual image is never moving from its original location. How cool is that. You can even make changes to an image and export from a collection.

You can also create subcollections within a collection. It is a great way of organizing your images. Any Collection can also be set to be a Target Collection. A Target Collection will automatically send an image to a Collection deemed to be a Target by using the commands for a Quick Collection. For example if we wanted to make Portfolio a Target we would select the folder and Control Click on it, choosing Set as Target Collection (**Figure 7.11A**).

Each one of these images lives in a different folder, but they are all organized as a 'portfolio' collection based on the metadata

(A)

FIG 7.11A Example of a Collection

Smart Collections

Smart Collections are totally cool and new for 2.0. They allow you to select criteria to automatically group your images into collections. So for example we use keywords to define images going to different stock agencies as well as color labels. We use both because the color labels are more visual in grid mode. For Science Faction we use the yellow label and we use a keyword called Science Faction. We like to keep track of all of our images at the many different agencies and in the past we had to manually move them into their designated Collection which became tedious. Now we just build a Smart Collection that automatically moves any image with a yellow label and the keyword of Science Faction into its own special Smart Collection (**Figure 7.11B**).

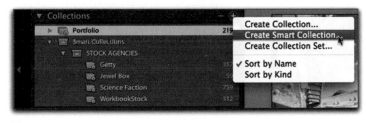

(B)

FIG 7.11B Options for Collections

Smart Collection Sets

We can even refine this more and build Smart Collection Sets. We have created a set called STOCK AGENCIES and in that set we have specialized Smart Collections for each agency.

For further refinement and categorizing Smart Collections can be placed into sets. We put all of our different stock agencies into a Smart Collection set called Stock Agencies (**Figures 7.11C and D**).

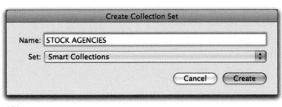

(C)

FIG 7.11C Creating Collections Sets

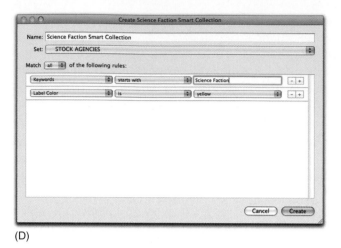

FIG 7.11D Creating Smart Collections (D)

Workflow Tip for Smart Collections

- Smart Collections can have very complex criteria. Hold down the Alt key on the plus sign when making decisions, the plus sign will turn into a # sign and give you the added ability to make conditional rules which are very cool (**Figure 7.11E**).

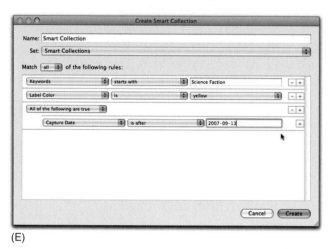

FIG 7.11E Creating Smart Collections with conditional rules (E)

More on Smart Collections

Smart Collections can be edited as well. In fact they can be renamed, deleted and you can even import and export Smart Collections to another catalog (**Figure 7.11F**).

Library Right-Side Panels

The right-hand panel of the Library displays a Histogram, Quick Develop, Keywording and Metadata.

(F)

FIG 7.11F Smart Collection Options

Histogram

The Histogram in the Library is a representation of the tonal range of the selected image. We will be going over the histogram in great detail in the Develop Module where you can actually adjust the histogram (**Figure 7.12**).

FIG 7.12 The Histogram Panel

Quick Develop Panel

The Quick Develop Panel expands when you click on the disclosure panel. The Quick Develop Panel provides you the ability to create color and tone adjustments to one or more images in the Library. The Quick Develop Panel also shows any Presets that you have created in the Develop Module and the Presets that come with Lightroom. The alt key toggles clarify and vibrance to sharpening and saturation. D-65 uses the Develop Module instead of this Quick Develop Panel, because it gives far greater control over to make adjustments to our images. D-65 also applies an ISO/camera-specific preset on import (**Figure 7.13**). More on this in the Develop Module…

FIG 7.13 The Quick Develop Panel

Keywording in the Library Module

Keywording has moved to the right-side panels of the Library Module and has got a big overhaul in 2.0. This is really where the

power of using Lightroom as a digital asset management system begins. The best way of using any DAM is to take advantage of the applications ability to find specific images. Proper keywording and fully filling out all metadata is not only advantageous but essentially the only way of finding specific images in a very large collection. It is one thing to scroll through a few hundred images to find the one you want. It is an entirely different matter to scroll through 50,000 images to find the one you want.

The Keyword List Panel

A keyword tag or 'keyword' is metadata that categorizes and describes the key elements of a photo. According to one study it may take more than 400 keywords to accurately describe an image without actually looking at the thumbnail. Building a Keyword Hierarchy can be a tedious and painful task but it is essential to Digital Asset Management.

Keywords help in identification and searching for images in a catalog. Keyword tags are stored either in the photo file or in XMP sidecar files or in Lightroom's catalog. The XMP can be read by any application that supports XMP metadata.

Keywording Images
To keyword your images, think globally first and then go for local. Think of keywording the same way you would classify an animal. A Spider Monkey would first be a Mammal then an Ape, then a monkey and finally a spider monkey. For example, to classify Miami Beach, you might want to make several keyword hierarchies. One Parent would be Continent with a child called North America. A second Parent might be called Countries, with a child keyword of United States. A third Parent might be called cities with a child keyword of Miami Beach. Continent, Country, State, City and so on would categorize the image.

On the following page is an example of an image of a blue iceberg from Antarctica with proper keywording. The Parent Keywords are in CAPS and the children are lowercase (**Figure 7.14**).

Creating and Managing Keywords
Keywords can be generated by clicking on the + sign to the left of Keyword List. They can also be removed by highlighting the keyword and clicking on the − sign to the left of Keyword List (**Figures 7.15A** and **B**).

FIG 7.14 An image with extensive keywords applied

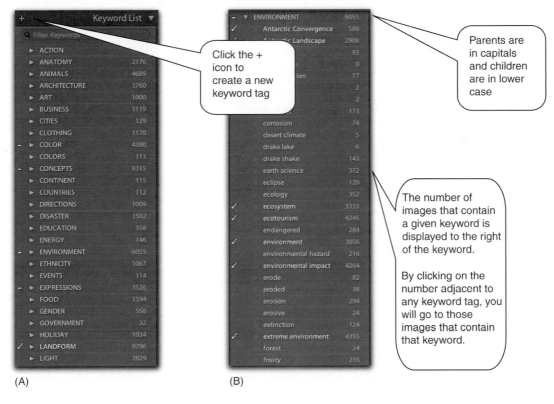

(A)

(B)

Click the + icon to create a new keyword tag

Parents are in capitals and children are in lower case

The number of images that contain a given keyword is displayed to the right of the keyword.

By clicking on the number adjacent to any keyword tag, you will go to those images that contain that keyword.

FIG 7.15

Creating Keyword Tags with Synonyms and Export Options

When creating keywords, you can add synonyms and export options. Synonyms are similar or related terms for keyword tags. Synonyms allow you to apply one keyword and automatically apply additional synonyms. For those of you keywording animals, one very useful synonym is to use the Latin name or scientific name of the animal as a synonym. You can also choose to include keywords or not on export. This too is a very significant feature. We use keywords for jobs and for names of folks we know. We put this type of information into a Parent Keyword called Private Metadata and we don't include it on export. This way the information becomes useful in searching within Lightroom but it isn't included in the images on export.

Keyword tags can be created as children of parent keyword tags. For example, a parent tag might be 'WEATHER' and the child could be 'hurricane' and you could apply a group of synonyms at the same time (**Figure 7.16**).

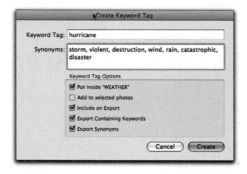

FIG 7.16 Creating Keyword Tags with synonyms and export options

The Keyword Filter

The Keyword Filter is new in Lightroom 2.0 and is a very useful tool. In our Keyword List, we have over 3500 keywords all listed in a hierarchy. One of the problems of working with keywords in Lightroom 1.4.1 was the process of locating a particular keyword in the hierarchy. Lightroom 2.0 makes this easy. Simply type in the keyword you are looking for in the filter and it locates it for you in the hierarchy. In **Figure 7.17** we searched for the keyword 'kiteboarding' and the filter traces it to the parent sports and the child kiteboarding. It also conveniently displays the number of images with this keyword. Keywording also utilizes autofill.

FIG 7.17 The Keyword Filter

The application tries to fill in the remainder of a word before you finish typing. While most folks find this useful, if you want to turn this off, Open Catalog Settings>Metadata tab then deactivate 'Offer suggestions from recently entered values'.

Some Keywording Tips
- If an asterisk appears next to a keyword that means that this keyword is present in some but not in all of the selected images (**Figure 7.18A**).
- In the grid mode, you can see that an image has keywords with the keyword badge. Clicking on this badge will bring you to the Keywords panel and display the keywords in the image (**Figure 7.18B**).

(A)

If one the keywords has an asterisk next to it, that means that the keyword is present in some, but not all of the images selected.

(B)

In the grid mode, you can see that an image has keywords with the keyword badge. Clicking on this badge will bring you to the keywords panel and display the keywords in the image.

FIG 7.18

- Clicking on the number of keywords for a keyword will bring up all of those images in the grid. In **Figure 7.18C** we clicked on 50 next to lightning and all 50 related images appear in the grid.

FIG 7.18C Clicking on the number of keywords for a keyword will bring up all of those images in the grid.

(C)

It is an awesome way to cull images and create collections of specific types of images. Every time you add a keyword to an image, the Keywords Tags panel will keep track of how many images in your entire Library have that specific keyword.

Keyword Sets

Keyword tags can also be organized into categories called keyword sets. We might create a keyword set for Hurricanes, which include words like storm, clouds, rain, wind, violent and destruction. Every time a hurricane is photographed, this entire set can be applied to those images. To create a Keyword Set go to the Keyword Set Panel and click on drop-down menu choosing save current settings as a new preset (**Figure 7.19**).

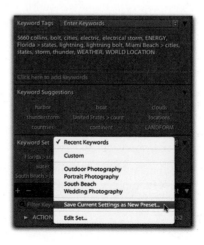

FIG 7.19 Keyword Sets

Organizing Keywords in Workflow

Though Keywording is very powerful, it still needs further organization and this will occur in future versions of Lightroom. In order to keep your keywords organized, we suggest creating keywords in the Keywording Tags panel and to regularly arrange Parents and Children in the Keyword List. Do not wait until you have several hundred keywords to begin the organization. D-65's advice is to organize on a regular basis.

Creating and Applying Keywords

You can create and apply keywords in various ways in the Library Module. We'll demonstrate them all below, even though a few of the tools haven't yet been covered in this chapter.

(1) **Keywording Panel**: The Keywording Panel is located on the right-hand panel side of the Library Module. To use it, select one image or more images in the grid and start typing the keyword(s) you want to insert in the keyword tags panel. Hit return and the keywords will be placed in the image. Note: Use pipe (|) between images to create hierarchies (**Figure 7.20**).

FIG 7.20

(2) **Copy and Paste Keywords**: Select one image, keyword it and then copy and paste the keywords from one to another.

(3) **Sync Keywords**: Select one image, keyword it, then select the other images you want to contain those keywords and choose Sync Metadata. Scroll down to Sync Keywords (**Figure 7.21**, on page 104).

(4) **Drag Keywords**: Select one image or a group of images and either drag the image(s) to the keyword as in **Figure 7.22A** on page 104 or drag the keyword to the image(s) as in **Figure 7.22B**, on page 104.

(5) **Spray Can Tool**

- Click on the Spray Can in the Toolbar and add keywords to the field in the Toolbar. After the keyword(s) are added, hit return to save them.
- The Stamper can then be used to apply these keywords to other images. Click on the image(s) that you want keyworded with the Stamper. Once you click on the image(s) you will

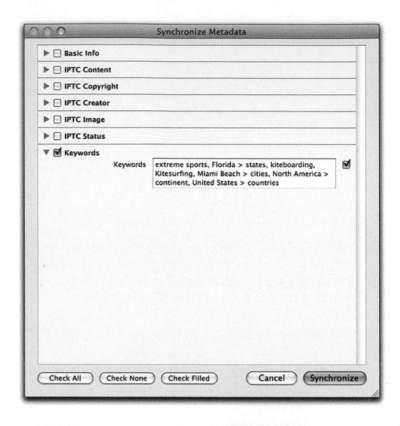

FIG 7.21 Synchronizing Keywords

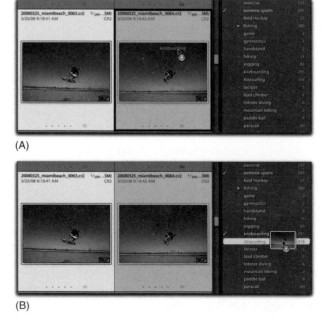

FIG 7.22 Applying Keywords via dragging

see the assigned keywords on your screen and the keywords have been applied (**Figures 7.23** and **7.24**).

FIG 7.23 Painting keywords using the Spray Can Tool

After clicking on the Stamp Tool, add keywords in the field. Then use the Stamp Tool to apply those keywords to other images.

FIG 7.24

Spray Can Tool Workflow Tips

- You will see an eraser appear after you spray the image. Clicking on the same image again will 'erase' the keywords that you just inserted.
- Remember to click off the Spray Can Tool when you are done with it, or you will continue to 'spray' all your images.
- If the Spray Can Tool has a keyword associated with it, the shortcut Shift-K will apply the keyword.

(6) **Check Box in the Keyword List Panel**: Select one image or a group of images and click on the check box next to the keyword you want to apply as in **Figure 7.25**.

FIG 7.25 Using the check box to apply keywords

(7) **Keyword Suggestions and Keyword Set**: New in 2.0 are Suggested Keywords in the Keywording panel. The concept is that if you apply a keyword to a specific image, that keyword will become a suggested keyword for any other images

that share a close enough capture time. While this is an improvement and should allow a faster way to generate and apply keywords you will find that just because the capture times are similar does not always mean that the images are similar. Thus sometimes this will work fantastically and other times like when you change scenes, this may not work at all. To apply both keywords from the Keyword Set and or from the Keyword Suggestions simply select your image(s) and click on the keyword(s) in the set or in the suggestions (**Figure 7.26**).

FIG 7.26 To apply both keywords from the Keyword Set and or from the Keyword Suggestions simply select your image(s) and click on the keyword(s) in the set or in the suggestions

Metadata Panel

The Metadata Panel is on the right side of the Library under the Keyword List. The metadata panel displays all the metadata in the image. You can apply metadata to one image and sync to the other images. You can also create metadata templates, save them and apply them using the fly-out arrow metadata presets. You can delete, add or change metadata to any single or group of images. The list of metadata can be a long one so the panel is configurable to show different configurations of available metadata. While D-65 prefers to show all metadata there are several views available as shown in **Figure 7.27**.

FIG 7.27 The Metadata Panel

Quick Describe View

While D-65 prefers to show all metadata one view that is very popular is Quick Describe which is shown in **Figure 7.28.**

FIG 7.28 Quick Describe View in the Metadata Panel

Using the Metadata Panel in Workflow

Now and certainly in the future all searching will be based on metadata. All the fields are important to fill out but particularly important are keywords and the caption field. A good caption and an image maintain a symbiotic relationship. A caption describes the unseen. The caption brings totality to the image by providing context and adding depth. The image draws attention to the caption, and the caption helps to provide the complete picture. The caption should provide the ' who, what, when and where' as well as information that can't necessarily be derived by simply looking at the image. All of this information is searchable which

means that a good caption can be the difference between finding an image or not. This is key for photographers looking at licensing stock. A good caption and proper keywording can give you an edge on your competition. D-65 applies a basic metadata template including copyright and contact information on import, and then uses this panel to apply selective metadata once the images are in the Library (**Figure 7.29**).

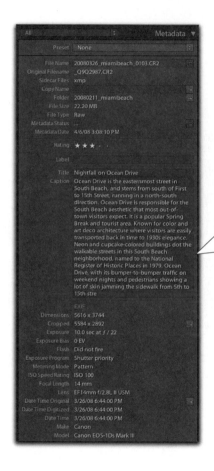

You can Copy Metadata from one image and Paste it into other images. For example, if you didn't apply Metadata such as IPTC on Import, then you could write it to one file and copy and paste it into the rest of your shoot. The Sync Metadata Button works in the same way and overwrites any existing metadata in the selected images.

You can also Edit the Capture Time if your camera was incorrectly set

FIG 7.29

Sample Caption for the Image

A large iceberg that has rolled over many times showing striations etched in the berg caused from trapped air and waves appears blue in color. Blue icebergs aren't really blue. They're perfectly clear, which allows light to pass through. Since ice filters out all colors

except blue, the iceberg emits blue light. Typically blue ones are very compressed originating from the bottom of a glacier. They can easily be 80,000 years old. Once they hit water they typically last only a few years. Glaciers in Antarctica calve more than 100,000 icebergs each year. An iceberg is only one-fifth above the water; the other four-fifths is submerged. Icebergs have many different forms, depending on their origin and age (**Figure 7.30**).

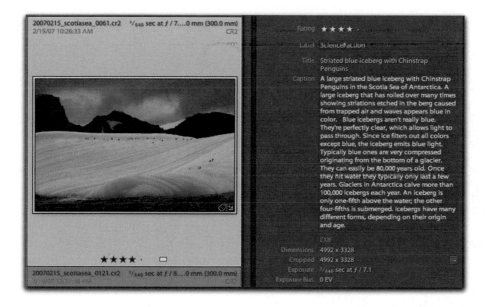

FIG 7.30 Captioning an image

Metadata Tips

- There is drop-down menu next to Preset which allows you to apply a metadata preset that you have already created, or edit a preset and save a new one.
- There is an icon to the right of File Name, which allows you to Batch Rename an individual photo, or groups of photos.
- To the right of Copy Name (when you are working on metadata on a virtual copy) there is an arrow that will bring you to the master file.
- To the right of Folder, there is an arrow that will display the folder from the selected image (good for use while in collections).
- Clicking on the arrow to the right of Date/Time Original will filter based on the exact date of the selected image. All of your images shot on that date will appear in the grid.

- Under E-mail, Website and Copyright Info URL, you can go directly to the URL or create an email by clicking on the arrow on the right (**Figure 7.31**).
- If an image has been cropped it will show crop dimensions and you can go directly to crop overlay.
- Images with GPS data (opens in google maps).
- Image with wav files attached will play.

Under Email, Website and Copyright Info URL, you can go directly to the URL or create an email by clicking on the arrow on the right

FIG 7.31

- When metadata has been changed or is not up to date, a badge in the image will show in the grid mode. By clicking on the badge the metadata can be updated in the selected images (**Figure 7.32**).

When metadata has been changed or is not up to date, a badge in the image will show in the grid mode. By clicking on the badge the metadata can be updated in the selected images

FIG 7.32

Adding metadata to one or more images is done similar to keywording and can be accomplished in several ways.

(1) **Metadata Panel**: Select one image or more images in the grid and start typing the metadata into the fields you want to insert in the metadata panel. Hit return and the metadata will be placed in the image(s) (**Figure 7.33**).

(2) **Sync Metadata Button** (Figure 7.34):

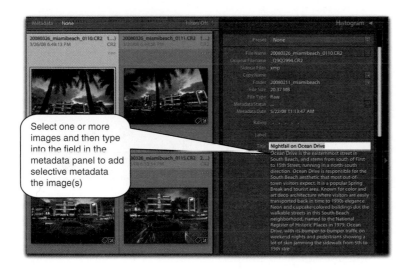

Select one or more images and then type into the field in the metadata panel to add selective metadata the image(s)

FIG 7.33

FIG 7.34 Synching Metadata

- Make the changes to the metadata panel as listed in the above example on one image.
- Select the other images you would like to apply this metadata to.
- Click on the Sync Metadata button to the right of the Toolbar.
- The Synchronize Metadata window will appear.
- You can choose by checking the boxes on the right, what fields you would like to synchronize. You can also change the information in any field in this window and apply it.
- Click on synchronize when you are ready to apply the metadata to your images.
- The metadata will be applied, but a new dialog box will appear, prompting you to create a metadata preset from the template.

111

- Hitting Save As will create a new preset. Hitting Don't Save will apply the metadata without creating a new preset (**Figure 7.35**).

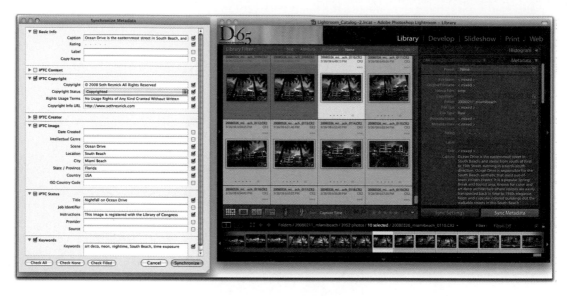

FIG 7.35

(3) **Copy and Paste Metadata**: You can also select one image, add metadata to a field and then copy and paste the metadata from one image to another.

(4) **Spraying Metadata with Spray Can Tool**
- Click on the Spray Can and choose to paint Metadata from the drop-down menu in the field in the Toolbar. Choose a template that you have created and hit return.
- The Stamper can then be used to apply this metadata to other images. Click on the image(s) that you want to add metadata with the Stamper. Once you click on the image(s) you will see the newly assigned metadata on your screen that has been applied (**Figure 7.36**).

FIG 7.36 Painting metadata using the Spray Can Tool

Creating a New Metadata Preset

You can create a metadata preset and choose it at any time or apply it during import. A template is useful if it is something you are going to use over and over again. D-65 creates a basic

copyright metadata preset which has copyright information and creator information. Filling out metadata creator information can aid in a defense against the pending Orphan Works Act which is a proposed change to current copyright law.

To create a new metadata preset

(1) Mouse down on the metadata preset drop-down menu and choose Edit Presets (**Figures 7.37A and B**). An old preset can be edited and updated or a new preset can be created and saved with a Preset Name (**Figure 7.37C**).

(A)

(B)

(C)

FIG 7.37 Creating and editing metadata presets

The Library Filter

The Library Filter is new in 2.0. It combines the old Metadata Browser and Find panel from Lightroom 1.4.1, and adds new

functionality and improved design. Located above the film grid, the Library Filter contains search criteria based on Text, Attribute and Metadata. Text can be searched for in File Name, Keywords or any searchable metadata. Attribute (we're not so fond of this name) provides the ability to search based on stars, flags, color labels and by master/virtual copy. Metadata can be searched by date, camera exif, lens, label, keywords, file type, serial number, GPS, Aperture, ISO, Shutter Speed, Location, City, State, Country, Creator, Copyright Status, Job, Aspect Ratio, even Treatment and Develop Presets.

The Filter uses 'AND' between the columns and 'OR' within the columns. You can even add more columns by pressing down on the drop-down menu at the far right of the Library Filter. All these features gathered under one roof makes this a pretty strong searching mechanism. Of course after the search has been performed and the images can be viewed in the grid, you can make the selection into a Quick Collection, Collection or even a Smart Collection.

Library Filter Keyboard Shortcut
The \ key will hide or open the Library Filter.

Using the Library Filter
Starting with **Figure 7.38A** we demonstrate the power of the Library Filter. We have selected our entire Library which is 31,339 images and hit the \ key opening the Library Filter.

(A)

FIG 7.38A The Library Module Filter

In **Figure** 7.38B we mouse down on the Text menu and select
Keywords from the drop-down menu. We choose Start With and
type in the keyword Kitesurfing. By the time we finish typing
Kitesur there are 318 images fitting that criteria.

(B)

FIG 7.38B Filtering using keywords

In **Figure** 7.38C we choose to show images with a red label from the
Attribute panel and from Metadata we choose All Dates, All cameras,
and All lens. This refined the selection down to seven images.

(C)

FIG 7.38C Filtering using attributes and metadata

115

In **Figure 7.38D** we have clicked on the drop-down menu at the far right next to Label and we choose Add Column. We add Keywords

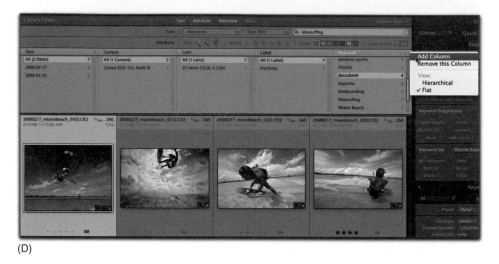

(D)

FIG 7.38D Adding additional criteria to the Filter Panel

 (**Figure 7.38E**) in Flat format and select a new keyword jbxsubmit. This keyword is a keyword for submission to our stock agencies Jewel Box. The keyword is private metadata meaning submission to Jewel Box Images. This narrows our search down to four images. We could of course save this final selection as a Quick Collection or Collection if we choose.

We can even save this set of search criteria as a preset to use in the future as demonstrated in **Figure 7.38F**. The Library Filter is truly an amazing new tool for Lightroom.

(E)

(F)

FIG 7.38E&F Creating and saving presets for the Library Filter

Import

We've finished the Panels and Library Filter, and now moving back to the left-hand side, we'll cover the import and export buttons (**Figure 7.39**).

Import & Export Buttons

FIG 7.39

In order to work on any image in Lightroom, it must first be imported. You can choose to import by either moving, copying or referencing the files into the Library. After the specified files have been imported, Lightroom will begin building previews, which will appear in the grid and filmstrip views. We demonstrate the steps for import in Chapter 13. Lightroom 2.0 can import the following file formats, and supports up to 65,000 pixels wide.

- raw
- dng
- tiff
- jpeg
- psd

Export

Lightroom allows you to export single or multiple images from the Library or Develop Modules to the location of your choice. D-65 uses the Export button after we have tweaked our files in the Develop Module. The files can be up sized, down sized or processed in really any way you need them. One very cool feature is that exporting works in the background, allowing you to perform multiple exports at the same time. We could even create an Action in Photoshop and turn that Action into a Droplet and have that executed automatically by Lightroom which is really cool. More on exporting will be discussed in Chapter 13.

Exporting formats include:

- dng
- jpg
- tiff
- psd

The Library Toolbar

The Toolbar is located under the grid and to the right of the export button. There are several buttons on the Toolbar that come as a default. Clicking on each tool will add further buttons to the Toolbar that are associated with that specific tool. The default Toolbar buttons in the Grid View are:

- The first one is Grid View, which displays the images like a light table
- The second one is Loupe View, which allows you to zoom in on an image up to 11:1 ratio
- The third is Compare View
- The fourth is Survey Mode

These change the views in the Library (**Figure 7.40A**).

This is the Toolbar in the Grid View, with the Filmstrip beneath. Some of the tools are hidden because the grid needs to be expanded to reveal the rest of the Toolbar.

FIG 7.40A (A)

Expanded Toolbar

Additionally, there are other options that you can add to the Toolbar. There is a drop-down arrow on the far right of the Toolbar, to the left of the Sync Settings button. Clicking on that drop-down menu will give you the options to add to the Toolbar and customize it for your needs. Simply check next to the field that you'd like to show. Anything checked in the drop-down menu will appear on the Toolbar. Your screen size will effect how many options you can have showing on your Toolbar.

(B)

FIG 7.40B

Toolbar Drop-Down Menu
See **Figure 7.40C**.

(C)

FIG 7.40C

Survey and Compare Modes
When you are editing your images in Lightroom you can select combinations of images and use the Compare or Survey buttons to help cull your edit. Once in Compare or Survey mode you can zoom in and check detail by using the zoom slider. You can collapse both the left- and right-side panels to view the images even larger by clicking on the Tab Key or using the arrows on the side of the panels. To exit compare mode, press the C key (**Figure 7.41**).

FIG 7.41 Survey and Compare Mode Buttons

Compare Mode

The Compare Mode cycles through a group of images to find the best picture within that group. When you click done, the 'select' is selected and you can rank it or add it to a quick collection if you are using quick collections for editing.

To use this feature, first highlight an image from the filmstrip. This will be your 'select'. Using the arrow key on the Toolbar (or you arrow keys) move through your images. When you find another image that you like better than the original select, click on the XY Make Select button and that takes your original select out, and puts the new image as your select and you can move through and compare all the images to that one.

Next to the Compare Button in the Toolbar is an icon that looks like a lock. It is called the Link Focus Icon. Locking the Link Focus Icon allows you to zoom in simultaneously on both images using the zoom slider. Unlocking the Link Focus Icon allows you to zoom in on the selected image. Using the Sync button next to the zoom slider can synchronize the zoom ratios between images. This is a great tool for editing and checking sharpness between images.

Tip: The spacebar can be used to toggle between Fit and 1:1 View

In **Figure 7.42A** we compare two images. In **Figure 7.42B** we lock the zoom and check focus and make our Candidate the new Select.

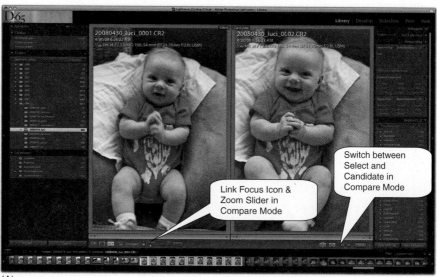

(A)

FIG 7.42

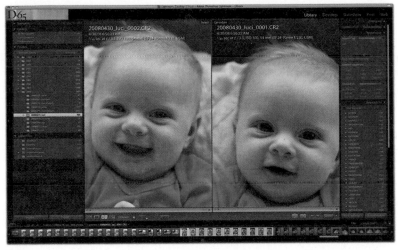

(B)

FIG 7.42 Using the Compare Button

Survey Mode

Survey Mode displays the active photo (the one you clicked on first denoted with a white box around it) and then one or more selected photos to compare it to (images with an x). If you want to compare more than two images at one time, it works great. You can change the orientation of the images, and zoom in and rate the images too (**Figure 7.43**).

FIG 7.43 Survey Mode

Spray Can

By clicking on the spray can icon, you have the ability to 'paint' in keywords, labels, flags, ratings, metadata, settings and rotation. A field opens next to the spray can and you insert the information you want to spray into the image. Click the spray can icon on an image(s) in the grid view and the information will be inserted. The spray can become an eraser after you apply it to the image, just in case you need to erase the information. Moving onto the next image, the icon will turn back into the spray can. Click Done on the far right of the Toolbar to get out of this feature (Figures 7.44A–C).

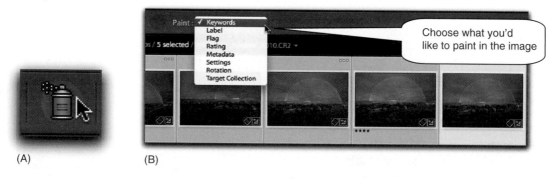

(A) (B)

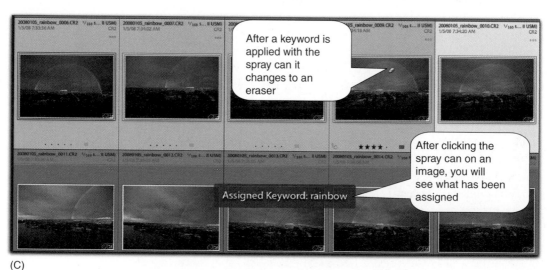

(C)

FIG 7.44 Using the Spray Can Tool

Sort Direction and Sort Criteria

Next to the Spray Can is Sort Direction (**Figure 7.45A**). This allows you to choose between ascending and descending order for your images to appear. There is a drop-down menu located next to the icon, which further allows you to define your sort criteria (see **Figure 7.45B**). You can even choose 'User Order' and organize the

(A)

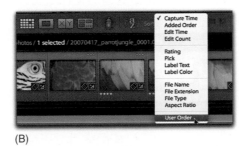
(B)

FIG 7.45 Sort direction options

images yourself by moving them in any order in the grid view. It is important to note that 'User Order' is only an option if you are on a folder. If you are on your entire catalog, user order is not an option.

Stars, Flags and Labels

Ranking and editing works in much the same way a film-based photographer works on a light table. First we click on an image and use the navigator tool with an appropriate zoom level to move through the image and check focus. After checking focus, a photographer typically used a star or dot to mark a select, two stars to mark second-tier selects and three or four stars to mark and cull 'keepers'. You can do exactly this within Lightroom. You can add and remove stars from an image by using theToolbar, or by using the number keys 1 through 5. You can also add color labels via the Toolbar, and by using the numbers 6 through 9. You can also rate and color label using the Photo Menu and then choosing Set Rating, Set Color Label or Set Flag. Additionally, you can select an image in Lightroom and manually add or subtract stars by clicking on the dots immediately below the thumbnail. In essence, there are a few ways to rate and color label your images. These rankings and color labels will stay with the image, in its metadata, even after you process the files. Why would you use both rankings and labels? There is always going to be a best image from a shoot and that image might get four stars. However, just because it is the best image from a shoot it does not necessarily

mean that it is a portfolio image. You could give four stars plus a color label to define an image that is the best from a shoot and a portfolio image (**Figures 7.46A** and **B**).

(A)

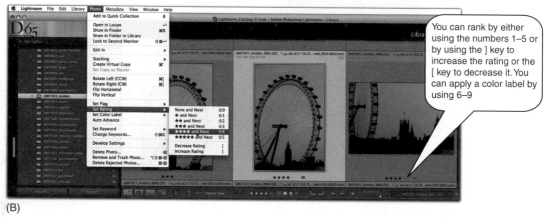

You can rank by either using the numbers 1–5 or by using the] key to increase the rating or the [key to decrease it. You can apply a color label by using 6–9

(B)

FIG 7.46 A&B Using Color Label

Color Label Sets

You can enhance Labels even further by creating a Color Label Set. We create a custom set using different colors for different stock agencies and to label an image as a portfolio image (**Figures 7.46C** and **D**).

(C)

(D)

FIG 7.46 C&D Creating custom label sets

Rating Shortcuts to Speed Up Workflow

- You can use the] key to increase the rating and the [key to lower the rating and Command Z will undo a rating.
- Having CAPS LOCK on while you are rating images automatically moves to the next image after you rate one image.
- You can also Set a Flag as a Pick, instead of rating and color labeling. For our workflow, we stick with ratings and color labels. The P key is a Pick, the X key is a reject and the U key removes the flag.

Rotate and Advance

You can manually rotate your images, counter clockwise with the left rotate icon, and clockwise with the right rotate icon. You can also select the next photo or previous photo with the left and right arrow keys (**Figure 7.47**).

FIG 7.47 Rotate and Advance buttons on the Toolbar

Impromptu Slideshow

At any time you can select a folder or group of images and build a slideshow on-the-fly by clicking on the slideshow icon. The slideshow will start playing almost immediately. Clicking the Escape button gets you out of the slideshow. The spacebar pauses and resumes playing the slideshow. The show automatically advances, but you can also use your arrow keys to go back and forth (**Figure 7.48**).

FIG 7.48 Slideshow Button

Thumbnail Slider and Active Image Cell

In the Grid View Toolbar, you can scale your thumbnails with the Thumbnail Slider. The thumbnail size in the filmstrip is also scalable. To change the Thumbnail preview size in the filmstrip, move your mouse between the Grid and the Filmstrip and then drag the filmstrip larger or smaller. The cell next to the thumbnail slider displays the name of the active image you have selected in the grid view (**Figure 7.49**).

FIG 7.49 Thumbnail Slider and Active Image Cell on the Toolbar

The Filmstrip

Located below the Toolbar is the Filmstrip. The filmstrip displays your current selection of images, based on either a folder, collection, keyword set or quick collection. You can move through the filmstrip using the arrow keys.

On top of the images in the filmstrip, is your filmstrip source. This shows the folder, search or collection that you have selected, the number of images in that selection as well as any active image name. At the top left of the Filmstrip is the ability to turn on a second monitor and to go backward or forward in your browsing history. Filtering tools are located at the far right of the filmstrip (**Figures 7.50A–C**).

(A)

(B)

(C)

FIG 7.50 (A) The Filmstrip Source

Multiple Monitors

New in 2.0 is the ability to add a second monitor. This is fantastic for editing and culling images and once you try a second monitor you will never want to work on one again. Grid, Loupe, Compare, and Survey and Slideshow are all available to use on the second monitor. This means you can see the Grid and the Loupe at the same time. This is very useful indeed. If you don't have a second display the new window will appear as a second window on your main display.

There are three views available for the Loupe View on the second monitor.

Normal mode, **Live mode** and **Locked mode**. With Live mode the second monitor is continually updated showing the image that the mouse is over on the main display (**Figure 7.51A**).

With Locked mode the image on the second monitor is fixed (**Figure 7.51B**).

(A)

(B)

FIG 7.51 (A) Dual Monitors with Live Mode. (B) Dual Monitors with Locked Mode

With Normal mode the image on the second monitor is the same image as the main but you can use a different zoom ratio which is fantastic for checking sharpness on the fly (**Figure 7.51C**).

(C)

FIG 7.51 Dual Monitors with Normal Mode

Keyboard shortcuts for multiple monitors:

- Grid (Shift + G)
- Loupe (Shift + E)
- Compare (Shift + C)
- Survey (Shift + N)
- Click and hold shows the MM list
- Slideshow cmd-shift-opt-enter

Forward and Backward Buttons

One very cool feature that has always been in Lightroom but few people know about is the ability to move forward and backward in your workflow. In **Figure 7.51D** we are on a folder of images called 20080211_miamibeach. As we browse this folder we see that there are many images with neon and we decide we want to see how many other images in the entire catalog have neon.

Since all of our images are keyworded we go to the Keyword List (**Figure 7.51E**) and Command click on the keyword 'neon'.

After we Click on the keyword 'neon' we are now in the entire Catalog showing all the images that contain the keyword 'neon'. We might consider making a collection of neon or we might want to go back to our Miami Beach images. Most folks end up

(D)

FIG 7.51

(E)

FIG 7.51

navigating through the hierarchy of folders and this can be tedious and time consuming (**Figure 7.51F**).

(F)

FIG 7.51

Simply by clicking on the 'Go Back' button in the Filmstrip we go back to our original folder (**Figure 7.51G**). The ability to go forward and back is a very useful (**Figure 7.51H**).

FIG 7.51

(G)

Filtering

The filmstrip also contains the filters and the filter on/off switch. Finding your rated and color-labeled images is easy in Lightroom. Go to the Filters and select how you want to filter. Filtering can be based on:

- flag status: Picks, Picks Only, Picks and Unflagged Photos, or Any Flag

(H)

FIG 7.51

- star rating
- color label
- or a combination of color label and rating

Filtering can be further defined by including greater than or equal to, less than or equal to or equal to.

The last button next to the color labels is Filter On/Off. D-65 suggests that at the end of a session of filtering, you turn off the filter. If you don't turn it off, the next time you come back to that specific folder, filtering will still be turned on. This might cause a scare because it will seem like many of your images are missing. This is because you are still filtering from a previous session in that folder (**Figure 7.52**, on page 132).

The Main Menus in the Library Module

The majority of your workflow can be accomplished in the window of the Library Module, but there are also some very important

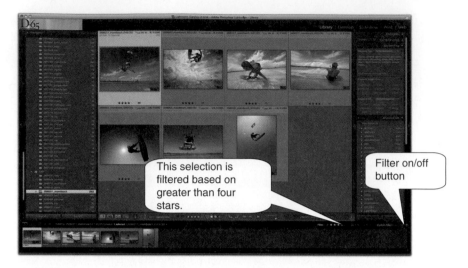

FIG 7.52

features that can be located from the menu bar. We'll cover each menu one by one below, pointing out the basics (**Figure 7.53**).

FIG 7.53

File Menu

The File Menu allows you to import, export and work with quick collections. It also allows you to export catalogs and create new catalogs. We'll talk more about exporting as a catalog later on in the tutorial. This is also where you can setup your catalog settings or preferences (**Figure 7.54**).

FIG 7.54 The File Menu

Edit Menu

The Edit Menu handles selections. In Lightroom, images that are selected will appear in both the filmstrip and Library Grid. You can change your ratings, flags and color labels here, as well as checking your spelling (**Figure 7.55**).

FIG 7.55 The Edit Menu

Active Photos

While you can select multiple images, only one image at a time is considered Active. The Active image's cell color is lighter and more opaque and is also the image that appears in the navigator (see example below) (**Figure 7.56**).

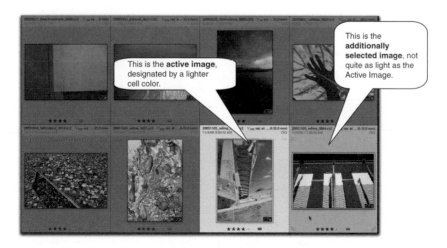

FIG 7.56

Library Menu

It is in the Library Menu that you create a new collection, folder, find images and turn filtering on and off.

Refine Photos causes any unflagged images in the folder to be marked as rejected and will set any picks back to unflagged. The rejected images will not go anywhere until you choose Delete Rejected Photos (from the Photo Menu). It is a way of editing.

You can also rename your images and convert to DNG, define preview quality and move through your selected images. D-65 renames its images here for the second time after editing if necessary (the first rename is on import).

You can change the quality of previously rendered previews here by selecting the folder of images, individual images or even your entire Library. While 1:1 Previews may be desirable, they take up a lot of space and can take a long time to generate a Library of high-res previews (**Figure 7.57**).

FIG 7.57 The Library Menu

FIG 7.58 The Photo Menu

Photo Menu

The Photo Menu has some Library basics such as Set Rating, Set Flag, Open in Loupe and Rotations. There are also some very cool features in the Photo Menu demonstrated in **Figure 7.58**.

Stacking

Stacking allows you to group images together, so there is one top image, and similar images are nested below the top image or select. To create a stack, you select the image that you want together and then from the Photo Menu, drop down to Stacking and fly out to

Group into Stack or use the keyboard shortcut, Command G. You can open a close stack by clicking on the stack icon in the top left of the image or through the menu or via the Photo Menu or by pressing S. You can move through stacks and even Auto Stack by Capture Time (Figures 7.59A and B).

(A)

FIG 7.59A Stacking

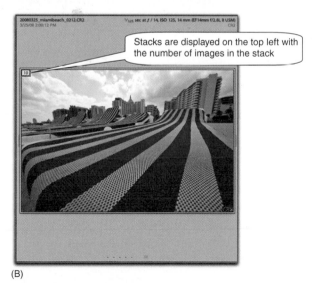

(B)

FIG 7.59B

Note: When applying changes to a stack, such as Renaming Photos, only the top image in the stack will be affected. If you want to apply a change to all the images in a stack, you will need to unstack them first. Also stacks can't contain images from different folders.

Virtual Copy

Virtual copy is also quite cool. A virtual copy is a copy of the metadata in the Lightroom catalog, which acts like a duplicate of the image. You would use this when you want have multiple versions of one image with different adjustments. You are not physically duplicating the image. You still only have one image, but with multiple sets of metadata. You can export a 'real' file from any virtual copy. The metadata on the virtual copy becomes an actual image on export only (**Figure 7.60**). Now that's cool!

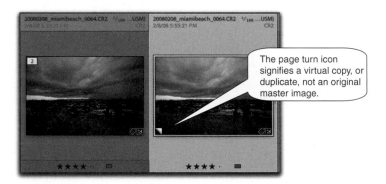

The page turn icon signifies a virtual copy, or duplicate, not an original master image.

FIG 7.60 Virtual Copy

Metadata Menu

There are many features in the Metadata Menu (**Figure 7.61**). One feature we find useful is the ability to edit the Color Label Sets, creating Labels specific for your workflow.

To create a Color Label Set, drop down to Color Label Set, fly out to Edit and the Edit Color Label Set Dialog Box pops up. See **Figure 7.46C**.

FIG 7.61 The Metadata Menu

Edit Capture Time

The ability to edit capture time is a noteworthy feature in this menu. Ideally you would want to have your camera date and time set correctly, but many times, this is not the case when crossing time zones. Lightroom offers a solution allowing you to adjust camera generated time and date (**Figure 7.62**).

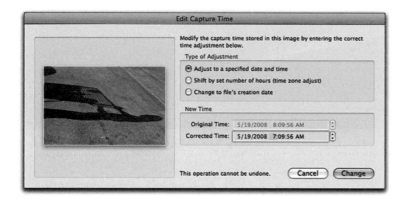

FIG 7.62 *Editing Capture Time*

Save Metadata to File

Metadata is automatically saved within the Lightroom catalog. If you want to export raw files to other applications, you choose Save Metadata To File for a folder or selected images. Sidecar .xmp files will be prepared for exporting. More on this topic and how it is related to workflow will be discussed later…

View Menu

One way to customize your Library is the display information over your images for both Grid and Loupe View. These can be set under the View Options in the View Menu.

Under Grid View, D-65 chooses Expanded Cells to display information on the thumbnails. Under Loupe View D-65 chooses to Show Info such as the filename, datetime created and caption info.

(A)

(B)

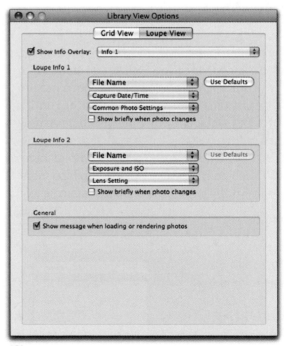

FIG 7.63 A,B&C Setting up View Options in Loupe and Grid Views

(C)

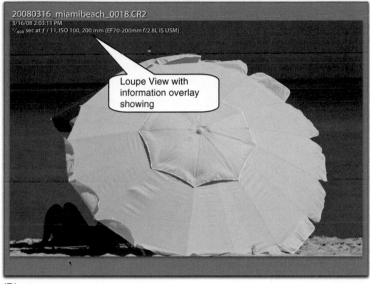

(D)

FIG 7.63

(E)

FIG 7.63

Whatever information is useful to you is correct to setup for your workflow (**Figures 7.63A–E**).

Enable Mirror Image

Choosing Enable Mirror Image Mode will flip all the images IN YOUR ENTIRE LIBRARY as if viewed in a mirror. This may be useful when showing someone portraits of himself or herself. Remember, when most people see themselves, they see themselves in a mirror and are not used to looking at themselves straight on.

Window Menu

The window menu brings you through the modules, determines screen mode and Lights Out. Lights Out, keyboard shortcut L, has three modes. The first is dim lights, which darkens everything in your screen, including a second monitor, except the images. Second is Full Lights Out Mode, which completely blacks out everything on the screen except the image(s). You can cycle through the various modes using the L key (**Figure 7.64**).

FIG 7.64 The Window Menu

Help Menu

Lightroom's online help is terrific. You can also check for updates and find keyboard shortcuts for each module in the Help Menu (**Figures 7.65** and **7.66**).

FIG 7.65 The Help Menu

Library Shortcuts

View Shortcuts

Esc	Return to previous view
Return	Enter Loupe or 1:1 view
E	Enter Loupe view
C	Enter Compare mode
G	Enter Grid Mode
Command + Return	Enter Impromptu Slideshow mode
F	Cycle to next Screen Mode
Command + Option + F	Return to Normal Screen Mode
L	Cycle through Lights Out modes
Command + J	Grid View Options
J	Cycle Grid Views
/	Hide/Show the Filter Bar

Rating Shortcuts

1-5	Set ratings
Shift + 1-5	Set ratings and move to next photo
6-9	Set color labels
Shift + 6-9	Set color labels and move to next photo
0	Reset ratings to none
[Decrease the rating
]	Increase the rating

Flagging Shortcuts

`	Toggle Flagged Status
Command + Up Arrow	Increase Flag Status
Command + Down Arrow	Decrease Flag Status

Target Collection Shortcuts

B	Add to Target Collection
Command + B	Show Target Collection
Command+Shift+B	Clear Quick Collection

Photo Shortcuts

Command + Shift + I	Import photos
Command + Shift + E	Export photos
Command + [Rotate left
Command +]	Rotate right
Command + E	Edit in Photoshop
Command + S	Save Metadata to File
Command + -	Zoom out
Command + =	Zoom in
Z	Zoom to 100%
Command + G	Stack photos
Command + Shift + G	Unstack photos
Command + R	Reveal in Finder
Delete	Remove from Library
F2	Rename File
Command + Shift + C	Copy Develop Settings
Command + Shift + V	Paste Develop Settings
Command + Left Arrow	Previous selected photo
Command + Right Arrow	Next selected photo
Command + L	Enable/Disable Library Filters

Panel Shortcuts

Tab	Hide/Show the side panels
Shift + Tab	Hide/Show all the panels
T	Hide/Show the toolbar
Command + F	Activate the search field
Command + K	Activate the keyword entry field
Command + Option + Up Arrow	Return to the previous module

FIG 7.66 Library Module Keyboard Shortcuts

Summary

The Library Module is command central for Lightroom. This is your digital asset management system. It is where you view, sort, search, manage, organize, rank, compare and browse through your images.

The Lightroom Library Module is a true database that catalogs all imported images so you can view previews and data whether the images are online or not. The left side holds the Navigator, Catalog, Folders and Collections panel as well as the Import and Export buttons. The right-hand panel holds Histogram, Quick Develop, Keywording, Keyword List and Metadata panels as well as the Sync Settings and Sync Metadata buttons. The Library Filter is located above the Grid, which resides in the middle of the main window and displays your images. At the bottom of the grid is the toolbar. The filmstrip is located underneath the toolbar.

Discussion Questions

(1) Q. How do you cycle between Fit and 1:1 in the Navigator?

A. If you click on Fit and then click on 1:1, you will be able to cycle between those two views by using the space bar, or clicking on the image in loupe view.

(2) Q. What is a Target Collection?

A. Any collection can be deemed a Target Collection. A target is simply the location that the image(s) will be referenced to when using the keyboard shortcut B. By default, Quick Collection is your Target Collection. You can only have one Target Collection at a time.

(3) Q. How do you move images from one folder to another?

A. To move images, select the images you want to move in the grid mode, and drag them to the new folder location. You will see an icon, which looks like a stack of slides. The original location is shaded in light gray and the new location is shaded in light blue. These are the actual images that are moving, not reference files. The files will physically move in the hard drive that they reside as well.

(4) Q. What is the advantage and downside of high-res previews?

A. If you render high-res 1:1 previews, you can even zoom in on these files without any artifacting even when the files are off-line. This is one large plus for generating 1:1 previews. You can take them on the road without having the files and still make web galleries and slideshows and view the images at 100%. The only downside is that these previews do take up considerable space.

(5) Q. What is a Smart Collection?

A. Smart Collections allow you to select criteria to automatically group your images into collections. Smart Collections can have very complex criteria. If you hold down the Alt key on the plus sign when making decisions, the plus sign will turn into a # sign and give you the added ability to make conditional rules.

(6) Q. What would the proper hierarchy be for keywording the location of South Beach in Miami Beach, Florida?

A. Continent>North America
Country>United States

State>Florida
City>Miami Beach
Scene>South Beach

(7) Q. Name three ways to apply keywords.

A **Keywording Panel**: Select one image or more images in the grid and start typing the keyword(s) you want to insert in the Keyword Tags Panel. Hit return and the keywords will be placed in the image. **Copy and Paste Keywords**: Select one image, keyword it and then copy and paste the keywords from one to another. **Spray Can Tool**: Click on the Spray Can and add keywords to the field in the Toolbar. After the keyword(s) are added, hit return to save them.

(8) Q. What does a good caption provide for an image?

A. A good caption and an image maintain a symbiotic relationship. A caption describes the unseen. The caption brings totality to the image by providing context and adding depth. The image draws attention to the caption, and the caption helps to provide the complete picture. The caption should provide the 'who, what, when and where' as well as information that can't necessarily be derived by simply looking at the image.

(9) Q. When culling images is there a way to get two images side-by-side to decide which one is better?

A. When you are editing your images in Lightroom you can select combinations of images and use the Compare or Survey buttons to help cull your edit. Once in Compare or Survey mode you can zoom in and check detail by using the zoom slider. You can collapse both the left- and right-side panels to view the images even larger by clicking on the Tab Key or using the arrows on the side of the panels. To exit Compare mode, press the C key.

(10) Q. Describe a situation where you might use both rankings and labels?

A. There is always going to be a best image from a shoot and that image might get four stars. However just because it is the best image from a shoot it does not necessarily mean that it is a portfolio image. You could give four stars plus a color label to define an image that is the best from a shoot and a portfolio image.

(11) Q. What are each of the modes for a second monitor and what do they do?

A. There are three views available for the Loupe View on the second monitor:

Normal mode, **Live mode** and **Locked mode**. With Live mode the second monitor is continually updated showing the image that the mouse is over on the main display. With Locked mode the image on the second monitor is fixed. With Normal mode the image on the second monitor is the same image as the main but you can use a different zoom ratio which is fantastic for checking sharpness on the fly.

(12) Q. What is a Virtual Copy and why would you use one?

A. A Virtual Copy is a copy of the metadata in the Lightroom Library, which acts like a duplicate of the image. You would use this when you want have multiple versions of one image with different adjustments. You are not physically duplicating the image. You still only have one image with multiple sets of metadata. You can export a 'real' file from any Virtual Copy. The metadata on the Virtual Copy becomes an actual image on export only.

The Develop Module

The Develop Module holds all the controls that you need to adjust images. It is D-65's 'tweaking command central'. The image processing engine used in Lightroom is Adobe Photoshop Camera Raw, which ensures that digital raw images processed in Lightroom are fully compatible with Camera Raw and vice versa. Synchronization, Exposure, Shadows and White Balance will seem very familiar, plus there is tons of added new functionality. The Develop Module utilizes sliders, and will be much easier to comprehend the power of these sliders and adjusting your images if you understand specifically what each of sliders is designed to do. The Develop Module adds new features and a new concept in Lightroom 2.0 with the inclusion of Localized Adjustments. We will explain each panel and slider fully within this chapter, but first we'll explain the concept of Parametric Editing.

Nondestructive or Parametric Editing

While Photoshop has a mix of destructive and nondestructive editing features, adjustments to images made in Lightroom are done with a very new approach. All the edits made in Lightroom are nondestructive. What does this mean?

A nondestructive edit doesn't alter the original pixels in your image. The big advantage of nondestructive editing is that you can undo any edit at any time, and in any order. You can go back and change the parameters of any edit at any time, keeping the history of a file even after the file is closed. Lightroom also allows all of the controls to be used not only for RAW and DNG files but also for JPG, TIF and PSD. It is completely nondestructive on RAW files, and nondestructive on other files until you save the metadata to the file. This is a major breakthrough for adjusting images.

The editing data is stored inside the Lightroom's catalog, whether you choose to import your images into the library or leave them in their original locations and import them as references. If you're working with raw files, you can also choose to have the edits and metadata changes stored in sidecar XMP files, just as you do in Bridge.

Workflow Tip: *On our main computer, we always choose to activate this feature by going to Lightroom's File Menu \> Catalog Settings \> Metadata, and checking 'Automatically write changes into XMP sidecar files' option. While this **does slow performance down** it alleviates potential issues with regards to losing the .xmp sidecar files. More on this later....*

While raw files don't have an embedded color profile, the Develop Module assumes a very wide color space based on the values of ProPhoto RGB. ProPhoto is a color space that contains all of the colors that your camera is able to capture. Since ProPhoto is really a 16-bit space, Lightroom uses a native bit depth of 16-bits per channel. Lightroom is capable of 32,000 levels of tonal information, which surpasses the amount from any digital camera today. In English, quite simply Lightroom can safely contain all the tone and color information from any camera.

Lightroom manages color internally by using a gamma of 1.0 instead of 1.8. A gamma of 1.0 matches the native gamma of raw camera files. Here is where it gets a bit complicated. To provide

useful information in the Histogram and corresponding RGB values, Lightroom utilizes a gamma value of 2.2.

The addition of Localized Adjustments in the Develop Module adds amazing power to Lightroom reducing the necessity for Photoshop in many cases.

Features in Develop

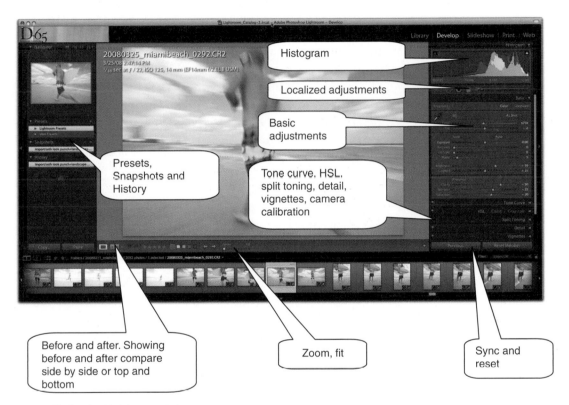

Histogram

Localized adjustments

Basic adjustments

Presets, Snapshots and History

Tone curve, HSL, split toning, detail, vignettes, camera calibration

Before and after. Showing before and after compare side by side or top and bottom

Zoom, fit

Sync and reset

FIG 8.1 The Develop Module main window

Toolbar in Develop Module

We'll start off with the toolbar, and then move to the left and right-side panels in the Develop Module (**Figure 8.1**). The toolbar in Develop has been cleaned up quite a bit in 2.0, adding some editing features from the Library Module that are useful in Develop Mode (**Figure 8.2**).

FIG 8.2 Toolbar in the Develop Module

Loupe View

The first button is Loupe view, which offers you the ability to zoom in on an image, same as in the Library.

Before and After View

The button next to it is Before/After view, which is a very handy feature. This allows you to compare an image before and after you have made adjustments. You can view either side by side, or top and bottom. The down arrow next to the compare view allows you to choose orientation.

Flag as Pick or Rejected

You can flag an image as a Pick or as Rejected in the Develop toolbar.

Ranking and Labels

You can rank an image and or apply a color label in the Develop toolbar.

Move Forward or Backward

You can move forward or backwards through the filmstrip with these buttons.

Impromptu Slideshow

This button lets you create a slideshow on the fly.

Zoom Fit

With this button you can go from Fit all the way to 11:1.

Develop Module Panels

Now let's move to the right-side panels.

Histogram

The Lightroom Histogram appears in the top right-hand corner of both the Develop and Library modules. A histogram is a visual representation of the tonal range in your image and how much range of a given tone exists. The Histogram in Lightroom is showing three layers of color representing the red, green and blue channels. The left side of the histogram represents pixels with 0% luminance (black) while the right side represents pixels with 100% luminance (white) (**Figure 8.3**).

The Histogram Panel in Lightroom's Develop Module becomes a tool. You can adjust an image by adjusting the Histogram itself. The

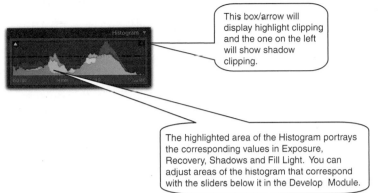

This box/arrow will display highlight clipping and the one on the left will show shadow clipping.

The highlighted area of the Histogram portrays the corresponding values in Exposure, Recovery, Shadows and Fill Light. You can adjust areas of the histogram that correspond with the sliders below it in the Develop Module.

FIG 8.3

Blacks, Fill Light, Exposure and Highlight Recovery, all shown in the Histogram, directly relate to the Tone Sliders below the Histogram. You can physically make adjustments to an image by dragging the tone sliders or the histogram.

The histogram also allows you to preview the image with a clipping warning for both Shadows and Highlights by clicking on the shadow and highlight buttons. A color overlay with blue used to indicate shadow clipping and red to indicate highlight clipping is displayed, as shown in **Figure 8.4.**

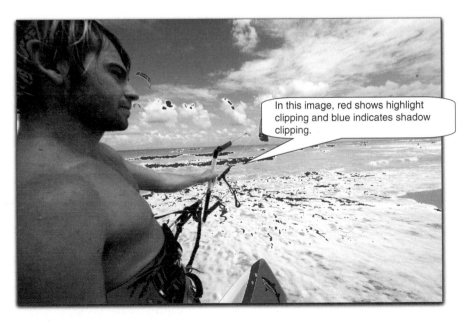

In this image, red shows highlight clipping and blue indicates shadow clipping.

FIG 8.4

Localized Adjustments

Localized Adjustments are the greatest change in Lightroom 2.0. Up until now corrections were 'global', meaning that they affected the entire image. The engineering team did a fantastic job of bringing what was only available in Photoshop to Lightroom. Lightroom 2.0 provides localized corrections with a paintbrush. The adjustments are done using masks. You paint a mask and fill it with one of the adjustments listed below. And the best part is…it is all nondestructive.

You can now paint on the following adjustments:

- Exposure
- Brightness
- Contrast
- Saturation
- Clarity
- Sharpness
- Tint

Lightroom 2.0 also provides a Graduated Filter with an Effect Slider similar to the Brush Tool.

Cropping, Spot Removal and Red Eye Reduction are also located in the tool strip, which then opens the tool drawer. These used to be located on the toolbar in Lightroom 1.4.1. We'll explain how these work first (**Figure 8.5**).

FIG 8.5 Localized Adjustment Panel

Crop Overlay and Straighten Tool

When you click on the Crop Tool or select R, the tool strip expands and offers more options including the croppers, lock, drop down menu with crop presets and the straighten tool. The Reset button on the bottom of the panel clears the settings you apply in this panel (**Figure 8.6**).

You can also choose from a drop down menu of aspect ratio presets next to the lock. You can also enter and save custom presets.

FIG 8.6

Clicking on the Crop Overlay will present a crop-bounding box that allows you to crop your image, as shown in **Figure 8.7**. You can choose to constrain the image by locking the lock button and using the handles on the crop overlay or move the image behind it.

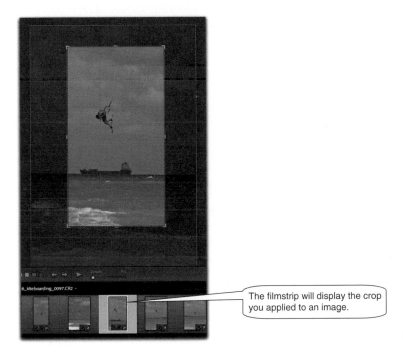

The filmstrip will display the crop you applied to an image.

FIG 8.7

Straighten Tool and the Straighten Tool Slider
This tool is great for straightening a horizon line.

Using the Straighten Tool and Straighten Tool Slider
You can straighten an image in two ways:

(1) Moving the mouse down on the Straighten Slider, as shown in **Figure 8.8A**, and dragging it to the right or left will straighten out your image in live time using a grid to align the horizontal or vertical access.

Use the Straighten Ruler or Slider to correct your image.

(A)

FIG 8.8 (Continued)

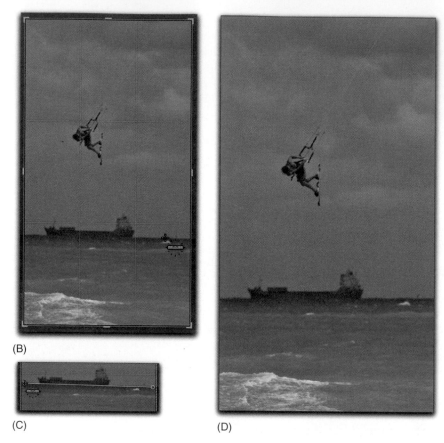

(B)

(C)

(D)

FIG 8.8 B,C&D Using the Straighten tool

(2) The Straighten Tool (the ruler) works by grabbing it from the toolbar, mouse down, drag the ruler into the image and draw a line along the path you want to straighten, as demonstrated in Figure 8.8B and C.

(3) The final image is cropped and skyline is straight (**Figure 8.8D**).

Red Eye Reduction Tool

The Red Eye Reduction Tool does exactly what it is called, reduces red eye (Figure 8.9A).

Using the Red Eye Reduction Tool

(1) Click on a red eye to see the slider. Make a selection around the red eye using the Pupil Size Slider, which increases the size of the selected area (**Figure 8.9B**).

(2) **Figure 8.9C** shows a before and after using Red Eye Reduction.

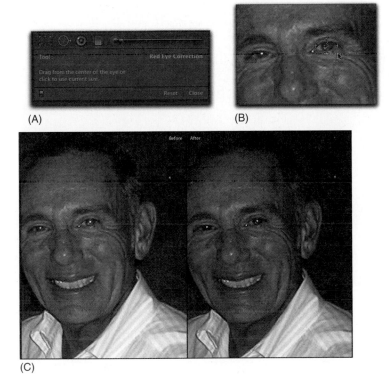

(A)

(B)

(C)

FIG 8.9 A,B&C Using the Red Eye Reduction tool

Remove Spots Tool

Dust on sensors is inherent in digital imaging. The Remove Spots Tool gives you the ability to get of them quickly, and with ease. Clicking on the Remove Spots Button will give you the options of Cloning or Healing, a Spot Size Slider and Opacity.

Cloning and Healing

There is a difference between the cloning and healing tools. Cloning applies the same sampled area to a different area – it is an exact duplicate of what you are selecting. Healing matches' texture, lighting and shading from the sampled area to the selected area you are correcting.

Generally the Cloning Tool is a better choice when removing a spot close to an edge, and the Spot Healing Tool a better choice when you are away from a defined edge.

153

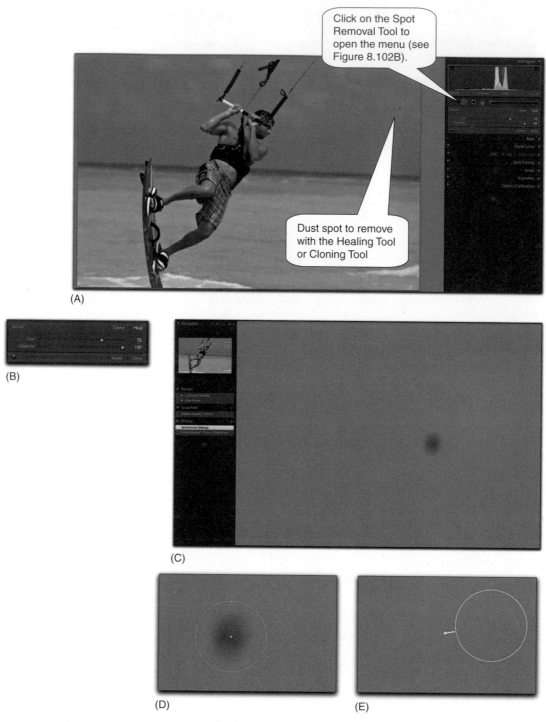

FIG 8.10 A–E Using the Spot Removal tool

(F)

(G)

(H)

FIG 8.10 F-H Using the Spot Removal tool

Let's look at an example. There is a dust spot on the sensor in the upper right-hand corner of **Figure 8.10A**. The spot is in the sky so the Spot Healing Tool would be fine, but we are going to demonstrate both methods.

Using the Remove Spots Tool

(1) Click on the Spot Removal Tool to open the menu (see **Figure 8.10B**).
(2) Using the Navigator, navigate to the dust spot using the little rectangle and zoom in to at least 1:1 to see the dust spot. In this case we are zooming to 2:1 (**Figure 8.10C**).
(3) **To Clone:** Pick Clone and a brush size the same size or a bit larger than the object you want to clone. Mouse down and move the circle to the area you want to clone. Note the Left bracket will make the selection area smaller and the Right Bracket will make the selection area larger as will the scroll wheel (**Figure 8.10D**).
(4) Mouse Down and drag the circle to the area that you want to Clone from (**Figure 8.10E**).
(5) Release the mouse and the cloned object will appear. Both the size of the selection circle and the Opacity can be adjusted further after you release the mouse (**Figure 8.10F**).

(1) **To Heal**: Select the Healing Tool and mouse down on what you want healed (**Figure 8.10G**).
(2) It will automatically make a selection matching the texture, lighting and shading of the sampled adjacent area. This will remove the dust or spot quite easily. D-65 uses Healing for all dust and spot removal on our RAW files. It is an awesome tool!! (**Figure 8.10H**).

Spot Tool Workflow Tip: The H key hides the Spot Tool. We use H a lot to hide the spot tool so we can see if there's another spot close by, and then press H again to reveal the Spot Tool.

Localized Corrections Graduated Filter

2.0 was designed for localized lightening and darkening. One of the coolest new tools for Localized adjustments is the Graduated

(A)

(B)

The default view is button mode. D-65 prefers to toggle to use the slider mode.

FIG 8.11 A&B The Graduated Filter Panel

Filter Tool. To activate the Graduated Filter click on the gradient icon or use the keyboard shortcut M.

The Graduated Filter Panel (**Figure 8.11**) offers many choices:

- Exposure corresponds to F stops with a range of −4.00 to +4.00.
- Brightness makes a midpoint, or gamma adjustment, to your image. Essentially think of Brightness as a mid-tone adjustment.
- Contrast increases or decreases contrast by adjusting the white and black points simultaneously.
- Saturation works like vibrance. You can add Saturation by moving the slider towards the plus side, and you can desaturate by moving the slider towards the minus side.
- Clarity is mid-tone contrast and it works like sharpening – it needs edges. More clarity is adding sharpness but in a tonal way, less clarity is like smoothing and is great for skin tones.
- Sharpness adjusts overall sharpness of an image.
- Color allow you to create a tint within an image.

Using the Graduated Filter

The image in **Figure 8.12** would be more pleasing to the eye in multiple ways by using Lightroom's Graduated Filter.

FIG 8.12 Using the Graduated Filter

(1) For starters, we could bring down the sky. Let's set exposure to about 1 1/4 stop down. To do this, we mouse down and drag the slider tool from the top down to the horizon line to apply the Graduated Filter.

Graduated Filter Workflow Tip: *Hold the Shift key down when you drag down the Graduated Filter, and it will be applied perfectly level. This is an ideal tool for this image. If you do not hold the Shift key down the Graduated Filter can be applied at an angle* (**Figure 8.13**).

FIG 8.13

(2) After we make our basic adjustment, we can refine the Graduated Filter and see the effects in live time. In **Figure 8.14** we have decreased exposure to −2.67, added a bit of Contrast, Saturation and Clarity and we have added a bit of a warm tint.

FIG 8.14

(3) In **Figure 8.15** we see the 'Pin' or market showing where the Graduated Filter was applied. The H key will show and hide the Pin.

(4) In **Figure 8.16** we apply a new Graduated Filter from the bottom up opening up exposure and Brightness a bit.

FIG 8.15

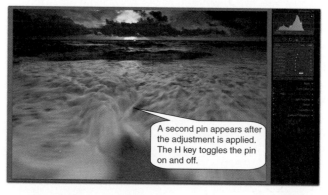

FIG 8.16

A second pin appears after the adjustment is applied. The H key toggles the pin on and off.

(5) In **Figure 8.17** we see the before and after of the image. The sky has been successfully darkened and warmed up and

FIG 8.17

the water in the foreground has been lightened. All of this is nondestructive and relatively easy to apply.

FIG 8.18

Localized Adjustment Brush

Probably the coolest new feature in Lightroom 2.0 is the Localized Adjustment Brush (**Figure 8.18**).

This brush just plain rocks, providing a simple painting tool to locally and nondestructively adjust Exposure, Brightness, Contrast, Saturation, Clarity, Sharpness and Tint. There is an Effect drop down menu that defines the initial setting for the Brush. You can also create two preset brushes (A and B). Each preset brush can be adjusted for Size, Feather, Flow and Density. There even is an Auto Mask capability which confines the brush strokes to areas of similar color (**Figure 8.19**).

FIG 8.19 Localized Adjustment Brush Panel

Using Localized Adjustments

(1) To define a brush tint value or preset you need to double click the large color chip then click the color picker on the palette (**Figure 8.20**).

Tip: *Sampling color from the image click in the color floating panel, keep the mouse button pressed and go anywhere on your image: an eyedropper will replace the mouse cursor.*

FIG 8.20

(2) The panel can be configured to use as sliders or plus and minus button presets by using the button just under Edit. The plus/minus view is all about presets and adjusting a preset using the amount slider. The slider view is all about adjusting individual effects (**Figure 8.21**).

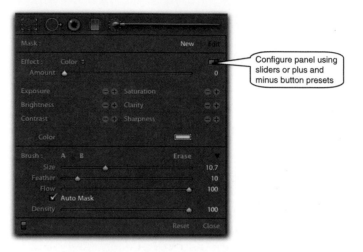

Configure panel using sliders or plus and minus button presets

FIG 8.21

Localized Corrections Adjustment Brush controls work in the following ways:

- **Amount**: controls the degree of the effect being applied.
- **Exposure**: corresponds to F stops with a range of −4.00 to +4.00.
- **Brightness**: makes a midpoint, or gamma adjustment, to your image – think of Brightness as a mid-tone adjustment.
- **Contrast**: increases or decreases contrast by adjusting the white and black points simultaneously.
- **Saturation**: increases saturation when it is 'plus' and decreases saturation when it is on the minus side.
- **Clarity**: is mid-tone contrast and it is like sharpening – it needs edges. More clarity is adding sharpness but in a tonal way, less clarity is like smoothing and is great for skin tones.
- **Sharpness**: adjusts overall sharpness.
- **Color**: allows you to create a tint.
- **Size**: controls the diameter of the brush.
- **Feather**: the larger the feather, the softer the gradation.
- **Flow**: the strength at which the tool is working, somewhat like opacity.
- **Density**: similar in concept to opacity but slightly different.

For example, setting the Density to less than 100 will cause brush strokes applied with the lower setting to be some percentage of the Amount specified. This means that you can have an Exposure −4,

but if some brush strokes are applied with a density setting of 50 those strokes will only have 50% strength or −2. The individual strokes can be varied in their density, but still be part of the same pin, which can have its overall strength controlled with the Amount Slider.

Localized Adjustment Brush Tips

- Holding down the alt key will allow you to subtract from the mask.
- To paint a new adjustment, click NEW and then change a value, such as brightness. When you click on it after you have made the adjustment, you can see this is like the ultimate dodge and burn.
- Auto Sync only syncs global corrections. It does not sync local corrections. Regular Sync will sync everything selected.

Using the Localized Adjustment brushes

Figure 8.22 could certainly benefit from lightening the water and part of the island as well as some darkening of the sky and boosting saturation in the rainbow and warming up the sky a bit.

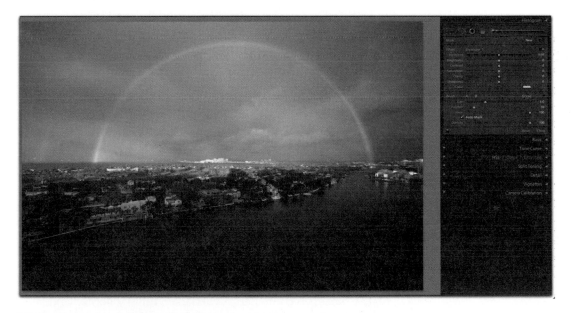

FIG 8.22 Image prior to applying localized adjustments

(1) We select Exposure, change value about 1/2 stop, then paint a stroke to lighten the water (**Figure 8.23**).

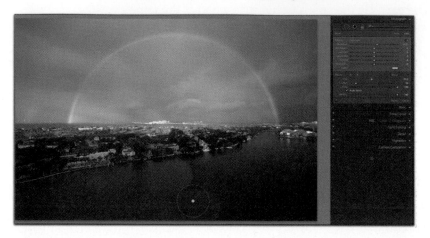

FIG 8.23

(2) When we complete the task we hover over the 'pin' and check the mask. We hit the alt key and clean up some of the edges (**Figure 8.24**).

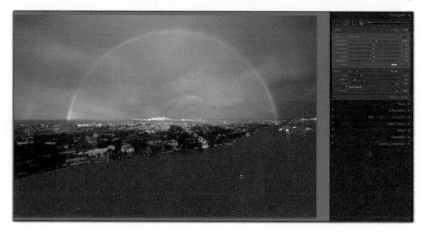

FIG 8.24

Localized Adjustment Workflow Tip: *The O key will allow you to toggle the mask on and off.*

Tip: *You may at times find that the red overlay for the mask doesn't work for you. To change the color of the overlay when using the adjustment brush move your cursor over the pin to show the red overlay, then press Shift - O you can cycle through different color overlays.*

(3) The process is continued as we darken the sky, lighten and darken parts of the island and add a bit of a tint to the sky and

island. Finally we choose Saturation and lightly paint over the rainbow increasing the saturation to make it more pronounced and vivid (**Figure 8.25**).

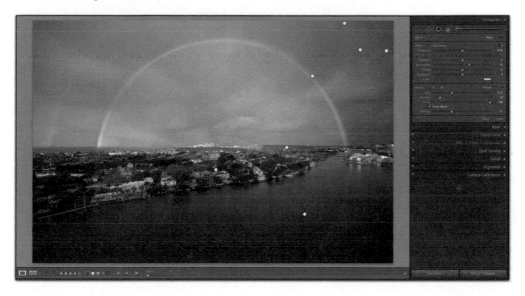

FIG 8.25

(4) Finally we compare the two images using the Y key for before/after view and all of this took only a few minutes to complete. WOW! (**Figure 8.26**).

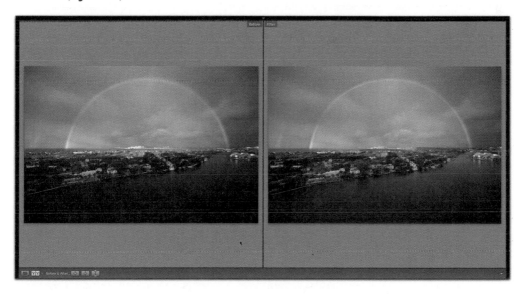

FIG 8.26

The Basic Panel

The Basic Panel holds all of our basic adjustments including Temperature, Tint, White Balance, Exposure, Recovery, Fill Light, Blacks, Brightness, Contrast, Vibrance and Saturation. It's not so basic ☺.

Treatment

The Treatment Panel holds the White Balance, Temperature and Tint Sliders. You can also covert an image to Grayscale in this panel (**Figure 8.27**).

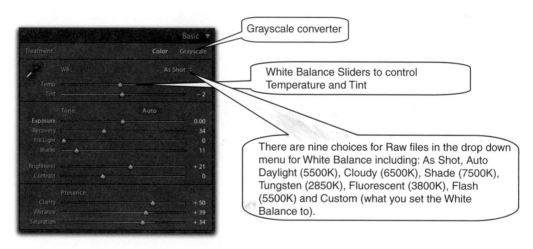

Grayscale converter

White Balance Sliders to control Temperature and Tint

There are nine choices for Raw files in the drop down menu for White Balance including: As Shot, Auto Daylight (5500K), Cloudy (6500K), Shade (7500K), Tungsten (2850K), Fluorescent (3800K), Flash (5500K) and Custom (what you set the White Balance to).

FIG 8.27 The Basic Panel

White Balance

The first slider controls the White Point. The numbers on the slider 2000–50,000 refer to the temperature measured in Kelvin. White balance indicates the color of the light under which the image was captured. The default value is the white balance at which the image was captured 'As Shot'. The white balance of an image can be adjusted in three ways.

- Choosing a value from the white balance drop down menu.
- Sliding the Temperature Slider and the Tint Slider.
- Using the White Balance Selector Tool to click on a neutral white or gray area in the photo.

Temperature

The Temperature Slider allows you to fine-tune the white balance to a precise color temperature using a Kelvin color temperature scale. Moving the slider to the left produces a correction for images taken with a lower temperature. The slider adds blue to the image to compensate for yellow of lower temperature values. Moving the slider to the right produces a correction for images taken with a higher color temperature. The slider adds yellow to the image to compensate for blue of higher temperature values.

- Moving the slider to the left makes the images appear cooler, while moving the slider to the right make the images appear warmer.
- When working with JPEG, TIFF and PSD's, the scale is -100 to $+100$, rather than in Kelvin.

Tint

The Tint Slider allows you to fine-tune the white balance to compensate for green or magenta tints in images. Moving the slider to the left adds green while moving the slider to the right adds magenta. Think of tint as a personal adjustment slider. If you think your images from your camera are slightly green or magenta, you can correct that cast here.

Tint Workflow Tip: *If the cast appears in the shadows, refer to the Shadow Tint Slider in the Camera Calibration Panel.*

White Balance Selector Tool

The White Balance Selector Tool is located in the top left of the Basic Panel. It looks like an eye dropper. To white balance the image, pick an area that is neutral light gray or close to the second white patch on a GretagMacBeth card. While you are working with this tool, the navigator will display a preview of the color balance as you move the tool around the image.

White Balance Toolbar Options

- **Show Loupe:** This displays a close-up view with the corresponding RGB values (shown on the following page).
- **Scale Slider:** This zooms the close-up view of the Loupe.

- **Auto Dismiss**: This dismisses the White Balance Selector Tool after one click. We choose not to have this checked in our workflow.
- **Done**: Dismisses the White Balance Selector Tool, changing it to the Hand or Zoom Tool.

Workflow Shortcuts in the Basic Panel

- Command U: Auto Tone
- Command Shift U: Auto White Balance
- W key: White Balance Selector Tool

White Balance Demo

So let's go ahead and white balance shown in **Figure 8.28**.

FIG 8.28 Image before being white balanced

FIG 8.29

(1) We select the White Balance Tool **Figure 8.29**.
(2) Next we go the Navigator and zoom in to a section of the image that has white with detail. In this case the white of the eye is perfect. We choose to uncheck Auto Dismiss so that we can make multiple selections with the White Balance Tool if we desire. Then we click on the White of the eye, and the image is white balanced (**Figure 8.30**).
(3) Our image, **Figure 8.31**, now has the correct white balance.

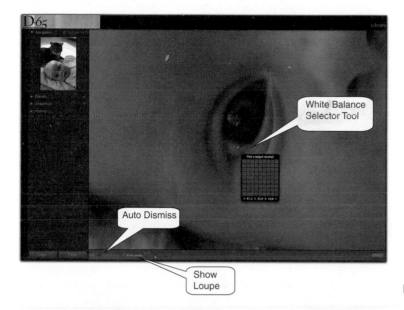

FIG 8.30

FIG 8.31 Figure after being white balanced

Using an X-Rite ColorChecker to Achieve White Balance

Another way to achieve a correct white balance would be to place
an X-Rite ColorChecker into the scene. Using the White Balance
Selector Tool, click on the second patch from the bottom right on

the checker. This will provide the correct white balance. Now the one image can be synced to a group of other images, and we will cover this later (**Figure 8.32**).

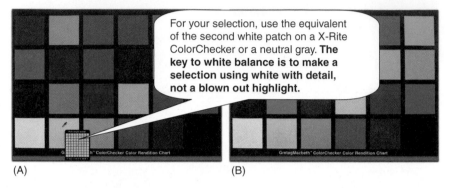

(A) (B)

FIG 8.32

The Tone Panel

The Tone Panel holds the Exposure, Recovery, Fill Light, Blacks, Brightness, and Contrast Sliders. ***The sliders in this panel ideally should be used in the order they appear***.

Exposure Slider

The Exposure Slider sets the white point, controlling the overall image brightness. The values shown on the right of the slider (+1.00) is equivalent to roughly opening up one stop. The slider works the same for the negative values.

Using the Exposure Slider to set White and Black Points

The Exposure Slider provides yet another incredibly valuable tool for a photographer using Lightroom. Pressing down the option key while moving the slider will locate the technically correct white point. The technically correct white point is at the point when you first begin to see detail. This is very similar to the Levels Dialog in Photoshop. The 'unclipped' areas of the image are black, and the 'clipped' areas appear as white. Move the slider just to the point that an image begins to become clipped, and set the whites and blacks accordingly.

Underexposing to hold highlights when using digital capture is generally a bad idea. You will lose dynamic range, and there will be a tendency to induce posterization when the image is lightened. An ideal exposure has specular highlights just at the

point of clipping. One of Lightroom's most remarkable features is its extended highlight recovery logic. If you have a choice during capture, it's better to choose overexposure than underexposure (**Figure 8.33**).

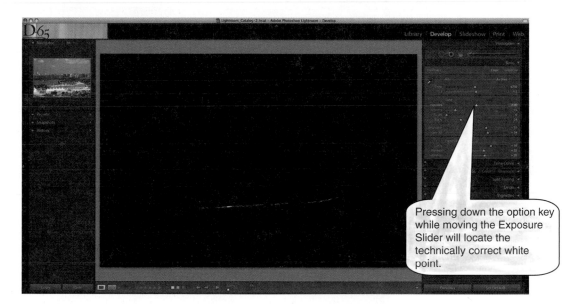

> Pressing down the option key while moving the Exposure Slider will locate the technically correct white point.

FIG 8.33

Recovery

D-65 suggests using the Exposure Slider to get the overall image luminance correct and then use Highlight Recovery to bring back any blown highlights. Recovery reduces the tones of extreme highlights that were lost because of camera overexposure. Lightroom can actually recover lost detail in RAW image files, even if two channels are clipped.

The Recovery Slider actually works with highlight recovery. It does this by trading between exposure, which acts linearly, and clips highlights and brightness, which acts nonlinearly and compresses highlights. By balancing these, it avoids making changes outside the highlights, so its effects are very subtle. The benefit of this control is that you do not need to move the Exposure Slider to the left, making a negative move, to recover highlight detail.

Recovery Slider Workflow Tip: Hold down the Alt/Option button and move it while using the Recovery Slider until the clipped areas disappear (**Figure 8.34**).

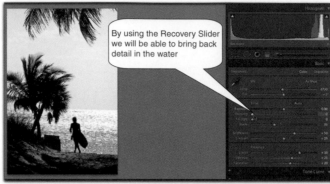

(A)

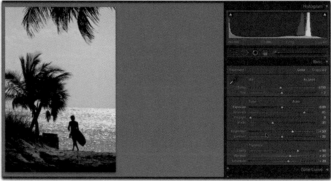

FIG 8.34 Using the Recovery slider (B)

Fill Light

Fill Light gives the ability to pull added detail out of the shadows without affecting the rest of the image. It really does work as if a fill light was added to the scene. Notice in the yacht interior in **Figure 8.35A**. In **Figure 8.35B**, we used the Fill Light Slider and are able to raise the appearance of the ambient light in the interior as if we had a very large fill card being held by two assistants.

Blacks

Blacks control the amount of black value in an image. It will have its greatest effect on the shadows and in some cases may increase contrast as well. Moving the slider to the right increases the areas that become black as demonstrated in **Figure 8.36**.

Blacks Workflow Tip: Pressing down the option key while moving the slider will locate the technically correct black point. (exactly like

(A)

(B)

FIG 8.35 Using Fill Light

(A)

(B)

FIG 8.36 Using the Black slider

Exposure.) The technically correct black point is at the point when you first begin to get detail.

Brightness

The Brightness Slider adjusts the midtones. This adjustment compresses the highlights and allows you to visually manipulate how bright or dark an image appears. Large changes in brightness will also effect shadow and highlight clipping. You may have to adjust Exposure, Recovery and Blacks if you make large adjustments with Brightness. In **Figure 8.37B** we have raised the midtones of **Figure 8.37A** by adjusting Brightness.

(A)

FIG 8.37 Using the Brightness slider (B)

Contrast

The Contrast Slider increases or decreases contrast in an image. Its greatest effect is on the midtones, like Brightness. As the Contrast Slider is moved to the right, the darker areas of an image will become darker, the lighter areas will become lighter, as shown in **Figure 8.38**.

Auto

The Auto button will analyze an image creating a custom-tone map based on the individual characteristics of the image. Auto will

(A)

(B)

FIG 8.38 Using the Contrast slider

often produce excellent results. Auto is a very good starting point when correcting images, allowing the user to see how Lightroom would want to correct a particular image.

Workflow Tips for the Tone Panel:

- *Command U auto corrects all of the Tone Panel Sliders.*
- *You can rest any slider to its default by double clicking on it.*

The Presence Panel

There are three sliders in the 'Presence' panel: Clarity, Vibrance, and Saturation.

Clarity

Clarity is a mid-tone contrast adjustment tool. It will give your images extra punch. Clarity adds depth to an image by increasing local contrast. When using this setting, it is best to zoom in to 100% or greater. To maximize the effect, increase the setting until you see halos near the edge details of the image, and then reduce the setting slightly. Clarity is one of the most popular photographer

173

(A)

(B)

FIG 8.39 Using the Clarity slider

friendly features in Lightroom. In **Figure 8.39A** Clarity is set to 0 and in **Figure 8.39B** it is set to 35. Look at the incredible difference!

Vibrance

Vibrance increases the saturation in a nonlinear or nonequal manner, meaning lower saturated values are increased more than high saturation values. This differs from Saturation in that Saturation does an across the board saturation increase regardless of what the current value is. Vibrance is particularly useful in adjusting colors that would otherwise be clipped and as they become fully saturated. It constrains the colors that would become out-of-gamut with printing. It is excellent for adjusting skin tones because it creates saturation without the skin tones going magenta. In **Figure 8.40A** Vibrance is set to 0 and in **Figure 8.40B** it is set to 48. The blues and greens are popping in **Figure 8.40B**, but the skin tone remains the same as in **Figure 8.40A**.

Saturation

Many photographers have always been attracted to the saturated colors of Kodachrome or Velvia. Think of Saturation as your Kodachrome or Velvia adjustment tool. The Saturation Slider gives you the option of reproducing that look and feel. Moving the slider to a value of −100 makes a monochrome image. Moving the slider to a value of +100 doubles the saturation. Be aware that too much saturation can be a bad thing. If you increase the saturation value to a very high number, you are likely to create out-of-gamut colors (**Figure 8.41**)

(A)

(B)

FIG 8.40 Using the Vibrance slider

(A)

FIG 8.41

(B)

FIG 8.41 Using the Saturation slider

The Tone Curve Panel
Tone Curve Controls

The Tone Curve Controls tool (**Figure 8.42**) is perhaps the most powerful and flexible image manipulation tool in Lightroom. The tone curves affects tones and contrast. Similar to Photoshop levels, curves can take input tones and selectively stretch or compress them. Unlike levels however, which only has black, white and midpoint control, a tonal curve is controlled using any number of anchor points. The key concept with tone curves is that you can redistribute contrast. These are controlled with Highlights, Lights, Darks and Shadows and refer to:

Highlights: The brightest points of the image.

Lights: From the midtones to the highlights.

FIG 8.42 The Tone Curve Panel

Darks: From the midtones to the shadows.

Shadows: The darkest points of the image.

So if I want to bring down or control my brightest tones in an image, I would concentrate my efforts on the Highlight Slider. Being able to work on essentially four different tonal ranges of the image independently gives you a tremendous amount of versatility and control. Each of the controls in the Tone Curve Panel is contributing to the shape of the final curve applied to your image.

The histogram in the Tone Curve Panel represents the range of values you define when you set your black and white point.

Under the Histogram you will find three sliders, which give even more control over the range of the area that you are working on. You can narrow or broaden the range of tones affected by the curve by expanding or contracting the area of the curve. As you move through the Tone Curve, you will see the corresponding parts of the image made active in the panel.

The coolest thing in the Tone Curve Panel is the Targeted Adjustment Tool. Click on the Targeted Adjustment Tool and move it into the area(s) of the image you want to adjust. Then mouse down and use the up and down arrow keys to open up or close down that area of the image. This will be reflected in the Tone Curve. In **Figure 8.43** we have selectively toned down the Highlights and the Darks. **Figure 8.44**, on page 178, shows the before and after.

FIG 8.43

FIG 8.44 A before and after using the Tone Curve

Point Curve
You can apply varying degrees of an S Curve, using the Point Curve Tool. You can choose from Linear, Medium Contrast or Strong Contrast.

Tone Curve Workflow Tip: *Drag the curve and histogram to make adjustments.*

The HSL/Color/Grayscale Panel
At first glance the Color Adjustment Panels seem a bit intimidating but they actually make a lot of sense after you play with them for a little while. This panel fine tunes Hue, Saturation and Luminance on individual channels. Hue changes the color of the chosen channel. Saturation intensifies or reduces the color. Luminance changes the brightness of the color channel.

This panel also has a Targeted Adjustment Tool so that you can mouse down on any area of an image and using your arrow keys, adjust that specific area in the specific channels that are being affected in Hue, Saturation or Luminance.

Hue
The Hue Sliders control color balance. There are six sliders and each slider will produce an effect on that particular hue. There are separate sliders for altering the hue, saturation and lightness of the reds, yellows, greens, cyans, yellows, and magentas in your image. As an example if you use the Yellow slider, moving it to the right

will make the yellows greener and moving it to the left will make the yellows more red.

Saturation

The Saturation Sliders control the amount of saturation for each hue. Moving them to the right increases saturation and moving them to the left decreases saturation.

Luminance

The Luminance Sliders will darken or lighten colors. Moving them to the right will lighten and moving to the left will darken.

HSL and Color do the same thing, just have a different display. Color does not have a Targeted Adjustment Tool.

HSL/Color Demo

In the images below, we wanted to create the look of a polarizing filter on the sky. We increase the chroma of the blue sky, and increase the saturation of the sky, and lower the luminance of the sky.

(1) In **Figure 8.45** we start by putting the Targeted Adjustment Tool on an area of the blue sky. We choose Hue and bump it up to +15 using the up arrow tool.

FIG 8.45 Using the HSL sliders

(2) In **Figure 8.46** we switch to Saturation and bump up Blue Saturation to +69 using the up arrow key.

(3) In **Figure 8.47** we switch to Luminance and knock down the Blue Luminance using the down arrow key to −78 and the Aqua to −2.

FIG 8.46

FIG 8.47

(4) In **Figure 8.48** we do a comparison of where we started and we can see that the effect is very similar to using a Polarizing Filter.

FIG 8.48

Grayscale Mix

Selecting Grayscale activates the Grayscale Panel. The default Grayscale setting applies an Auto adjustment that is based on the current White Balance Temperature and Tint settings. This default conversion is a good starting point to work from, as shown in **Figure 8.49**.

(A)

(B)

FIG 8.49 Using Grayscale Mix

Once you get familiar with the Grayscale Mix Panel you will be able to create custom grayscale conversions by mixing with sliders for

all the color channels. This panel also has a Targeted Adjustment Tool, which works great! You can create any black and white effect you have ever dreamed of.

The Split Toning Panel

Using the split toning controls on images after they have been converted to monochrome allows you to add some color to the image. You can independently control the hue shift and saturation of Highlights and Shadows. The Hue Sliders adjust the hue and the Saturation Sliders can be used to apply varying degrees of color tone. The Balance Slider balances the effect between the Highlights and the Shadows. A positive number on the Balance Slider increases the effect of the Highlights Slider, while a negative number increases the effect of the Shadows Sliders.

This tool is useful for creating Black and White effects such as Sepia, Brown Tone, Warm Tone, Cool Tone, etc. These adjustments can be saved as a Custom Preset and used again later. You can create your own 'look' to use over and over again. Of course you can do this on color images as well allowing you to warm highlights and cool shadows.

Using Split Toning

1. Hold the option button down, and mouse down on hue.
2. If you drag the slider back and forth, you will see the hue change. Find a hue you like for the highlights and release the mouse.
3. Now go to the Saturation Slider, starting at 0.
4. Drag the slider to the right until you have the appropriate saturation of the hue.
5. Do the same thing for the shadows (**Figure 8.50**).

The Detail Panel
Sharpening
The Detail Panel in Lightroom allows you to sharpen using Amount, Radius, Detail and Masking with the use of sliders. The detail panel also incorporates Noise Reduction and Chromatic Aberration.

The Sharpening Panel has a default set for raw file processing because most raw files need some degree of sharpening. We'll explain why.

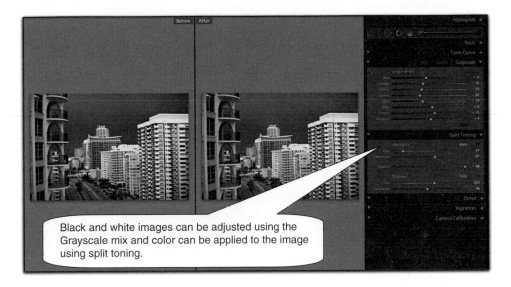

Black and white images can be adjusted using the Grayscale mix and color can be applied to the image using split toning.

FIG 8.50

When photons are digitized to pixels, sharpness is lost because regardless of how large the sensor is, pixels are sampled as a fixed grid of graytones that mimic the continuous graduations of color perceived by the human eye into shape-specific pixels. This process of digitalization is accomplished by reconstructing data at a 'frequency' that produces aliasing or nonalignment. Hence, most cameras today deploy an anti-aliasing filter that eliminates the highest frequency detail. The net effect is the detail rendered appears soft. So digital photographs look soft because of the very nature of pixel. For this reason we typically want to capture sharpen-defining basic focus restoring any sharpness that was lost in the capture process.

The Sharpening Default for Lightroom is:

- Amount 25
- Radius 1.0
- Detail 25
- Masking 0

When sharpening, it is critical to set the zoom level to 100% or greater in order to view the effects of the sharpening controls. A general rule when doing sharpening is to sharpen pixels without adding any ugly artifacting. New in Lightroom 2.0 is a magnification window right in the Sharpening Panel. You can click

on the little button in the upper left-hand corner and wherever your cursor moves will be magnified in the window. A mouse click locks the focus on a specific point (see **Figures 8.51** and **52**).

FIG 8.51 Locking the focus for Sharpening

FIG 8.52 Locking the focus for Sharpening

Sharpening Different Types of Images

Most images tend to be either high frequency or low frequency. High-frequency images are highly textured and detailed, and low-frequency images have less texture and detail. Faces are a good example of low-frequency images and a close-up of a text on a soda can would be a good example of high-frequency detail.

There are two Sharpening Presets that come with Lightroom. One is a preset for Portrait work and one is a preset for Landscapes. These are both very good starting points. You may find them satisfactory, or you may want to create your own sharpening custom preset.

Portrait Preset Applied

Notice in **Figure 8.53**, that the skin is smooth while the eyes are sharp. When the Landscape Preset is applied to the same image, **Figure 8.54**, there is noticeable difference. You can see the hair in detail across the face, and blemishes are emphasized. Everything is very sharp, too sharp for this type of image.

FIG 8.53 Sharpening Portrait Preset Applied

FIG 8.54 Landscape Preset Applied

Landscape Preset Applied
(**Figure 8.54**)

How to Sharpen

When we see an image we see the whole image, but the digital image is really comprised of pixels with a distinct shape. When enlarged they can be viewed as blocks.

The edges of these blocks are both light and dark. Sharpening essentially makes the edge of the lighter block a lighter value and the edges of a darker block darker (**Figure 8.55**).

FIG 8.55

Amount: The Amount regulates how aggressive the sharpening will be by controlling edge definition. With the Amount set to 0 (0 turns off sharpening) the edges will be less prominent and as the amount is increased the edges will get more exaggerated. The light lines will get lighter and the dark lines will get darker. This adjustment locates pixels that differ from the surrounding pixels and increases contrast.

Amount Workflow Tip: Press Alt (Windows) or Option (Mac OS) while dragging this slider to view the sharpening on a grayscale preview which may make it easier to see (**Figures 8.56** and **8.57**).

FIG 8.56 Sharpening Amount slider

FIG 8.57 Sharpening Amount slider

Radius: The Radius determines how wide an area is affected by the sharpening. An amount between .8 and 1.8 is generally useful. Using a higher radius may cause halos at the edges. Landscapes generally use the more radius and portraits generally use less. The amount really depends on the detail of the image. Very fine details need a smaller radius. Using too large a radius will generally result in unnatural looking results.

Radius Workflow Tip: Press Alt (Windows) or Option (Mac OS) while dragging this slider to preview the radius effect in grayscale on edge definition (**Figures 8.58** and **8.59**).

FIG 8.58 Sharpening Radius slider

FIG 8.59 Sharpening Radius slider

Detail: The Detail Slider adjusts the quantity of high-frequency information sharpened and how much suppression is applied to the edges to counter halos. Lower settings primarily sharpen edges to remove blurring. Higher values are useful for making the textures in the image more pronounced. When detail is at 100 there is no halo suppression, and when it is at 0 there is total halo suppression.

Detail Workflow Tip: *Press Alt (Windows) or Option (Mac OS) while dragging this slider to view the sharpening on a grayscale preview which may make it easier to see (****Figures 8.60*** *and* ***8.61****).*

FIG 8.60 Sharpening Detail slider

FIG 8.61 Sharpening Detail slider

Masking: Masking sets how much of a mask will be applied to the edges. The Edge Masking amount (which you can preview by holding the option/alt key) goes from 0 where it's hitting ONLY edges to 100 where there is no edge preservation. At zero, everything in the image receives the same degree of sharpening. At 100, sharpening is mostly restricted to the areas near the strongest edges.

*Masking Workflow Tip: When you hold down the Option/Alt key and drag the slider the white areas will be sharpened and the black areas will be masked (**Figures 8.62** and **8.63**).*

FIG 8.62 Sharpening Masking slider

FIG 8.63 Sharpening Masking slider

D-65's Suggested Starting Point for Sharpening
D-65 has found that as general rule for all images, as a medium ground starting point:

- Amount is between 25 and 50
- Radius is between .8 and 1.8

- Detail 25–65
- Masking between 15 and 30
- With Landscapes we would want less masking and with portraits more masking.

Noise Reduction

Noise is an inherent issue with digital cameras and long exposures. Noise can only be eliminated at the sensor level. After capture noise can be masked to be less noticeable. The need to adjust Luminance Smoothing and Color Noise Reduction depends on the specific camera model. Shooting at the optimum ISO may eliminate the need to adjust these values for many cameras. Also some of the new cameras like the Canon 1DSM111 and the Nikon D3 really do a phenomenal job of reducing or eliminating noise at the sensor level.

There are two kinds of noise, luminance noise and color noise. Luminance noise makes an image look grainy on screen and looks monochromatic. With today's cameras, shooting at a low ISO should reduce most luminance noise. Luminance Smoothing reduces noise in the darker tones, which usually result from shooting at a high ISO value. To reduce luminance noise, slide the Luminance Smoothing Slider to a higher value. Be aware that adjusting the Luminance Smoothing Slider may impact image sharpness.

Color noise is visible as random red and blue pixels. Color Noise Reduction reduces the random green and magenta bits in the shadows and highlights of the image. To reduce color noise, slide the Color Noise Reduction Slider until the noise is eliminated from the image.

Noise is not grain and should not be confused as such. Grain can be beautiful, but an image filled with noise is usually not that pleasing to the eye. Noise reduction can present a bit of a dilemma. Removing luminance noise reduces the sharpness of the image and removing the color noise damages some of the correct color. There is no perfect noise reduction. Something is always sacrificed so noise reduction becomes a balance between how much softness and color damage you can tolerate, and how much noise you want to remove.

Lightroom's Noise Reduction masks the effects of noise, while maintaining image detail. To judge noise you typically want to look

at the shadows and make sure that you are at 100%. Some images may contain both color noise and luminance noise. When working on the Luminance channel, you can quickly compromise image detail so remember the trick is to reduce noise without losing too much image detail.

Figure 8.64A illustrates color noise in the shadows of this night shot. We adjust the Color Slider and in **Figure 8.64B** we have significantly removed or rather 'masked' the noise.

(A)

(B)

FIG 8.64 Noise Reduction

While reducing noise is adequate in Lightroom, D-65 suggests for high noise levels, a third party product, called ImagenomicNoiseware.

Chromatic Aberration

Chromatic Aberration is caused from the lens focusing colors of light as different frequencies. Each color is in focus but at a slightly different size, and that results in color fringing. The results of these lens defects are enhanced in digital cameras, and in the long term we need better lenses manufactured.

Red/Cyan: Adjusts the size of the red channel relative to the green channel. This compensates for red/cyan color fringing.

Blue/Yellow: Adjusts the size of the blue channel relative to the green channel. This compensates for blue/yellow color fringing.

DeFringe: You have choices of highlight edges, all edges or off.

In **Figure 8.65A** there is magenta fringing occurring on the top edge of this iceberg. By using the Red/Cyan slider in the Chromatic Aberration Panel we can significantly reduce the fringing as seen in **Figure 8.65B**.

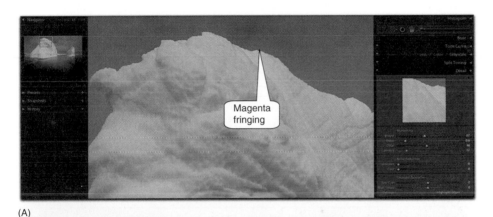

(A)

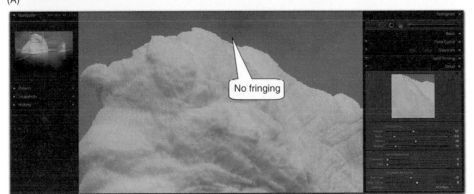

(B)

FIG 8.65 Chromatic Aberration sliders

You may need to zoom in to 100% to see fringing. You are most likely to see fringing when you have something light against a darker background and the fringing will occur along the edge.

The Vignettes Panel
Lens Correction and Post-Crop

Lens Vignetting is fairly common with many wide-angle lenses and Lightroom can help to reduce it. Vignetting can also be used as a creative tool (**Figure 8.66**). Moving the Amount Slider to the right lightens the corners of the image and moving the slider to the left darkens the corners of the image. So negative numbers darken, positive lighten. The midpoint controls how far from the edge the effect begins. In **Figures 8.67** and **8.68** we attempt to remove lens vignetting at the bottom left and right corners of the image. The Post-Crop vignette does the same thing but only on the cropped area of your image.

FIG 8.66 Vignettes Panel

FIG 8.67 Using the Vignettes Panel

FIG 8.68 Using the Vignettes Panel

The Camera Calibration Panel

Camera calibration is probably one of the most misunderstood, cool functions of the Develop Module. Many folks will never use this because they really don't understand what they are missing. Most people assume that the way they see the image on the back of the Camera LCD is correct, but is it really correct?

A Canon rendering of a file is different from a Nikon rendering and both are different from Lightroom, Aperture, PhotoMechanic and any other Raw Image Processor. Different, yes, but not necessarily any more correct. The color you see on the LCD on the back of the camera is your first impression of your image, so the brain assumes it is accurate. In reality that LCD rendering is composed of a low-res sRGB display. It's not accurate color of the raw data captured within the image file.

Another factor to consider is cameras can vary a lot in color response from camera to camera. Each and every chip is slightly different, so even two of the same make and model cameras may have a slightly different look.

For each camera raw format that is supported, Thomas Knoll created two profiles, which measure the camera sensors under both tungsten and controlled daylight. This is the default for how your camera's files are rendered in Lightroom. If Thomas's renderings don't suite your fancy, you can alter them and this is

where Lightroom's Camera Calibration Panel comes into play (**Figure 8.69**).

FIG 8.69 Camera Calibration Panel

The Camera Calibration Sliders can be used to make fine-tuned adjustments to the camera's color response. So two or more cameras can be made to look alike. If your camera is a little magenta or a little green it can be corrected. Camera Calibration makes it possible to have the look of Kodachrome, Infrared or even the look of Canon DPP, Nikon Capture or even the rendering an individual photographer, like a 'Jay Maisel look'.

You can create a custom profile by adjusting the sliders in this panel to create any 'look'. To take this idea further, suppose you were working for a clothing company and it was critical that the color in the photographs truly matched the color of the clothing. If you really want to take this up a notch visit: http://fors.net/chromoholics/. Thomas Fors has written a script that builds a profile for your camera. You photograph an X-Rite ColorChecker and the script adjusts each patch on the Color Checker for your camera. This allows your camera to produce a file as close to a perfect white balance as possible.

Additionally with the release of Lightroom 2.0 Adobe has released new beta camera profiles for Camera Raw 4.5 and Lightroom 2.0 as well as a beta of the new application called DNG Profile Editor for editing DNG profiles. The betas of the profiles and the editor app are on Adobe Labs at http://labs.adobe.com/wiki/index.php/DNG_Profiles. The concept of the profile editor is improving color rendering for raw digital images. There are Adobe Standard camera profiles that significantly improve color rendering, especially in reds, yellows, and oranges as well as Camera Matching profiles that match the camera manufacturers' color appearance. There is also a DNG Profile Editor, a free software utility for editing camera profiles.

The Camera Calibration Panel also has a drop down where you can save specific looks that you create, or that are created by third parties (see **Figure 8.70**).

FIG 8.70 Using custom looks in the Camera Calibration Panel

Camera Calibration Workflow Tip: In the 'Camera Calibration' Panel choose your preferred profile from the Profile menu. Then hold down the Alt/Option key. The 'Reset' button in the lower right turns into a 'Set Default...' button. Click it. Now all new images for this camera will use your chosen profile.

The Presets Panel
Moving over to the left-hand side of the Develop Module, located underneath the Navigator is the Presets Panel. Lightroom comes with several Develop Presets. A Preset is a combination of Develop Settings that are already saved that you can apply to one or more images. Scroll over a Lightroom Preset and view what the adjustment will look like on the image in the Navigator. If you want to apply that Preset, just click on it. This will sync those Preset Develop Settings to your image.

User Presets
Lightroom comes with several Develop Presets, but you can also create your own Custom Presets. These Custom Presets offer a way to save a group of Develop Settings and apply them to other images. Once saved, Presets will appear in the Presets Panel under

User Presets. They will also appear in the list of options for Develop Settings when you import photos (**Figure 8.71**).

You can scroll over a preset and preview what the image will look like, like the Sepia preset shown here.

You can create a new preset by clicking on the + button and delete them using the − button.

FIG 8.71

Why Save a User Preset?

There are some adjustments that we would like to apply to every image we process. These are called 'global changes'. For example, we shoot with several Canon 1DS Mark111's and even though the color temperature may be set the same on two cameras the results are slightly different because no two sensors are exactly the same. On one camera shooting on cloudy produces 6400K and on the other it produces 6350K. To create consistency between cameras we create a global setting of 6500K, the traditional industry standard for cloudy and apply that to all files shot on the cloudy setting.

Presets can also be used to create a certain 'look'. We personally have always liked the look of saturation from Kodakchrome film. Another preset we've created is called Seth Kodachrome which simulates Seth's interpretation of a memorable case of Kodachrome. These presets can be applied in the Develop Module, and also on files being imported into Lightroom. D-65 suggests saving any develop setting or adjustment that you may want to use again in the future, as a User Preset.

Creating a User Preset

We create a Preset that we use over and over again on Import to all of our daylight images.

This Preset does the following:

- Color temperature to 6500K
- Tint to +10
- Blacks to 3
- Clarity +50
- Vibrance +25
- Saturation +17
- Sharpening: Amount 40, Radius .8, Detail 50, Masking 35
- Color Noise Reduction to 20

1. To create this Preset, make the above changes in the Develop Module to an image that is at camera default.
2. Click on the plus (+) sign next to Presets on the left-hand side to open the New Develop Preset dialog box.
3. Check the settings that correspond with the develop settings we are saving.
4. The Preset is given a name of SETH KODACHROME.
5. After this we choose create from the lower right-hand corner of the presets dialog box (see **Figure 8.72**).

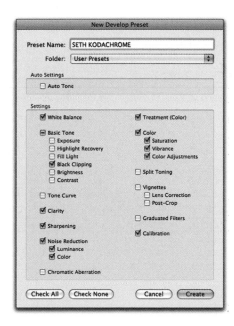

FIG 8.72 Creating a Develop Preset

New user preset

FIG 8.73

6. After naming and saving our Preset, it appears under User Presets, as shown in **Figure 8.73**. This preset can even be applied to images in the future as they are imported, as shown in the Import dialog box under Information To Apply > Develop Settings in **Figure 8.74**.

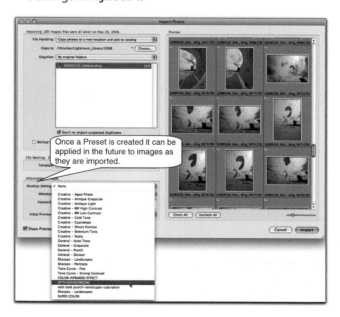

Once a Preset is created it can be applied in the future to images as they are imported.

FIG 8.74

The History Panel

History saves all develop adjustments as a state. The History Panel will list any develop preset that was applied at import, and also lists all future develop adjustments as they are done. These are listed in a chronological order within the History Panel. You can go forwards and backwards in History by rolling over a state and you will see the preview in the Navigator. You can even copy and paste states to other images. As you make these changes, they are recorded in the History Panel. Any time you want to compare a previous interpretation, or return to one, just click on that state in the History Panel and you're right there (**Figure 8.75**).

FIG 8.75 The History Panel

The Snapshots Panel

The Snapshots Panel is located right above the History Panel. Snapshots are basically saving specific steps of History that you might want to go back to on an image. When the History List becomes too long, you can create a Snapshot to save a specific state. This allows you to go back to a state in History, once it has been cleared.

Technically the Snapshot Function is used to perform a sequence of steps in the Develop Module similar to an action in Photoshop that can be stored as a single step. Snapshots can be used to store your favorite history states as a saved setting. Rather than use the

History Panel to wade through a long list of history states, it is often more convenient to use Snapshots. Some folks simply prefer to use Virtual Copies instead of Snapshots but the choice is yours. To create a Snapshot, click on the History state you want to save for an image. Then click on the plus button next to the Snapshots Panel. Name the Snapshot and click off the field. You can delete Snapshots with the – button. **Figure 8.76** shows the Snapshots Panel.

FIG 8.76 The Snapshots Panel

In **Figures 8.76–8.79** we have three Snapshots. We have our one view in the main window and are going through the various sequences of Develop adjustments which have been saved as Snapshots.

Before/After Workflow Tip: *When you edit an image in one of the Before/After viewing modes, you can make umpteen adjustments and at any time compare the 'After' with the 'Before'. The problem is that you are always comparing back to the original state. A neat way*

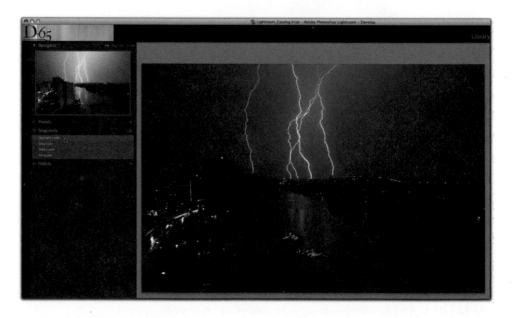

FIG 8.77 Before and After using Snapshots

FIG 8.78 Before and After using Snapshots

FIG 8.79 Before and After using Snapshots

to compare to the last state is by clicking on the Copy settings from the After photo to the Before photo. This will update the 'Before' with the 'After'. This is very much like creating a snapshot of the settings allowing you to make further adjustments and compare these with the latest version.

Summary

Adjustments to images made in Lightroom's Develop Module are done with a very new approach, Parametric Editing. While Photoshop has a mix of destructive and nondestructive editing features all the edits you make in Lightroom are nondestructive. A nondestructive edit doesn't alter the original pixels in your image.

The big advantage of nondestructive editing is that you can undo any edit at any time, and in any order, and you can go back and change the parameters of any edit at any time keeping the history of a file even after the file is closed. Once you get used to the nondestructive editing system in Lightroom, it will be hard to go back to a destructive system.

The Develop Module holds all the controls that you need to adjust images. It is D-65's 'tweaking command central'. The image processing engine used in Lightroom is Adobe Photoshop Camera Raw, which ensures that digital raw images processed in

Lightroom are fully compatible with Camera Raw and vice versa. Synchronization, Exposure, Shadows and White Balance will seem very familiar, plus there is tons of added new functionality.

Localized Adjustments are the greatest change in Lightroom 2.0. Up until now corrections were global meaning that they affected the entire image. Lightroom 2.0 provides localized corrections with a paint brush. You can now paint on adjustments. These include: Exposure, Brightness, Contrast, Saturation, Clarity, Sharpness and Tint. The way it works is through the use of masks. You paint a mask and fill it with an adjustment and it is all nondestructive.

Discussion Questions

(1) Q. What do the left and right sides of the Histogram represent in the Develop Module?

A. The Histogram in Lightroom is showing three layers of color representing the red, green and blue channels. The left side of the histogram represents pixels with 0% luminance (black) while the right side represents pixels with 100% luminance (white).

(2) Q. What is a Localized Adjustment and what Localized Adjustments can be achieved in Lightroom?

A. A Localized Adjustment is an adjustment to a part of the image rather than to the entire image which would be a global adjustment. Lightroom provides Localized Adjustments with a paint brush. You can now paint on adjustments. These include: Exposure, Brightness, Contrast, Saturation, Clarity, Sharpness and Tint. The way it works is through the use of masks. You paint a mask and fill it with an adjustment.

(3) Q. What are the two ways to straighten an out of kilter horizon in Lightroom?

A. Moving down on the Straighten Slider and dragging it to the right or left will straighten out your image in live time using a grid to align the horizontal or vertical access or you can use the Straighten Tool which works by grabbing it from the toolbar, moving down, and dragging the ruler into the image, drawing a line along the path you want to straighten. You can also use alt to show a grid.

(4) Q. Is it possible to remove dust spots in your image in Lightroom?

A. Yes, you can use one of two tools to accomplish the task. In Lightroom's Develop Module Clicking on the Remove Spots Button give you the options of Clone/Heal and a Spot Size Slider and Opacity. There is a difference between the cloning and healing tools. Cloning applies the same sampled area to a different area – it is an exact duplicate of what you are selecting. Healing matches texture, lighting and shading from the sampled area to the selected area you are correcting.

(5) Q. What do Size, Feather and Flow work control when using the brush in localized corrections?

A. Size controls the diameter of the brush. With a large Feather you get a softer gradation and Flow is the strength at which the tool is working, somewhat like opacity.

(6) Q. How do you subtract from a mask created with Localized Corrections?

A. When you complete a task you can hover over the 'pin' and check the mask or press O. Holding down the alt key will allow you to subtract from the mask.

(7) Q. What is White Balance?

A. White balance indicates the color of the light under which the image was captured. The default value is the white balance at which the image was captured 'As Shot'.

(8) Q. What is the proper patch to use on an X Rite ColorChecker for White Balance?

A. Using the second patch from the bottom right on the checker will provide the correct white balance.

(9) Q. Why is it a bad idea to underexpose in digital to hold highlights?

A. Underexposing to hold highlights when using digital capture is generally a bad idea. You will lose dynamic range, and there will be a tendency to induce posterization when the image is lightened. An ideal exposure has specular highlights just at the point of clipping.

(10) Q. What does Fill Light do?

A. Fill Light gives the ability to pull added detail out of the shadows without affecting the rest of the image. It really does work as if a fill light was added to the scene.

(11) Q. What slider do you use to control the midtones?

A. The Brightness Slider adjusts the midtones. This adjustment compresses the highlights and allows you to visually manipulate how bright or dark an image appears. Large changes in brightness will also effect shadow and highlight clipping.

(12) Q. What does Clarity do?

A. Clarity is a mid-tone contrast adjustment tool. It will give your images extra punch. Clarity adds depth to an image by increasing local contrast.

(13) Q. What is the difference between Vibrance and Saturation?

A. Vibrance increases the saturation in a nonlinear or nonequal manner, meaning lower saturated values are increased more than high saturation values. Saturation does an across the board saturation increase regardless of what the current saturation value is. Vibrance is particularly useful in adjusting colors that would otherwise be clipped and as they become fully saturated. It constrains the colors that would become out-of-gamut with printing. It is excellent for adjusting skin tones because it creates saturation without the skin tones going magenta.

(14) Q. What do Hue, Saturation and Luminance do in the HSL Panel?

A. The Hue Sliders control color balance. There are six sliders and each slider will produce an effect on that particular hue. There are separate sliders for altering the hue, saturation and lightness of the reds, yellows, greens, cyans, yellows, and magentas in your image. As an example if you use the Yellow slider, moving it to the right will make the yellows greener and moving it to the left will make the yellows more red.

The Saturation Sliders control the amount of saturation for each hue. Moving them to the right increases

saturation and moving them to the left decreases saturation.

The Luminance Sliders will darken or lighten colors. Moving them to the right will lighten and moving to the left will darken.

(15) Q. What does Split Toning do?

A. Using the Split Toning controls on images after they have been converted to monochrome allows you to add some color to the image. You independently control the hue shift and saturation of Highlights and Shadows. The Hue Sliders can be used to adjust the hue and the Saturation Sliders can be used to apply varying degrees of color tone. The Balance Slider balances the effect between the Highlights and the Shadows. A positive number on the Balance Slider increases the effect of the Highlights Slider, while a negative number increases the effect of the Shadow Sliders. You would use this to create Black and White effects such as Sepia, Brown Tone, Warm Tone, Cool Tone, etc.

(16) Q. What are high-frequency images?

A. Most images tend to be either high frequency or low frequency. High-frequency images are highly textured and detailed, and low -frequency images have less texture and detail. Faces are a good example of low - frequency images and a close-up of a text on a soda can is a good example of high-frequency detail.

(17) Q. What does Detail control in the Sharpening Panel?

A. The Detail Slider adjusts the quantity of high-frequency information sharpened and how much suppression is applied to the edges to counter halos. Lower settings primarily sharpen edges to remove blurring. Higher values are useful for making the textures in the image more pronounced. When detail is at 100 there is no halo suppression, and when it is at 0 there is total halo suppression.

(18) Q. What are two kinds of noise present in digital images and what are the differences?

A. There are two kinds of noise, luminance noise and color noise. Luminance noise makes an image look

grainy on screen and looks monochromatic. Luminance Smoothing reduces noise in the darker tones, which usually result from shooting at a high ISO value. Color noise is visible as random red and blue pixels. Color noise reduction reduces the random green and magenta bits in the shadows and highlights of the image.

(19) Q. What does the Calibration Panel do and why would you want to use it?

A. The Camera Calibration Sliders can be used to make fine-tuned adjustments to the camera's color response. So two or more cameras can be made to look alike. If your camera is a little magenta or a little green it can be corrected and what is totally cool is that Camera Calibration makes it possible to have the look of Kodachrome, Infrared or even the look of Canon, Nikon or an individual photographer. You can also choose profiles built specifically for RAW files produced by your camera as well as allowing you to create your own profiles.

(20) Q. Why save a Develop Preset?

A. There are some adjustments that we would like to do to every image we process. We call these 'global changes'. We create a Develop Preset that we use over and over again and can even apply on import.

(21) Q. What does the History Panel show and do you lose the history after you finish tweaking a file?

A. History saves the all develop adjustments as a state. The History Panel will list show any develop preset that was applied at import and also lists all future develop adjustments as they are done. These are listed in a chronological order within the History Panel. You can go forwards and backwards in History by rolling over a state and you will see the preview in the Navigator. Unlike Photoshop History is not lost when the file is closed.

(22) Q. What is a Snapshot and when would you use it?

A. You can create a Snapshot to save a specific state. This allows you to go back to a state in History, once it has been cleared. Snapshots are basically saving specific

steps of History that you might want to go back to on an image. Technically the Snapshot Function is used to perform a sequence of steps in the Develop Module similar to an action in Photoshop that can be stored as a single step. Snapshots can be used to store your favorite history states as a saved setting. Rather than use the History Panel to wade through a long list of history states, it is often more convenient to use Snapshots.

Global Corrections and Synchronizing Develop Settings

We have seen what all the buttons and controls in the Develop Module can do, and the power of parametric editing. One of the keys to using Lightroom is to adjust an image in the Develop Module and apply those changes to individual or groups of images. This is known as synchronizing settings or 'sync'. This really makes the work flow with Lightroom.

Let's go ahead and adjust an image and then synchronize the settings from one image to a group of others that are similar. There are two things that are really important to keep in mind as you set out to tweak your images. First, Lightroom is so good that you may be inclined to start fixing bad images. This is not efficient workflow.

If you waste all your time trying to fix bad images, you will slow down your workflow. If an image is poor to begin with, move on. Second, try and assess what you want to do to an image before you start working on it. You can always find more areas to adjust but again the goal is workflow. If you just keep playing without an end in mind, you will again be wasting time and slowing your workflow.

Adjusting an Image in the Develop Module

We have a group of images that were shot on a hot hazy afternoon. The image in **Figure 9.1** is the first of the series. What can we do to make it and the group of images more appealing?

FIG 9.1 Adjusting an image in the Develop Module

1. The first thing we can do is to add clarity and a bit of vibrance. This will give a little punch to the image. (**Figure 9.2**)
2. We select the White Balance Selector tool and click on an area that has white with detail as a starting point, as shown in **Figure 9.3**.

FIG 9.2 Adding Clarity and Vibrance

FIG 9.3 White Balancing the image

3. In **Figure 9.4** we bump exposure to plus .40 and increase blacks to 11 to add contrast. We then add some overall saturation to plus 16.

FIG 9.4 Increasing exposure and blacks

4. In **Figure 9.5** we have increased blue hue to make the sky a little more blue and increased both blue and red saturation to pump them up a bit. We lower the luminance of both blue and red to

FIG 9.5 Using HSL

darken them a bit and make them more pronounced. Finally, we sharpen the file using Landscape Preset in the Develop Module.

Synchronizing Develop Settings between Multiple Images

1. At this point we have done a pretty good job with global corrections on this image. Now we want to sync these settings to other similar images.
2. First select the image that we just worked on (or want to sync to) in the Filmstrip of the Develop Module. Then, select the images we want synced with that adjusted image as shown in **Figure 9.6**. ALWAYS select the adjusted image first and then select other images to sync to.

FIG 9.6 Selecting images in Filmstrip for Synchronizing Develop Settings

3. Choose Sync at the bottom of the Develop Module (**Figure 9.7**).
4. After we choose Sync, the Synchronize Settings dialog box appears. **Figure 9.8** is an example of the Synchronize Settings dialog box. We choose just the settings we want to sync and click on Synchronize. You can sync all the adjustments, or any part of the adjustments to other image(s).

FIG 9.7 Sync button

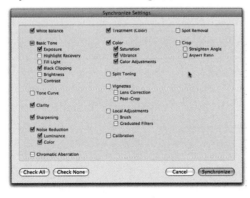

FIG 9.8 Synchronize Settings dialog box

5. After you synchronize, a dialog box appears showing that the image chosen is being synchronized to the selected images (**Figure 9.9**).

FIG 9.9 Synchronize progress dialog box

213

6. The Filmstrip will display the Develop settings being applied to the images, as shown in **Figure 9.10**.

FIG 9.10

Other Options Available When Adjusting Images in the Develop Module

Copy/Paste Buttons

You can adjust one image and choose Copy on the left-hand side of the toolbar, and then select another image(s) and choose Paste (also on the left-hand side of the toolbar). This will apply the Develop settings from one image to the newly selected images.

Sync Button

You can adjust one image and then choose another image(s) and choose Sync from the right-hand side of the toolbar. The Synchronize Settings dialog box will pop up. You can choose to synchronize all the settings by selecting Synchronize. If you want to synchronize a component or any combination of the settings, for example, a crop, but no color adjustments, then you could uncheck any of the boxes that you didn't want to synchronize. This is our favorite way of working and the one we demonstrated above.

Previous Button

Choosing Shift command on the Sync button will change it to the Previous button. This allows you to sync or copy settings from the last adjusted image to a new image, without having the prior image selected.

Reset Button

The Reset button takes the image back to camera default – the way it was shot without any develop settings.

Auto Sync

Command clicking on the sync button will change it to Auto Sync. Auto Sync bypasses the Synchronize dialog box. It is critical

to know that what was checked in the Sync dialog box the last time you used it before choosing this option, because all of those settings will be synchronized. Local corrections cannot auto sync.

Set Default

The option of clicking on Reset sets a new default. This will allow you to change the basic default develop settings. For example, you may want black to be 0 instead of 5. Lightroom and Camera Raw support the saving of user-defined Develop settings on the basis of camera model, serial number and/or ISO rating.

Reset Adobe

Shift clicking on Reset sets to the default Adobe settings.

Summary

Lightroom can significantly increase your workflow by decreasing the time needed to tweak your files. Don't waste time on bad images but rather concentrate on improving your good images. Analyze your images and decide what it is that you want to accomplish before you start playing in the Develop Module.

Look at groups of images that are similar and take advantage of the ability to synchronize the settings from one image to another group of images. You can sync all or just some of the develop settings.

Discussion Questions

(1) Q. Describe the basic steps for synchronizing an image to another group of images.

A. Select one image in the Develop Module of Lightroom and make changes to that image. With the image selected in the Filmstrip of the Develop Module, select other images that you want to apply the changes to. Now choose Sync in the bottom right-hand side of the Develop Module. Choose what settings you want to sync in the Sync dialog box and choose OK.

(2) Q. If we don't like the Adobe defaults, can we set your own?

A. Yes, you can make the adjustments you want to have as a default on one image, and choose Set Default by option clicking on the Reset button.

The Slideshow Module

Slideshow Module

The Slideshow Module in Lightroom offers an elegant way to assemble your images for a slideshow presentation. Slideshows can be used as a way to deliver images to clients, show your portfolio or even show your friends and family your favorite images.

The Slideshow, Print and Web modules all work relatively in the same fashion. The left panels contain a list of templates and collections along with a preview of each template. The center view displays the images. The toolbar contains controls for playing a preview of the slideshow and adding text to the slides. The right panels provide the controls for specifying how the images appear.

217

Slideshows can be created directly in Lightroom, and can include music from your iTunes Library and played from your computer, or the slideshow can be exported as PDF. If exported as a PDF, one can take advantage of everything that PDF offers, including password protection for viewing, opening, editing and/or printing. One new feature in 2.0 is the ability to Export to JPEG. This allows you to make slideshows to your own specs using any third-party slideshow product.

Creating a Slideshow

Select your images for a slideshow in the Library Module and click on the Slideshow Module. If you have Collections, they will be available directly from within the Slideshow Module on the left side Collections panel. We'll go through all the options available in this module (Figure 10.1).

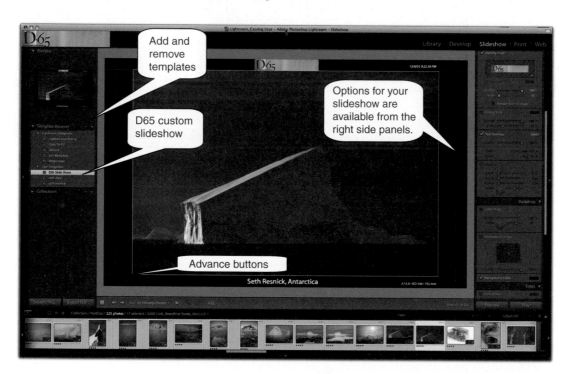

FIG 10.1　Slideshow Module Main Window

Slideshow Workflow Tip: *If you want to create a slideshow using images from multiple folders, then create a Quick Collection of those images and make the slideshow from that batch.*

Template Browser

Various presets and custom slideshows can be saved and will be available in the Template Browser. As you roll over the presets, you can get a preview of how the slideshow will look in the Preview Window. User-created custom slideshow presets will appear in the User Templates. D-65 has created a custom preset with our logo, filename and the EXIF metadata (Figure 10.2).

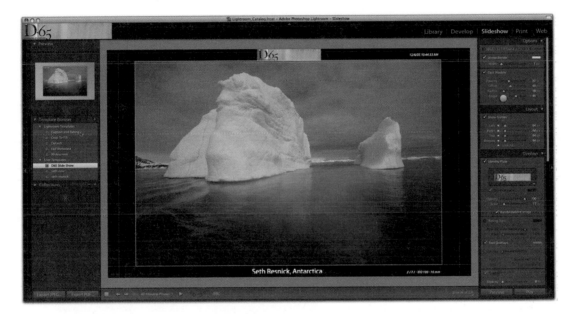

FIG 10.2 Slideshow Template Browser

Slideshow Template Presets

The Slideshow Module comes with template presets, or you can create your own custom templates. The included templates are the following:

- **Caption and Rating:** Centers images on a gray background. The stars and caption metadata are included.
- **Crop to Fill:** Displays a full-screen image. Note that verticals might be cropped to fit screen aspect ratio.
- **Default:** Very similar to Caption and Rating. Centers images on a gray background. The stars are included along with an identity plate.

219

- **EXIF Metadata:** Centers images on a black background with stars, EXIF information, along with an identity plate.
- **Widescreen:** Displays full frame of each photo, adding black bars to fill the aspect ratio of the screen.

Options Panel

Moving over to the right-hand side of the Slideshow Module is the Options panel. This is where you begin to control how the images in the slideshow will appear. Use the Options panel to zoom the image to fill the frame, or not, add a border with a specific color and size and even cast a shadow (**Figures 10.3A–C**).

(A)

(B)

(C)

FIG 10.3 Slideshow Options Panel

Stroke Border

Stroke Border provides the ability to add a border around your image in a specific color and pixel size. We have chosen a white border, 4 pixels wide, as shown in **Figures 10.4A** and **B**.

Color Picker Workflow Tip: *While the Color Picker is open, drag the cursor (eyedropper) onto the image to sample a color from the image* (**Figure 10.5**).

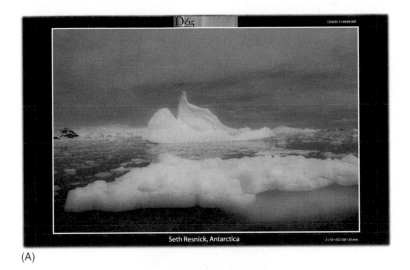

(A)

(B)

FIG 10.4 Slideshow Stroke Border

FIG 10.5 Slideshow Color Picker

Cast Shadow

There are four options to work with in Cast Shadow. They are as follows:

- **Opacity:** Displays the darkness of shadow cast
- **Offset:** The distance of the shadow from the image
- **Radius:** The hardness of the edge of the shadow
- **Angle:** The direction of shadow (**Figure 10.6**)

FIG 10.6 Slideshow Cast Shadow panel

FIG 10.7 Image with Slideshow Options applied

Figure 10.7 displays:

- Stroke border 4 px, white
- Cast shadow with opacity at 37%
- Offset to 53 px
- Radius 10 px
- Angle −36°

Layout Panel

This panel controls the guides and margins for the slideshow. Visual guides can be linked or controlled separately. In **Figures 10.8A** and **B**, we have chosen not to show the guides but to link all margins at 85 px.

(A)

(B)

FIG 10.8 Slideshow Layout Panel

Overlays Panel

If you create an Identity Plate, it will be available in Overlays to drop into your slideshow. Overlays gives you the ability to control placement, scale and opacity of your Identity Plate. You can also create and show text overlays, ratings and control drop shadows. The shadows for the text overlays have controls for:

- **Opacity:** Adjusts the darkness of the shadow cast
- **Offset:** The distance of the shadow from the image example
- **Radius:** Displays the hardness or softness of the edge of the shadow
- **Angle:** The direction of the shadow (**Figures 10.9A** and **B**)

For Fig_160N, We have chosen:

- Overlay with Identity Plate
- Opacity at 100%
- Scale at 21%
- We centered the identity plate by dragging the plate in the preview area
- We are showing our Rating Stars scaled to 37% in black with 100% opacity
- We have a white text overlay using the Font Myriad Web Pro
- We have created a drop shadow for our text overlay at an Opacity of 90% Offset by 27 px with a radius of 6 px and an angle of -29"

(A)

You can include the Rating Stars, and adjust the color, opacity and size of the stars

(B)

Text Overlays and Shadow allows you to cast a shadow on a text overlay.

FIG 10.9 Slideshow Overlays Panel

Backdrop Panel

The Backdrop settings allow you to apply a color wash, or a gradient shading on the background. This panel gives you the ability to control the opacity of the wash as well as the angle of the wash. You can also use an image as a backdrop or set the backdrop color. Color Wash applies a gradient wash on top of the background image (Figure 10.10).

Figure 10.11 shows the Backdrop panel set to:

- Dark gray color wash
- 69% opacity
- Angle of −152°

FIG 10.11 Image with Slideshow Backdrop Panel Adjustments

Adding a Background Image to a Slideshow

Drag an image from the Filmstrip into the background of the slide, as shown in Figure 10.12A. Use the Opacity slider to adjust the image's transparency (Figure 10.12B).

Background Image Workflow Tip: You can't remove an image from the background, but you can add a new image just by dragging the new image over the old one. You can also set opacity to 0% or don't have background image checked.

(A)

(B)

FIG 10.12 Slideshow with Background Image added

Background Color

The Background Color sets the color of the background
(**Figure 10.13**).

FIG 10.13 Setting the Slideshow
Background color

Titles Panel

The Titles panel allows you to create both opening and closing title
slides for your slideshow. The opening and closing slides can be
text only, or have an image or have both (**Figure 10.14**).

FIG 10.14 The Titles Panel

(A)

(B)

FIG 10.15 The Slideshow Playback Panel

Playback Panel

The Playback settings control the transition and duration of the transition (Figure 10.15A). You can also choose to add music from your iTunes (Figure 10.15B) or randomize the slides.

The Playback Screen selector comes in very handy with dual monitors. You can choose the screen to play the slideshow on, and blank out the second screen.

Slideshow Toolbar

Adding Customized Text

The ABC button located on the toolbar allows you to add text including the ability to add metadata and custom metadata from an image. You can scale the text and place it anywhere in the slideshow. In Figure 10.16, we are creating Custom Text for inclusion in our slideshow.

More Slideshow Toolbar Buttons

The toolbar controls going to the next or previous slide, rotation, stopping and playing of the slideshow as well as a text field and a drop-down menu that allows you to choose All Filmstrip Photos, Selected Photos or Flagged Photos (Figure 10.17).

FIG 10.16 & 10.17 Slideshow Toolbar Options

Exporting and Playing

The Export PDF button (**Figure 10.18**) allows you to export the slideshow as a PDF file. Export JPEG (**Figure 10.19A** and **B**) allows you to make slideshows to your own specs using any third-party slideshow product. Preview provides a preview of the show and Play will play the full slideshow.

(A)

(B)

FIG 10.18 & 10.19 Slideshow Export options

D-65 exposrts the slideshow to a job folder, using a file-naming convention that corresponds to the job name, such as 20080617_ clientx_slideshow.pdf. We then send that slideshow to a client for viewing. You can also play the slideshow on your computer with music from your iTunes Library, but the exported slideshow cannot hold music.

Quality: Sets the quality using JPEG options. The lower the number the lower the quality. The photos are automatically embedded with sRGB.

Width and Height: Pixel dimensions for slideshow. The pixel dimensions of your screen are the default size.

Exporting as a PDF Workflow Tip: *With the full version of Adobe Acrobat, the user can apply security settings to the PDF saved from Lightroom (Figure 10.19A). This means you have control over an end user opening the document, printing or editing. So, for a client who may have presented payment problems in the past, you could save the document with a password required to open the document. The document can be delivered but not opened. When payment is received, the password is sent and the document could be opened.*

Summary

The Slideshow Module in Lightroom offers an elegant way to assemble your images for creation of a slideshow presentation. The left panels contain a list of templates and a preview of each. The center displays the photos. The toolbar contains controls for playing a preview of the slideshow and adding text to the slides. The right panels provide the controls for specifying how the photos appear. When using a collection from the Slideshow, Print or Web modules, your settings are remembered in that collection, and when you double click from Library you are taken directly to the module you worked on that collection, such as Slideshow.

Discussion Questions

(1) Q. Is it possible to send a slideshow to a client? If so how would you do it?
 A. Build the Slideshow and export it as a PDF. The client only needs Adobe Acrobat Reader to view it, which comes with the operating system.

(2) Q. What is a benefit of delivering as a PDF?

A. The user can apply security settings to the PDF saved from Lightroom, if they have the full version of Adobe Acrobat. This means you have control over an end user opening the document, printing or editing. So, for a client who may have presented payment problems in the past, you could save the document with a password required to open the document. The document can be delivered but not opened. When payment is received, the password is sent and the document could be opened.

(3) Q. Can you export a Slideshow with sound?

A. Unfortunately, iTunes can only be used when the slideshow is played from within Lightroom. An exported slide show cannot yet contain sound from Lightroom.

The Print Module

Lightroom really makes printing a breeze, with many features for all your printing needs. Lightroom 2.0 allows you to put multisize images on a single page and to have multiple pages of multiple picture layouts. You can even use Draft Mode Printing, which renders from the preview. This is even more amazing because you can select a group of images and print them as a PDF and accomplish the task in seconds. Another plus is the ability to print straight to JPEG and to attach a profile. That means that you can produce print packages for a client and allow the client to print their own photos at their local lab. You can print more than one image at a time. In fact, you can actually send your entire catalog to the printer or just one image at a time. There are premade presets that provide all kinds of options including contact sheets. You can also create your own custom presets and save them for future use. The Print Module in Lightroom 2.0 has some amazing new features for printing.

The Slideshow, Print and Web modules have quite similar features and behavior. The left panel contains templates of page layouts, and the right panel contains all the options and controls for each layout. First, let's take a look at panels and features in the Print Module, and then we will go through the correct setup for making great prints (Figure 11.1).

FIG 11.1 Print Module Main Window

The Template Browser Panel

The Template Browser holds several preconfigured layouts for printing, or you can completely create your own custom layouts and add them to the Template Browser. You add and delete templates from this panel by clicking on the + and − signs (Figure 11.2).

Creating a Custom Print Template

To create a new template, you can modify existing templates or start from scratch. The easiest method is:

1. Select a template from the Template Browser.
2. Use the settings in the right panel to set up the layout you want.
3. Save it as a custom template by clicking on the + button on the right of the Template Browser.
4. Give the template a name and choose create.

5. The template will be saved in the User Templates folder of Lightroom, as displayed in Figure 11.3.

The Collections Panel

You can make selections for the Print Module from the Library Module or directly from your Collections, which appear in the Print Module. You can also make print-specific collections. Either choose the images you want to print from the Library grid mode or choose a collection from the Collections panel in the Print Module (Figure 11.4).

FIG 11.2 Print Template Panel

FIG 11.3 Print Template Panel

FIG 11.4 Print Collections Panel

233

Page Setup & Print Settings Buttons

On the lower left-hand corner of the Print Module are Page Setup and Print Settings. Here is where you select your paper size, orientation, color management and printer (Figures 11.5A–C).

(A)

(B)

FIG 11.5 A&B&C Print Page Setup & Settings

(C)

The Layout Engine Panel

Moving over to the right side of the Print Module is the Layout Engine. The Layout Engine contains the Contact Sheet/Grid layout and Picture Package. Contact Sheet/Grid allows you to print contact sheets of your selected images. Picture Package creates multipage layouts for an individual image in several different sizes (Figure 11.6A).

Picture Package allows you to create wallet size, 5 × 7 and 8 × 10 outputs, all at the same time. What is really neat is that Lightroom sizes the images to the page. If they don't fit on a page, Lightroom creates a new page. You can even create custom image sizes by simply grabbing a border with the mouse and extending it as displayed in Figure 11.6B. You can shift click and drag to keep the aspect ratio.

(A)

(B)

FIG 11.6 A&B Print Layout Engine

FIG 11.7

The Image Settings Panel

Image settings are used to rotate, crop and fit images in a layout (Figure 11.7).

- **Zoom to Fill frames:** Fills the frame, cropping the edges as necessary.
- **Auto-Rotate to Fit:** Rotates images to produce the largest image for the layout.
- **Repeat One Photo per Page:** This option allows you to repeat a photo multiple times on a page.
- **Stroke Border:** You can add a color border to your image to be printed by clicking on the color picker, choosing the appropriate color and adjusting the width of the border with the slider.

FIG 11.8

The Layout Panel

The Layout tools control margins, page grid, cell spacing and cell sizes as well as showing page bleeds. The following are the controls to use when creating custom templates (Figure 11.8):

- **Ruler Units:** Sets the ruler to inches, centimeters, millimeters, points or picas.
- **Margins:** Sets the page margins. Changing the margin will move the image in the Layout in real time.
- **Page Grid:** Control over the number of cell rows and columns.
- **Cell Spacing:** Controls the space between cells for rows and columns.
- **Cell Size:** Size of the image cells.

FIG 11.9

The Guides Panel

The Guides panel shows or hides rulers, page bleed, margins and gutters and image cells. The guides can be turned on and off for page bleed and layout purposes (Figure 11.9).

The Overlays Panel

Lightroom provides the ability to print various metadata as an overlay from the Photo Info dialog box, along with your identity plate. Many photographers like to put their copyright or logo

on proof images, and this is the place to create those overlays (Figure 11.10).

Identity Plate

If you have created an Identity Plate, you can choose to include it in your printing by checking this option. You can rotate the identity plate with the degree option on the right by clicking on it and selecting rotate on screen 90, 180 or −90. To move the identity plate, simply drag it to the desired location.

- **Opacity:** Controls the opacity of the identity plate.
- **Scale:** Controls the size of the identity plate.
- **Render behind image:** The identity plate will appear behind the photo.
- **Render on every image:** The identity plate will appear centered on every photo in a multiphoto layout. It can be further scaled using the controls in the Overlays panel.

FIG 11.10 Print Overlays Panel

Page Options

- **Page Numbers:** The page numbers will be printed on the bottom right of each page.
- **Page Info:** The sharpener setting, profile setting and printer name will be printed on the bottom of each page.
- **Crop Marks:** Crop marks printed around a photo for use as a cutting guide.

Photo Info

You can include the filename, title, keywords and caption excerpted from the metadata printed below each image. Select Photo Info and click the drop-down menu to the right.

- **Date:** Prints the creation date of the photo.
- **Equipment:** Prints camera information and lens information.
- **Exposure:** Prints shutter speed and f/stop.
- **Filename:** Prints the name of the image.
- **Sequence:** Prints sequential numbers based on how many images are printed, as in 1/4 2/4 3/4 4/4 for a sequence of 4 images.
- **Custom Text:** Prints any custom text entered.
- **Edit:** For editing Text Template Editor.

Font Size

You can set the size of the font chosen in points.

FIG 11.11 Image in Print Module with identity plate, Page Options and Custom Text

In Figure 11.11, we have an example of an image that has an identity plate, Page Options applied and photo information as Custom Text.

The Print Job Panel

This is really the control central for the Print Module. Color management, print resolution, rendering intents and sharpening are controlled in this panel. You decide on whether to print to a printer or to output straight to JPEG and to attach a profile. That means that you can produce print packages for a client and allow the client to print their own photos at their local lab. You can decide to allow the printer to control color management (not recommended by D-65) or choose a corresponding paper profile and allow Lightroom to control your color. On a Mac running OS X 10.5, you can even output in 16 bits. D-65 suggests that you let Lightroom handle color management. However, if you choose Draft Mode Printing, the printer automatically handles color (Figure 11.12).

FIG 11.12 The Print Job Panel

Draft Mode Printing

Draft Mode Printing is good for printing contact sheets and quick prints. It is also very cool to print to PDF. You can select some or all of the images in your library and print them fairly quickly to a PDF contact sheet based on the preview resolution chosen in the Catalog Preferences. In Draft Mode Printing, the cached preview is used for the print. If you choose an image without a fully cached preview, the thumbnail data is used and the prints may suffer from jaggies and artifacting. Sharpening and color management controls aren't available while using Draft Mode Printing. In Figures 11.13A and B, we rendered a 24-page PDF from raw files in a matter of seconds, using Draft Mode Printing.

(A)

(B)

FIG 11.13A&B Draft Mode Printing

Print Resolution

The print resolution defines the dots per inch (dpi) – not to be mistaken for pixels per inch (ppi) – for the printer. The default value is 240 ppi. As a side note, the Epson print engine can handle any resolution between 180 and 360 for matt papers and up to 480 for glossy papers. The ideal resolution for an image is the one that has the least change from the native resolution of the file.

Print Sharpening

Lightroom 2.0 includes output print sharpening based on PixelGenius PhotoKit Sharpener algorithms. Output sharpening is accounting for pixels being converted to dots on paper. You can choose the type of paper you are printing to and the degree of sharpening. When Draft Mode Printing is enabled, Print Sharpening is disabled.

16 Bit Output

Lightroom 2.0 includes the ability to output as 16-bit printing for Mac OS X 10.5.

Color Management
Profile: Other

If you have loaded paper profiles into your computer, they will be available in Color Management under Profile > Other. If you choose a custom printer profile, make sure that all color management is turned off in the printer driver software. This is controlled in the Print Settings button under Color Management (Figure 11.14).

FIG 11.14 Color Profiles in Print Module

Managed by Printer

If no profiles are installed in your computer, color will automatically be managed by the printer. If you use Managed by Printer, make sure to select ColorSync in the Color Management settings (Mac OS) or enable ICM Method for Image Color Management on PC. Depending on the printer driver software, you can usually find the color management settings below the Presets menu after the Print dialog box opens on a Mac and the Print Document dialog box opens at Setup\Properties\Advanced on a PC.

Rendering Intents

The printer's color space is likely smaller than the color space of the image to be printed. The rendering intent you choose will compensate for these out-of-gamut colors. Perceptual is for strong vibrant colors. Perceptual preserves the visual relationship between colors. Colors that are in gamut may change as out-of-gamut colors are shifted to reproducible colors. Relative Colormetric is for muted colors. Relative Colormetric rendering preserves all in-gamut colors and shifts out-of-gamut colors to the closest reproducible color. This option preserves more of the original color and is a good choice when you have few out-of-gamut colors.

The Print Button

Choose Print (Figure 11.15) to configure your print settings after you have used all the tools in the panels and you will wind up with a gorgeous print!

FIG 11.15 The Print Button

Making a Print

Printing seems to confuse a lot of folks, so we are going to do a quick step-by-step tutorial, reviewing the areas that seem to cause confusion. We are going to print a 13 × 19 A3 print with the Epson 3800 using Epson Premium Luster Photo Paper.

Every printer manufacturer will yield a different response to color, and changing inks and paper will also affect how the print will look. Lightroom's working color space ProPhoto RGB is an extremely wide and accommodating color space. The range of colors that are possible with certain paper and ink combinations in printers today may well exceed the gamut of Adobe98. Epson K3 inks and papers, such as Epson Premium Glossy or Epson Premium Luster, are capable of a gamut well beyond the boundaries of Adobe98.

To achieve the best results and the widest gamut, it is critical to have your monitor profiled so that you can rely on the colors you see being the actual colors you are trying to print.

1. First, select an image from the Library, or if the image is part of a collection, select the image from the Collections panel directly in the Print Module (Figure 11.16).
2. Next choose Page Setup from the bottom left of the Print Module to configure your paper size and choose your printer

FIG 11.16 Making a Print

(Figures 11.17A and B). Select our Epson Stylus Pro 3800. Choose your orientation and Scale at 100%. It is a good idea not to scale images in the Page Setup dialog box.

(A) (B)

FIG 11.17A&B Page Setup

3. Using Image Settings and Layout, create a 5.0 pt black border and 0.50 in margins all around (Figure 11.18).

4. In order to determine the ideal resolution for printing on Premium Luster Photo Paper to the Epson printer, we want to pick a resolution between 180 and 360. The goal is to change the native file resolution the least possible amount. Our original file is 16.54″ × 11.05″, and the file is a 62.9 M file. If our resolution is 245.707, then we won't change the native file size, and this will produce the optimum result. We were able to determine this by using Photoshop's Image Size menu. Figure 11.19, on page 244 demonstrates that, at this size, the file size is staying the same. We'll put the resolution in the Print Job panel in another couple of steps.

5. Now comes the confusion for many photographers. How to handle color management and how to handle the print engine? There are two choices when it comes to Color Management. You can use a custom printer profile, or turn over the color management to your printer. D-65 chooses Application Color Management, which basically means that the application

FIG 11.18 Print Image Settings and Layout

FIG 11.19 Photoshop Image Size

(Lightroom) manages the color, doing the conversions and handing that information over to the printer driver.

To utilize Application Color Management, you need an ICC profile associated with a particular paper/ink combination. You can download excellent profiles from many printer and paper companies. Epson has excellent free profiles on its website.

Adding Custom Profiles

To add custom printer profiles, place the profile in your computer's ColorSync (Mac) or Color (Windows) folder. On the Mac, place the ICC profile in the ColorSync folder in the main Library folder. In Windows, navigate to the Color folder in C:\Windows\System32\Spool\Drivers\Color and drop the ICC profile into the Color folder. After placing the new profile in the folder, restart Lightroom, and select Other; your profile list will appear.

Printer Manages Color

We don't recommend it, but if you don't have profiles, you have no choice but to select Printer Manages Color. The printer driver runs the show, and there can be many OS issues associated when printing this way, as drivers are not always up to date with the OS. The critical thing here is to select ColorSync (Mac) or ICM Color Management (Windows) as a Color Correction option. Even with

these options, you may have difficulty getting a print to look exactly the way you expect.

6. To choose the paper profile, click on Other (Figure 11.20) next to Color Management and select the paper profile for the 3800 printer using Epson Premium Luster Photo Paper. The name for that ICC profile is Pro38PLPP.

FIG 11.20 Applying Print profiles

7. In Figure 11.21, we have selected a print resolution of 246 (rounded up from 245.707). We want to apply a high degree of sharpening to keep the subject who is moving crisp in print. The Media Type is Glossy, and we are going to output in 16 bits, which is possible with Mac OS X 10.5.The rendering intent for this image is set to Perceptual as we have strong saturated color.

FIG 11.21 Applying Print profiles

8. The last series of steps are the most confusing of all. You can choose either Print Settings or Print. Print Settings will allow you to save the settings while Print offers the same settings but does not allow you to save. D-65 suggests choosing Print Settings so that you can save these final steps to use over again (Figure 11.22).

FIG 11.22

FIG 11.23 Print Settings

9. Choose Print Settings from the menu (Figure 11.23). Again, this is the most confusing part and one that is absolutely critical to get right. It's critical to keep this preset on Standard. There is an OS limitation that causes Lightroom not to recognize the settings if it is not on Standard.

10. In the Print Settings dialog box (Figure 11.24), first choose the **Media Type** that matches your paper. We choose Premium Luster Photo Paper.

11. **Set Color Settings to Off (No Color Adjustment).** This option is the single most important and the one that causes the most confusion. This sets the printer driver to off and allows Lightroom to hand off your color. This is the key element to making a good print.

12. In **Print Quality**, we choose 1440 in part because it saves a substantial amount of ink. 2880 vs. 1440 is debatable, as it is impossible to see the difference at a normal viewing distance.

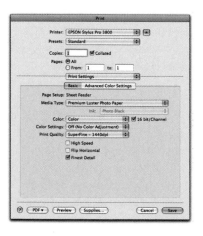

FIG 11.24 Print Setting Choices

For the best quality print, it's usually better to leave High Speed off while choosing Finest Detail if it is available.

13. Before saving these settings, check that Color Settings are indeed set to Off (No Color Adjustment) (Figure 11.25).

FIG 11.25 No Color Management

14. Click the **Save** button (Figure 11.26) when all the options are set correctly. This will ensure that the settings are stored and ready for creating a print template.

FIG 11.26 Save Settings

15. We are almost home free. Select Print One or Print from the lower right-hand panel of the Print Module. We choose to select Print One as long as we are only printing one print. If you select Print, you first get the Print dialog box and will have to choose Print on the lower right of the module (Figure 11.27).

FIG 11.27 Print One

16. GO CHECK THE PRINTER AND SEE THE RESULTS. In Figure 11.28, we have a print in front of the screen after doing the above steps, and it is pretty darn good.

FIG 11.28 Print held up to screen

17. We will probably use these exact settings again in the future, so let's create a custom template. Choose the + sign next to the Template Browser on the left-hand side of the Print Module. Name the New Template and choose Create (Figure 11.29).

FIG 11.29 Saving Print Template

Summary

Lightroom really makes printing a breeze, with all the features in the Print Module. Lightroom 2.0 can place multisize images on a single page and have multiple pages of multiple picture layouts. Draft Mode Printing renders from the preview, enabling speedy prints. Another plus is the ability to print straight to JPEG and to attach a profile. You can produce print packages for a client and allow the client to print their own photos at their local lab. You can also print more than one image at a time. In fact, you can actually send your entire catalog to the printer or just one image at a time. There are preconfigured presets that provide many options including contact sheets. You can also create your own custom presets and save them for future use. Just as in the Slideshow and Web modules, the left panel contains templates of page layouts and collections, and the right panel contains all the options and controls for each layout.

Discussion Questions

(1) Q. What is the difference between printing to a printer and printing to JPEG?

A. You decide on whether to print directly to your printer or to output straight to JPEG and to attach a profile. That means that you can produce print packages for a client

and allow the client to print their own photos at their local lab.

(2) Q. Does Lightroom 2.0 handle 16-bit printing?

A. Yes, but only on Mac OS X 10.5 or later.

(3) Q. What is Draft Mode Printing, and discuss one scenario where you might want to use it?

A. Draft Mode Printing is good for printing contact sheets and quick prints and very cool to print to PDF. In fact, you could select all the images in your library and fairly quickly print them all in a PDF contact sheet based on the preview resolution chosen in the Catalog Preferences. In Draft Mode Printing, the cached preview is used for the print. If you choose an image without a fully cached preview, the thumbnail data is used and the prints may suffer from jaggies and artifacting. Sharpening and color management controls aren't available while using Draft Mode Printing.

(4) Q. For an Epson printer was is the ideal print resolution?

A. The print resolution defines the dots per inch (dpi) – not to be mistaken for pixels per inch (ppi) – for the printer. The default value is 240 ppi. The Epson print engine can handle any resolution between 180 and 360 for matt papers and up to 480 for glossy papers. The ideal resolution is one that has the least change from the native resolution of the file.

(5) Q. What is the difference between Relative Colormetric and Perceptual?

A. This refers to how Lightroom converts the image into a printing color space. Choosing Perceptual or Relative Colormetric will determine how any out-of-gamut colors are handled. Perceptual rendering is good when your image has many out-of-gamut colors. Relative Colormetric preserves all in-gamut colors and shifts out-of-gamut colors to the closest reproducible color. This option preserves more of the original color and is desirable when you have few out-of-gamut colors. As a general rule, Relative Colormetric works well with muted tones and Perceptual works well with strong saturated colors.

(6) Q. If you have paper profiles loaded, where do you find them in the Print Module?

A. If you have loaded paper profiles into your computer, they will be available in Color Management under Profile > Other.

(7) Q. What are the two options for handling Color Management in the Print Module?

A. There are two choices when it comes to Color Management. You can use a custom printer profile or turn over the color management to your printer.

(8) Q. What does application color management mean?

A. Application color management means that the application (Lightroom) manages the color, doing the conversions and handing that information over to the printer driver.

(9) Q. What is the most important thing to do in the Print Settings dialog box if you are using paper profiles and application color management?

A. Set Color Settings to Off (No Color Adjustment).

The Web Module

Lightroom's Web Module allows you to create web galleries directly from RAW images with very little effort and no knowledge of programming. The galleries can be previewed in Lightroom, exported to a folder or uploaded to a web site. There are a wide variety of templates to choose from or you can create your own using Flash or html. There is also an array of third-party templates available on the web. The Web Module is designed very similarly to the Print and Slideshow Modules, with templates and collections on the left-hand panels, and features on the right-side panels. Web Galleries are an excellent way for clients to view your images and you can use your tweaked raw files to create a gallery for a fast streamlined workflow.

Web Module Features

You can add an Identity Plate with a web link and an e-mail address. You can also choose from a wide array of metadata to

display or even create custom tokens of almost any metadata available in Lightroom. You can even apply output sharpening to keep the images crisp even when they are small in size on the web. There is also a very cool built in FTP function, allowing you to upload your web gallery directly to your web site (Figure 12.1).

FIG 12.1 Web Module Main Window

Creating a Web Gallery

A web photo gallery can be created by selecting images in the Library Grid Model or from a Collection that is available inside the Web Module. Let's build a Web Gallery and discuss the available features along the way.

1. Choose your selection of images from the Library Module or the Collections Panel in the Web Module that you want to use to create your web gallery. You can choose which images to

use ... all, selected or flagged. This is the same for all output modules. For this demo, we have selected 60 images using the Filmstrip in the Web Module from a Collection called Portfolio (Figure 12.2).

FIG 12.2 Choosing selection for Web Module from Filmstrip

Template Browser and Preview Panels

On the top left-hand side of the Web Module is a Template Browser and a Preview Panel to see what the templates look like. The Template Browser provides two distinct methods of Web Gallery displays. You can choose a traditional html style with thumbnails on a main page and enlarged images on individual pages or a Flash gallery with features like autoplay. HTML Galleries use static XHTML, CSS and Javascript. A user can customize these galleries as they contain standard HTML components. The Flash templates are totally cool and offer some of the unique technology of flash directly to the user inside of Lightroom.

2. We have chosen the default HTML gallery for this demo (Figure 12.3).

FIG 12.3 Web Gallery Template Browser

Engine Panel

On the top right-hand side is the Web Gallery Engine which provides Lightroom users with some very interesting third-party template options. Although we are going to build our gallery with HTML we want to show you a few other options available in the Engine (Figure 12.4).

FIG 12.4 Web Gallery Engine Panel

Figures 12.5A–C show some of the possibilities from third-party vendors for producing web templates.

(A) (C) (B)

FIG 12.5

Site Info Panel

The Site Info Panel offers controls for:

a. **Site Title**: Your Name
b. **Collection Title**: Your Job Name
c. **Collection Description:** What you shot? For example, 'Images shot on South Beach for Client XYZ'
d. **Contact Info:** Your E-mail Address
e. **Web or Mail Link:** http://www.yourwebsite.com
f. **Identity Plate:** You can add your identity Plate or Logo with a link to your web site. Click on the drop-down menu next to identity plate to create or new one, or use what you have already setup in Lightroom. Under Web or Mail Link, put in your web site. This creates a link on the logo or identity plate.

3. The next step in producing our web gallery is to fill out the Site Info Panel located under the Engine on the top right-hand side of the Web Module (Figure 12.6).

FIG 12.6 Web Gallery Site Info Panel

Color Palette Panel

The next Panel is the Color Palette. You can choose colors for a variety of options. Choose Colors that are different for Text and Detail Text. Detail Matte is the area around the image when it is enlarged, so you might like to create a frame around the image with a different color. Rollover is when you scroll over the images on the index page. The Grid Lines and Colors are also for the index page.

4. We chose a dark gray for our Background, Rollovers and Grid Lines; black for our Cells and Detail Matte; and a light gray for our Text (Figure 12.7).

FIG 12.7 Web Panel Color Palette Panel

Appearance Panel

The Appearance Panel is where you choose how many rows and columns you want, the size of the images on the page and whether you want a border around the images. You can also choose to display a cell number for each image and section borders too (the dotted lines above and below the cells) and whether there is a drop shadow on the background from the image.

FIG 12.8

5. We choose no Drop Shadow, a light border defining each section of the gallery, 6 column-wide gallery, a border around each image of 53 pixels and an image size of 800 pixels (Figure 12.8).

Image Info Panel

Image Info allows the user to decide what metadata you want to display with the images. The Title and Caption can be applied by simply checking the box next to each option. Additional metadata can be displayed by clicking on the drop-down menus.

6. We have chosen to use Title and Caption and to custom apply the metadata for Filename. For this to work, the images need to contain title and caption metadata. This is the same for all output modules (Figure 12.9).

Output Settings Panel

The next choice to make is for Output Settings. You can select the Quality for the jpg output and the degree of Output Sharpening needed for the web gallery. This is new in 2.0 and quite a big deal. The algorithms are based upon Pixel Genius PhotoKit Sharpener and make a major difference in how the images will look on the web. Lastly, you can choose to show a Copyright Watermark as well as other metadata.

7. We have chosen to render our images at a jpg quality of 80, show all metadata, apply a copyright watermark and apply standard sharpening for web output. The copyright info is being extracted from the IPTC metadata and will add your copyright to the image as an overlay. We always choose to check this box (Figure 12.10).

Upload Settings

You can configure your Upload Settings so that you can accomplish an FTP transfer directly from Lightroom to your web site. There is a drop-down menu on the right of the panel so that you can put in your username and password for the FTP transfer and save the settings as a preset.

8. We filled out all of our FTP information and saved it as a New Preset (Figure 12.11).

FIG 12.9

FIG 12.10

FIG 12.11 Web Module FTP Panel

Export/Upload

On the bottom right of the Web Module there is a choice to Export or Upload. Upload initiates the FTP transfer settings set up in Upload Settings. Export will export the web gallery files to a folder and location of your choice for offline viewing, or to upload the gallery at a later time using FTP software such as Transmit or Fetch. One word of caution: for FTP the gallery is always index.html, so unless you have a subfolder selected it might overwrite an existing index.html. The subfolder gets created automatically if it isn't there or you can just be careful which directory you upload to (Figure 12.12).

FIG 12.12 Export Upload Button

Preview

Before Exporting or Uploading, you can preview your web gallery in the default browser.

9. Choose Preview in Browser on the lower left-hand corner of the Web Module to view your web gallery (Figure 12.13).

FIG 12.13 Preview in Browser

257

(A)

(B)

FIG 12.14 Examples of Web Galleries

10. So let's take a look at what our gallery looks like in our default browser which in our case is Safari. Figure 12.14A shows the index page and Figure 12.14B shows an image page. If we wanted to keep this as a template to use in the future we could save it by clicking on +sign to the right of the Template Browser.

Summary

Lightroom's Web Module allows you to create web galleries directly from RAW images with very little effort and no knowledge of programming. The galleries can be previewed in Lightroom or exported to a folder. There are a wide variety of templates to choose from or you can create your own using Flash or html. There is also an array of third-party templates available on the web. Lightroom adds many features and controls along with a very cool built in FTP function, allowing you to upload your web gallery directly to your web site. Web Galleries are an excellent way for clients to view your images and you can use your tweaked raw files to create a gallery for a fast streamlined workflow.

Discussion Questions

(1) Q. Name two places that you can select files from to create a web gallery.
 A. A web photo gallery can be created by selecting images in the Library or from a Collection which is available inside the Web Module.

(2) Q. Do you have to process files in order to create a web gallery?
 A. No, you can create a web gallery directly from raw files.

(3) Q. What are the two types of galleries that can be created in Lightroom?
 A. HTML galleries and Flash galleries.

(4) Q. What would be the purpose of including an Identity Plate in a web gallery?
 A. The Identity Plate can be made to include an active link. So for example to use the Identity Plate for D-65 in a web gallery would bring the user directly to the D-65 web site.

(5) Q. How do you set the columns when creating an html web gallery?
 A. Use the Appearance Panel and roll the mouse over the Grid Pages to select how many columns wide you want your web gallery.

(6) Q. Can you include more than just the Title and Caption in
you web gallery?

A. Yes, you can select almost any metadata available in
Lightroom to be included by using the drop-down menu
in the Image Info Panel.

(7) Q. How would you include a Copyright Watermark in your
web gallery?

A. You can choose to show a Copyright Watermark from
the Output Settings Panel. The copyright info would be
extracted from the IPTC metadata. This field would need
to be filled out for the metadata to be available.

(8) Q. After creating a web gallery what are your options for
output?

A. You can preview in your default web browser, upload
directly to a web site via FTP transfer or you can output to
a folder.

D-65's Lightroom Workflow

Now that we have reviewed all of Lightroom's modules and concepts, it's time to put Lightroom into action and tie it all together to achieve efficient digital workflow. This chapter covers the D-65 Lightroom workflow.

For this tutorial, we are going to start with a memory card with images from a shoot. These raw files will be:

1. downloaded from the memory card and imported in Lightroom,
2. edited and ranked,
3. metadata and keywords applied,
4. renamed,
5. color corrected and 'tweaked',
6. shown to client via web gallery, PDF contact sheet or slideshow,
7. exported into the type of files we need for our job, and
8. organized into a job folder for archiving.

As we go through this tutorial, each major step of the workflow is colored RED.

Make sure that Lightroom's preferences are set up, and you have created a Lightroom_Catalog, and a Lightroom_Library to store images in your desired location (refer to Chapters 4 and 5).

Step 1: Importing Images into Lightroom

There are several ways to import images into Lightroom. Images can be imported from the following sources:

- New images directly from a memory card
- Existing images on your computer
- Existing on external media such as a hard drive, CD/DVD
- Tethered from a camera

While all methods work well with Lightroom, each requires different import setup. The D-65 workflow outlined below is specifically for shooting raw files and importing from a memory card into Lightroom.

When you insert a memory card into a card reader, an icon of the card will appear on your desktop and Lightroom will automatically open the Import Photos dialog box (Figure 13.1).

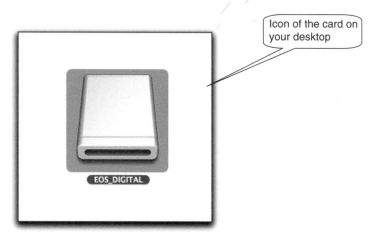

Icon of the card on your desktop

EOS_DIGITAL

FIG 13.1

1. Open Lightroom. Load your memory card into your card reader and wait for the Import Photos dialog box to pop up.

On the following page is a picture of how the import dialog box appears in default form when you first trigger it. We will go through each field and describe how we use it (Figure 13.2).

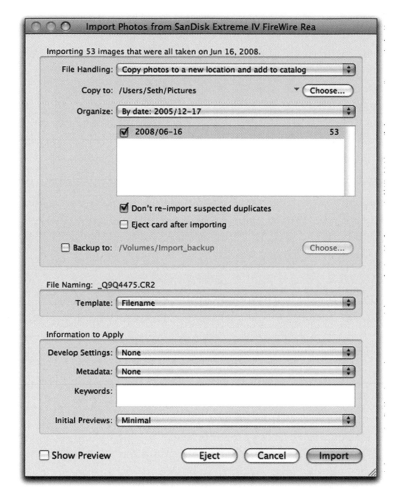

FIG 13.2 Import Dialog Box

The top of the Import Photos dialog box displays the card reader you are using, how many images you shot and on what day(s) they were shot. In Figure 13.2 you can see that there are 53 images taken on June 16, 2008 being imported from our SanDisk Extreme IV Firewire Reader.

File Handling
Under File Handling, there are two choices depending on your philosophy. They are:

• copy photos to a new location and adding to catalog, or
• copying photos as Digital Negative (DNG) and adding to catalog.

We firmly believe that DNG will prevail and become the adopted universal raw format, but it is not universal with all software manufacturers yet. For this reason, D-65 still believes in keeping the original proprietary raw file from the camera manufacturer along with a DNG copy AFTER the tweaks have been applied to the raw files. We want our DNG's to have the same information as our proprietary raw files, which is why we create DNG's from the proprietary raw files after we are finished with working on them in Lightroom.

To accomplish this, D-65 chooses to copy photos to a new location, our Lightroom_Library hard drive, and adding to catalog. We are copying from our memory card to our Lightroom_Library hard drive. Further down the line in our workflow, we will make DNGs and save them in our archive.

FROM THE IMPORT PHOTOS DIALOG BOX CHOOSE:
1. Copy photos to a new location and add to catalog.
2. Copy to Lightroom_Library (choose whatever hard drive that you setup as your library to hold images for Lightroom).
3. Organize Into one folder.
4. Check Put in subfolder: Name your subfolder with your job name, such as 20080616_Indiancreek.
5. Check Don't reimport suspected duplicates.
6. Check Eject card after importing.
7. Backup To: D-65 always recommends backing up to a secondary location. We suggest an external hard drive or a second internal drive (if you have one) for your backup. If you do have an external drive to dedicate for this import backup, choose it now (Figure 13.3).

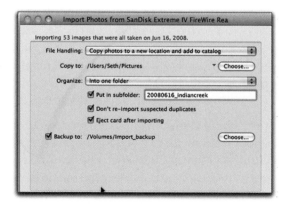

FIG 13.3 Import Diaglog Box Choices

More on Backup To

This backup causes confusion to many photographers. They assume that they have a full backup of the imported files, but in fact this backup only provides a backup of the exact structure of the files on the memory card with their original camera-generated names. So if you rename in the import dialog box, apply a metadata preset, or any develop preset or keywords, none of these will be available in the backup. This is really just a temporary 'insurance plan', should something go wrong with the import. The import backup will be deleted at the end of the job, after we have archived our job (Figure 13.4).

FIG 13.4 Import Backup

File Naming

D-65 renames our images on import. To make the workflow flow, we are going to create a File Naming Preset to use on all shoots. This preset will name our files with a naming convention consisting of YYYYMMDD_jobname_seq#(0001).the three-letter file-type extension. This will allow you to batch rename your files giving them a meaningful name for easy retrieval from an archive. Our demo photos are from a shoot on Indian Creek that took place on June 16, 2008. Hence, we are renaming the proprietary raw files in the following way:

20080616_indiancreek_0001.CR2

File Naming Standards

Digital photography has increased the importance of naming conventions because the digital camera creates the initial name assigned to a file. That's convenient, but these file names, such as 'UY74O822', are cryptic and random.

The solution to this problem is for every photographer to develop a naming convention based on standards and using it consistently to name your files. This will give you a standardized nomenclature that will help you categorize, organize and later locate your images. A good file-naming system will not only ensure consistency but also form the backbone of the file retrieval process.

To create a file-naming system, you need to essentially generate your own secret code. Now, this code does not have to be worthy of an über-geek award. In fact, it doesn't have to involve anything more complicated than giving each image a sequential number or a descriptive name. It may even include IPTC (descriptive

information about the image) or EXIF (technical data taken from the camera) data as well as other information of your choice.

Finding a Simple Solution

Yes, naming a file is important, but doing so correctly is also crucial – and is all too often overlooked by many photographers. Some use relatively generic names, such as 'cat1.JPG', but these make it difficult to locate files later. Others simply ignore naming conventions, increasing the risk that the files will not be readable on other computers.

Again, the file-naming convention you come up with needs to address two separate issues: (1) a naming system that works for you, and that you can use on the fly – ideally, file naming should be done at the time of capture, not later on; and (2) adherence to certain known standards that will ensure the file names remain intact across a variety of platforms and systems.

The Right Name

Files should be named using a convention that provides accurate information about each file *and* for which it was created. A naming system based on the date you capture the image and a series of letters defining the file is a great place to start. With such a system, you can address criteria such as high-resolution files, layered files or when they were published.

If we use our Indian Creek images as an example, the file name would be: 20080616_indiancreek_0001.CR2. The numbers '20080616' define the date, as in June 16, 2008. Using the reverse date order ensures files are always sorted in order. The 'indiancreek' designation defines the actual job in our naming convention. The '0001' defines the image number, and 'CR2' defines the type of file. In this case, Canon's Raw file format.

From this basic formula, you can add in other components to your file name, which can further help you describe the image files and job. Some additional examples follow:

- 20080616_indiancreek_l_0001.psd: The lowercase 'l' designates my retouched file with all layers included.
- 20080616_indiancreek _bw_0001.psd: This is a variation of the file that was converted to black and white.
- 20080616_indaincreek_cf_0001.tif: This is the actual image that was used as a final file for the client, using 'cf' to designate 'client final'.

Adhering To Standards

There are some basic rules to follow when it comes to naming files. First, all file names should be limited to a total character length of 31 including the file-type extension. Second, all file names must include the correct three-letter file-type extension. Examples of file-type extensions are jpg, tif, dng, psd and pdf. To address cross-platform usability, file names should not contain special characters or symbols other than underscore '_' or hyphen '-'. In fact, it is best to avoid punctuation characters in file names altogether because some characters are reserved for use only by the operating system. It is wise to use only lower-case characters because some operating systems such as Unix are case-sensitive.

Once you have a system in place, it should meet these technical guidelines and still provide enough information about the image so that you do not have to open the file to identify the image. The file name should give you everything you need to know. Searching on a file name should yield results.

Creating a File Naming Preset

To create our File Naming preset, follow the steps listed below.

1. From the File Naming Template drop-down menu, choose edit (Figure 13.5, on page 268).
2. The Filename Template Editor window will pop up. The default in the example window is filename.
3. Delete the token filename in the example window by clicking on it and hitting the delete key. Now you are starting with a clean template. (A token is the term for any field you are inserting or deleting in this window.)
4. Go to the fourth window down, Additional, and choose YYYYMMDD from the drop-down menu and click on Insert. Your first token will contain the year, month and day the image was shot. Lightroom extracts this information from the metadata coming from the camera, so make sure your date/time is correct in the camera.
5. Your cursor should be in the example window after the newly inserted date token. Manually type in an underscore after the first token. This will separate the tokens that we will be stringing together.
6. Go down to Custom, and click on Insert to the right of Custom Text. This will insert Custom Text as your next token.

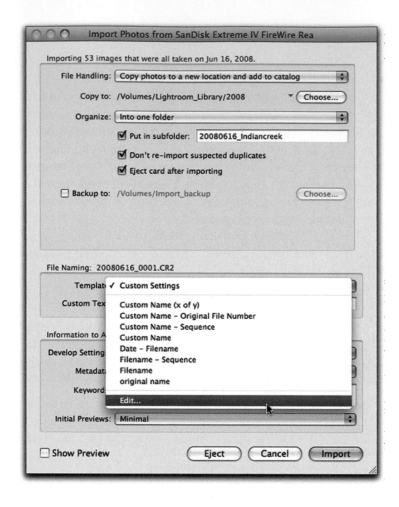

FIG 13.5 File Naming Template

7. Again, manually type in an underscore next to Custom Text to separate the tokens in the example window.
8. Go down to Numbering and from the third drop-down menu, Sequence, choose: Sequence #(0001) and click on Insert. This is your final token to insert, but DO NOT click on Done yet.
9. Now we will save this as a Preset, so we can use it over and over again. To save the preset, go to the drop-down menu at the top of the window, under Preset, and choose Save Current Settings as New Preset (Figure 13.6).
10. Call it yymmdd_jobname_0001.ext (This describes how exactly your file will be named) and choose Create (Figure 13.7).
11. Now choose Done in the Filename Template Editor window.
12. You will automatically be back in the Import Photos dialog box and you can apply this File Naming Preset to your images.

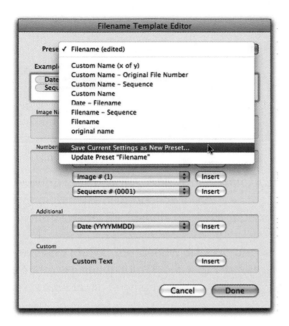

FIG 13.6 Filename Template Editor

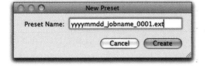

FIG 13.7 Saving Filename Preset

From the Template drop-down menu, choose yyyymmdd_
jobname_0001.ext. Next to Custom Text, type in your job
name. In our example below, we typed in indiancreek.

13. Our Start Number is 1, since this is the first image of our shoot
(Figure 13.8).

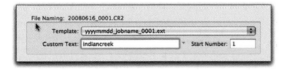

FIG 13.8 Custom Text in File Naming
Template

The cool part of saving a File Naming Preset such as this one is
that it can be used over and over again for every job. The only
thing that will ever need to be edited is the actual job name under
Custom Text and Start Number.

Information to Apply

Develop Settings

You can further increase your workflow efficiency by applying Develop Presets to images on import. D-65 has created a Develop Preset that we would like to apply to all images on import. The setting adjusts vibrance, saturation, black point, clarity, and sharpening to simulate the look of Kodachrome film. We created this Custom Preset in the Develop Module (see Chapter 9). Depending upon your needs as a photographer, you may or may not apply a Develop Setting on import.

Choose whether to apply a Develop Setting or not at this time (Figure 13.9).

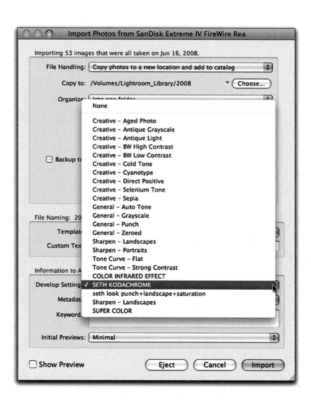

FIG 13.9 Applying Develop Preset on Import

Metadata

D-65 creates a basic Metadata Preset with our copyright and contact information. We apply this preset on import to all of our images. We add further metadata using the Metadata Panel in the Library to add specific information on each job.

What is Metadata?

Metadata is a set of standardized information about a photo, such as the author's name, resolution, color space, copyright, and keywords applied to it. For example, most digital cameras attach some basic information about a file, such as height, width, file format and the time the image was taken. Lightroom supports the information standard developed by the International Press Telecommunications Council (IPTC) to identify transmitted text and images. This standard includes entries for descriptions, keywords, categories, credits and origins. You can use metadata to streamline your workflow and organize your files.

File information is stored using the Extensible Metadata Platform (XMP) standard. XMP is built on XML. In the case of camera raw files that have a proprietary file format, XMP isn't written into the original files. To avoid file corruption, XMP metadata is stored in a separate file called a sidecar file. For all other file formats supported by Lightroom (JPEG, TIFF, PSD and DNG), XMP metadata is written into the files in the location specified for that data. XMP facilitates the exchange of metadata between Adobe applications and across publishing workflows. For example, you can save metadata from one file as a template and then import the metadata into other files.

Metadata that is stored in other formats, such as EXIF, IPTC (IIM) and TIFF, is synchronized and described with XMP so that it can be more easily viewed and managed.

Creating a Metadata Preset

In our workflow, we create a basic copyright template as follows that we apply to all our imported images:

1. Under Metadata, select NEW from the drop-down menu. We will fill out this template with information for a basic copyright template (Figure 13.10).

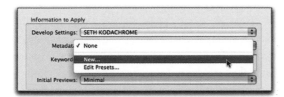

FIG 13.10 Creating Metadata Preset

2. Name the Preset (at the top of the window) 2008_basic_
 copyright.
3. Fill out the fields that are appropriate for you. D-65 suggests
 that at a minimum you fill out the copyright fields and creator
 fields or you can be quite specific as demonstrated below.
4. Choose Create (Figure 13.11).

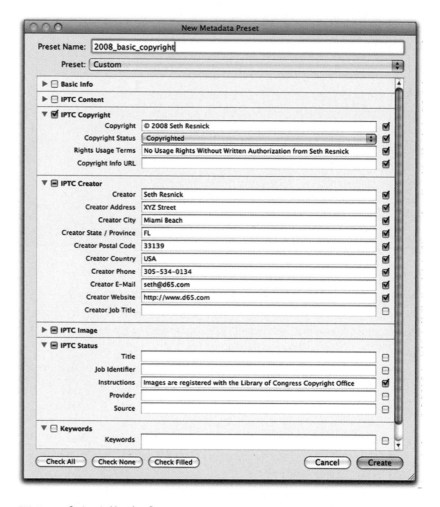

FIG 13.11 Options in Metadata Preset

5. You will automatically be back in the Import Photos dialog
 box and you can apply this Metadata Preset to your images.
 From the Metadata drop-down menu, choose 2008_basic_
 copyright.

Keywords

Lightroom gives you the ability to apply a set of keywords to your images upon import. Depending on the circumstances of your shoot, you may want to do this for all images or for selective ones at a later date, or both. We find it easier to use the Keyword Panel in the Library Module and add keywords after the images are imported.

1. Add keywords if you like at this point.

Initial Previews

There are several choices for import and a new choice for 2.0. The choices are:

- Minimal: Very low-grade jpeg preview. It is sort of science fiction. It is simply based on the sRGB preview on the back of the camera LCD. Keep in mind that while it may be faster it is not rendering the raw data. Also, the LCD on the back of the camera is very poor compared to the profiled and calibrated screen you are using.
- Use Embedded and Sidecar: This is a new choice for 2.0. These previews are rendered from the preview embedded with the image so they could be a larger preview. They are still low-resolution files that are really only usable for fast loading in the Grid view. Lightroom will begin to render these in time to Standard Previews. The real concept here is that the sidecar preview will allow you to see the file and begin rating and culling very fast. The problem, however, is that if you go to Develop or even to Zoom, Lightroom will re-render the file, which will take time and slow down the power of the CPU.
- Standard: Renders the preview directly from the RAW images during import in Adobe98.
- 1:1: Renders the preview directly from the RAW data during import in ProPhoto RGB. While this takes the longest to render, it is the choice for D-65. Once these are rendered, we can move from image to image in the Library and to Develop without wait time. The downside is that initial rendering can take a fair amount of time.

Show Preview

The right side of the Import Photos dialog box contains a preview of the images on your card. Dragging the slider to the right will make the images larger.

1. Check 'Show Preview' on the bottom left (Figure 13.12).

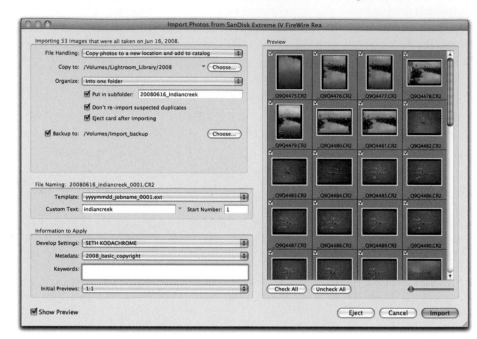

FIG 13.12 Show Preview in Import Dialog Box

Import

1. After completing all of the above steps, you are now ready to import your files into Lightroom. Click on import on the lower right of the Import Photos dialog box. The files will be imported into Lightroom and start to render one by one. You can monitor the import progress via the activity viewer in the top left-hand corner of the Library Module (Figures 13.13).

(A) (B)

FIG 13.13 Import Progress

2. Now that you are in the Library Module, notice that your Previous Import is selected under the Catalog Panel (top left-hand side). Navigate to the Folders Panel. Make sure you select (highlight) the folder of images you are importing. This assures that you are working on the correct folder (Figure 13.14).

FIG 13.14 Folder of newly imported images in Library Module

Step 2: Editing

The next step in our workflow is to edit – editing and ranking works in much the same way as a film-based photographer works on a light table.

First, we go to the Secondary Window button and take advantage of using multiple monitors. Then we click on an image and go to full screen. We then use the Tab key and Shift Tab to expand our view, and collapse the panels. Using the arrow keys, we start moving through the images. We use the navigator tool with an appropriate zoom level to move through the image and check focus. After checking focus, a photographer typically throws rejects in the trash, uses one star or dot to mark a select, two stars to mark second-tier selects and three stars to mark and cull 'keepers'. We can do exactly this within Lightroom.

Rating Images

We can add and remove stars from an image using the number keys 1 through 5. We can also add color labels by using the numbers 6 through 9. You can also rate and color label using the Photo Menu and then choosing Set Rating, Set Color Label or Set Flag. Additionally, you can select an image in Lightroom and manually add or subtract stars by clicking on the dots immediately

below the thumbnail. In essence, there are a number of ways to rate and color label your images. These rankings and color labels will stay with the image in its metadata even after you process the files (Figure 13.15).

FIG 13.15 Using Multiple Monitors for Editing images

Deleting Images

You can delete images in Lightroom in two ways:

1. Hit the delete key when an image is selected in the Grid view to delete images one by one.
2. Use the X key on an image to Flag as Rejected. After you are done with editing the entire shoot and hitting the X key on all images you want to delete, go to the Photo Menu and choose Delete Rejected Photos.

D-65 suggests deleting the images from the disk, not just from the Lightroom catalog. We have no use for outtakes in our library (Figure 13.16).

FIG 13.16 Deleting Images from Library

Rotating Images

To rotate images, you can click on the bottom left or right of the cell on the selected image in the Grid view or Command/Control. Rotate is also included in the Photo Menu (Figure 13.17).

In the Photo Menu, you can rate, color label, flag, rotate and delete rejected photos.

FIG 13.17 Ranking, Rotating and Deleting images

1. Rank and edit your images.
2. Rotate images if needed.
3. Delete your outtakes.

Rating Shortcuts

- You can use the] key to increase the rating and the [key to lower the rating, and Command Z will undo a rating.
- Having Caps Lock on while you are rating images automatically moves to the next image after you rate one image.
- You can also Set a Flag as a Pick, instead of rating and color labeling. For our workflow, we stick with ratings and color labels.

Step 3: Add Keywords and Additional Metadata

After we edit, we add keywords and additional metadata to all our images. We start by adding global keywords and metadata, and then local keywords and metadata on smaller groups and individual images (see Chapter 8).

1. Add keywords and metadata to your images (Figure 13.18, on page 278).

Step 4: Rename Your Images

Before we move into the Develop Module, we will rename our images since we have deleted some in our editing process. If you have deleted any images in your edit and would like your images numbered sequentially, then you can rename your images now.

FIG 13.18 Add Keywords and Additional Metadata

1. Select all images. Go to the Library Menu and drop-down Rename Photo (F2) (**Figure 13.19**).

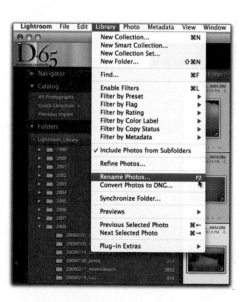

FIG 13.19 Renaming Photos

2. The Rename Photos dialog box pops up. Choose the template we just created (yyyymmdd_jobname_0001.ext), put in your

job name next to Custom Text and the Start Number is 1.
Choose OK (Figure 13.20).

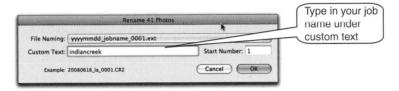

FIG 13.20 Applying Custom Text in
Rename

Step 5: Color Correcting, 'Tweaking' Your Files and Synchronizing Setting in the Develop Module

1. Click on the Develop Module.
2. Now move through all of your files in the Develop Module, tweaking and synching. Once all of your files have been color corrected, we will be ready for the next step of the workflow.
3. Go back to the Library Module and we are ready to export (Figure 13.21).

FIG 13.21 Synchronizing Settings in Develop Module

Step 6: Create a Web Gallery or Slideshow for Your Client

See Chapters 10 and 12.

Step 7: Exporting Your Files and Creating a Job Folder

Lightroom is capable of exporting TIFF, PSD, JPEG and DNG files. This is how Lightroom processes files. Whether you need any or all of these files will depend on your specific workflow and your needs as a photographer.

For D-65's workflow, we always create two types of files from our tweaked RAW files.

1. DNG format for archiving.
2. JPGs in sRGB color space at 72 ppi and 600 pixels wide for copyright registration and submission to stock agents.

Then, after our client reviews our images from our web gallery, we export the finals that they have selected. The third type of file that we export is:

3. Any type of file our client requests on a per job basis. D-65 usually delivers client finals as TIFs.

Creating a Job Folder

We choose Export from the Library Module. On export, we will create a new job folder on our desktop, or on our hard drive(s) dedicated for our job folders. We use the job folder to organize files for archiving. This folder will be archived on multiple external hard drives, both on-site and off-site. You tweak your files in Lightroom and then export (process) them into the file type(s) you need for the job. All these processed files go into a job folder for that specific job. This is all for organization and archiving. Let's explain this concept a bit more…

In the film world when you returned to the lab to pick up your film, it was given to you in a well-organized manner. The E-6 slides were in a box, the C-41 negatives were in sleeves and the prints were in glassine envelopes. You then took those chromes or negatives back to the office and filed them away. We are going to simulate that same concept by creating a job folder for each and every job. The job folder will contain subfolders for all of the different file types and information required for that job such as DNG, JPG, TIFF, PSD, Invoice,

Model Releases, Layouts, Slideshows, Web Galleries etc. The job folder and subfolders will use a naming convention similar to what you used for your image names. For example, for our job on Indian Creek, we would create a job folder called 20080616_indiancreek_ job. The subfolders we create on Export within this job folder will be:

- 20080616_indiancreek_dng
- 20080616_indiancreek_jpg

We always use the year, month and first day of the job with an underscore and then job name for our file naming convention.

We choose to leave the proprietary RAW files from the camera on our hard drive named Lightroom_Library, not in our job folder. Any database will slow down as it accumulates information. Lightroom will currently slow down with more than 100,000 files.

For this reason we choose to keep only our raw files in Lightroom and our processed files on external hard drives dedicated to holding just our job folders, outside of the Lightroom_Library hard drive.

Should we need to browse through these job folder hard drives, we would do so using Bridge, which is an advanced browser capable of reading many file types including PDFs. As a browser, Bridge must physically be connected to the source of the media it is reading. You can scroll through an entire directory and see any image in the directory as long as you have access to that directory. In simple English, if you have stored all your images on one external hard drive, Bridge does a great job of seeing all those images as long as the hard drive is connected to your computer. Once you disconnect the external hard drive from your computer, Bridge can no longer see any of those images. Bridge is simply a browser, great for viewing the contents of your job folders.

The D-65 solution is to take advantage of having Lightroom act as a compliment to both Photoshop and Bridge. We import new images into Lightroom, adding metadata upon import. The images are ranked, have selective metadata and captioning and are developed. All this is part of 'normal' Lightroom workflow. After the raw files are tweaked in the develop mode, we export a DNG from Lightroom to a job folder for each shoot along with a JPG, and any other type of file needed for that job. The DNGs, JPGs and other files for the job are in a job folder accessed with Bridge. The DNGs, JPGs and any other type of file can then be opened up in Bridge to reflect all the metadata that was entered in Lightroom. By doing this we are not bogging down the Lightroom catalog.

Let's export some files for our Indian Creek job into a job folder. For our workflow in this job, we are going to create a set of dng files, a set of small jpg files for the copyright office and four full-size tif files of our client's selects from the web gallery that we had already posted for their review.

STEPS FOR EXPORT

1. Select all your images in the Library Grid Mode (you don't have to select them all unless you want to process them all – this all depends on your workflow).
2. Click on the Export button (left of the toolbar).
3. The Export dialog box will pop up.
4. Export Location: We are choosing Export To: Specific folder. Choose your hard drive where your job folders are located (we have a hard-drive setup dedicated to holding all our job folders) (Figure 13.22).

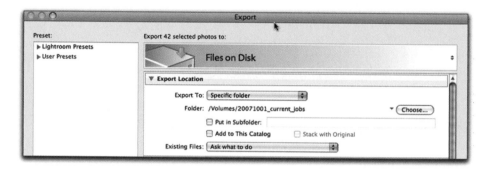

FIG 13.22 Export Dialog Box

5. Create a new job folder on that drive by clicking on New folder (Figure 13.23).
6. Name the folder with the file naming convention for the job. Our job folder name is 20080616_indiancreek_job.
7. After you name the folder, choose Create (Figure 13.24).
8. Then click Choose back in the directory window. You will be brought back to the Export dialog box.
9. Check Put in Subfolder: Give the subfolder the file naming convention for your job and file type you are creating. We will create DNGs for our first type of file for this job. Our subfolder is 20080616_indiancreek_dng. For our workflow, we do NOT click on Add to This Catalog or Stack with Original (Figure 13.25).

FIG 13.23 Job Drive

FIG 13.24 Job Folder on Job Drive

FIG 13.25 Exporting DNG files to Job Drive

10. Existing Files: Choose Ask what to do. There should not be any
existing files in this job folder, but we keep this selected as a
precaution.
11. File Naming: Under the Template drop-down menu, choose
Filename. This preserves the filename that we already have
given to our files. If you wanted to rename your files to a

different naming convention for your client's needs, this is where you can do it (Figure 13.26).

FIG 13.26 Filename for DNG files

12. File Settings: This is where you choose what type of file you will be exporting. Choose the format, and then you will get different options for each type of format. Under Format choose DNG. The DNG options that we choose are:
 • JPG Preview: Medium Size
 • Image Conversion Method: Preserve Raw Image
 • Options: Check Compressed (lossless) (Figure 13.27).

FIG 13.27 DNG Preview Options

13. Image Sizing: This is where you can upres/downres and resize your files if needed. Since DNG files are raw, we cannot check any of these options. We would choose our parameters in this section for any jpg, psd or tiff files.

14. Output Sharpening: Lightroom allows output sharpening for Screen or Print, using algorithms based on Pixel Genius's Photokit Sharpener. Since we are creating DNGs, there is no output sharpening, but we would use this feature for our processed files.

15. Metadata: There are three choices under Metadata. You can minimize the embedded Metatdata, (which only includes the copyright) which D-65 does not recommend. We do choose Write Keywords as Lightroom Hierarchy option so that the hierarchial order of the keywords is visible in your processed files. We do not Add Copyright Watermarks on our files, but it is a great idea for proofs for wedding photographers.

16. Post-Processing: We might or might not do any post-processing from export depending upon the job. Check the advanced Chapter 16 for more information on Post-Processing on Export.
17. Click on Export. Your RAW files will be converted to DNG and wind up in a DNG subfolder of the job folder in your job folder hard drive (Figure 13.28).

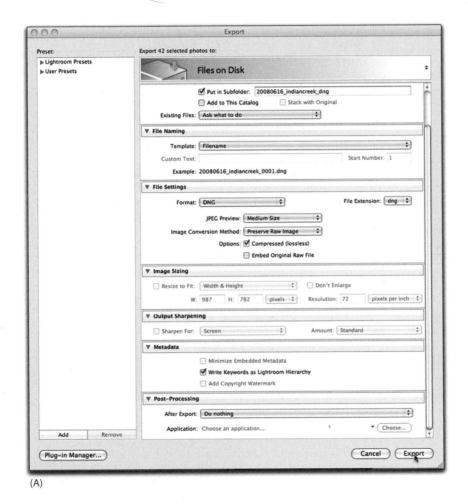

(A)

(B)

FIG 13.28 Exporting DNG's to Job Folder

We will repeat the same Export steps for JPGs (or whatever type of file you may need for the job).

EXPORTING JPEGs: The following specs are for jpg files for the copyright office. We send small jpg and not high-resolution files because there have been cases of theft at the copyright office since it is a public place.

1. All the images are selected in the Library Grid Mode.
2. Choose Export. The Export dialog box will pop up.
3. Change the subfolder name to 20080616_indiancreek_jpg.
4. Under File Naming Template, keep Filename.
5. Under File Settings: Format will be JPG. Quality is 80. Color Space sRGB.
6. Under Image Sizing: Check Resize to Fit and drop down to Width and Height. Width is 600 and height is 600 pixels. Resolution is 72 pixels per inch.
7. Output Sharpening: Check Sharpen For Screen. Amount Standard. Sharpening is not critical for the copyright office, but if we are going to the extent to produce these files, we might as well sharpen them for screen use.
8. Metadata: Choose Write Keywords as Lightroom Hierarchy.
9. Post-Processing: After Export, click on Do nothing.
10. Click on Export. Your RAW files will be converted to JPGs and wind up in a JPG subfolder of the job folder in your job folder hard drive (Figure 13.29).

EXPORTING TIFs FOR THE CLIENT: We are delivering these TIFFs in ColorMatch RGB. Ideally we would deliver in CMYK for print use, but we only deliver in CMYK if we get complete cooperation from the client. When we deliver in RGB, we like to deliver in ColorMatch RGB because it is very close to CMYK. Delivering in Adobe98 is like saying 'See all of this color, well you can't have it.' When delivering in ColorMatch, the client can see and have all of the color.

1. We select the four images our client chose in the Library Grid Mode.
2. Click on Export.
3. The Export dialog box will pop up. Change the subfolder name to 20080616_indiancreek_cf.
4. Under File Naming Template, keep Filename.
5. Under File Settings
 Format: TIFF
 Compression: None

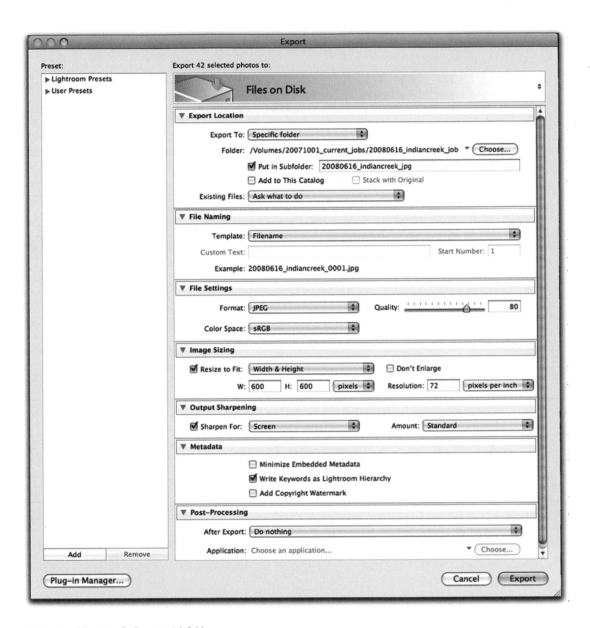

FIG 13.29 JPG options for Export to Job Folder

Color Space: Choose Other. The Choose Profiles dialog box will appear, check Include Display Profiles at the bottom left. Then check ColorMatch RGB. Choose OK (Figure 13.30).

FIG 13.30 Color Profiles for Tiff file Export

6. Under Image Sizing: Do not check Resize to Fit. We are sending full-size files to the client. Resolution is 266 ppi, which is two times the line screen of 133 for the press the client is using.

7. Output Sharpening: Lightroom's Output Sharpening is for Screen and InkJet Printing. For web press printing, we would opt for the third-party plug-in Pixel Genius Photokit Sharpener, or leave output sharpening up to the client.

8. Metadata: Choose Write Keywords as Lightroom Hierarchy.

9. Post-Processing: After Export, click on Do nothing.

10. Click on Export. The four RAW files that the client selected will be converted to TIFFs and wind up in a TIFF subfolder of the job folder in your job folder hard drive.

11. Click on Export (Figure 13.31).

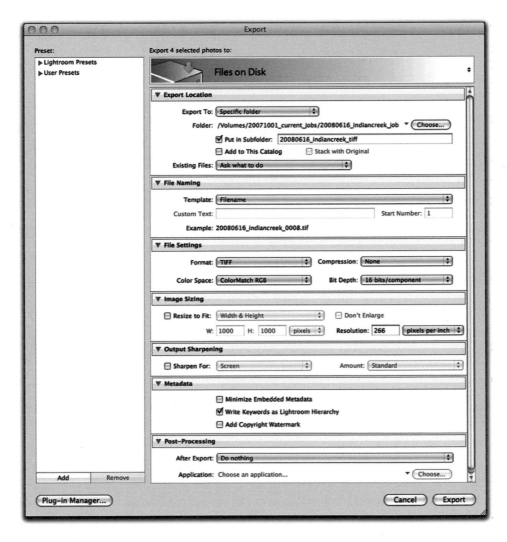

FIG 13.31 Tiff options for Export to job Folder

The beauty of this is that you can export all of these at the same time. You do not have to wait until one group is done to xport another group. It is being done in the background. On the top left

of the Library, Lightroom will show you that three operations are in progress. If you wanted to cancel one of the operations, just click on the X key. In Figure 13.32 below shows Job Folder with DNG, JPG and Tiff files.

FIG 13.32 Job Folder with DNG, JPG and Tiff files

UPRESING ON EXPORT

Lightroom does an excellent job with upresing as well. The upres is done with a proprietary algorithm similar to bi-cubic smoother. We demonstrated going down in size to create smaller jpg files for the copyright office, but you can also create larger files very easily. Follow the same steps as above, and then under Image Sizing, put in the width and height either in inches, pixels or centimeters as per your file requirements. If you wanted to make a 13 × 19 print, put in those numbers. It's that easy ☺

THE WORKFLOW CONTINUES DEPENDING UPON YOUR NEEDS. Your and your client's needs for export may be quite different, but can be accomplished exactly the same way, using job folders for organization.

Archiving

Backup is important, but backup is not preservation. The goal of D-65 is to have an EXACT DUPLICATE of our catalog and all of our image files on multiple media in multiple locations.

An archive should be made regularly because computers are not 100% reliable. Hard disks malfunction, viruses and worms corrupt data, and people can make simple mistakes like deleting when they didn't mean to. Having an archive means you can recover from such things, with little if any data lost.

As Hurricane Wilma passed over Miami Beach, we watched and took photographs from our 17th-floor apartment, which faces the Atlantic Ocean on the front side and the intercoastal on the backside. We live on a very narrow section of Miami Beach, which is roughly one foot above sea level. Our building flooded, our docks were destroyed, and as the storm intensified we watched the roof come off of the building next store. As we looked out

at the raging storm, we realized that our building was actually swaying a few degrees in this class 3 hurricane. We were lucky, but countless others weren't so lucky (Figures 14.1 and 14.2).

FIG 14.1 Damage from Class 3 hurricane in Miami Beach

FIG 14.2 Damage from Class 3 hurricane in Miami Beach

Hurricanes, typhoons, tornados, fires, volcanoes, blizzards and even tsunamis are a fact of life and they wreck lives and destroy property. After each of these events you can usually find a news clip where a reporter asks someone if they were able to save or salvage any of their belongings. You know the scenario because you have seen it hundreds of times. There is a man or woman crying at the scene of what was once their house devastated, because they lost everything. When they can salvage items, they typically grab the memories such as wedding pictures, baby pictures or family pictures. While having little financial value, these items contain tremendous personal value and are irreplaceable. Did you ever stop and think what would happen to your image collection even if it were on multiple media, but all stored in only one location?

If you are a digital photographer, your data are the heart of your business. Not having an archive strategy in place means that a single malfunction can leave your business without any data, thus placing the future of the business in jeopardy. We also suggest having a place that is safe for the computer in the event that one has to evacuate. We wrap all of drives and computers in hefty garbage bags and put them in the bathtub at the approach of a hurricane. The bathtub will hopefully drain if there is water and most bathrooms have doors to offer extra protection. Ideally, a bathroom on an upper floor would be a wiser choice than one in the basement.

Duplicate Backups in Multiple Places

While basic computer backups are a good start, a backup is not necessarily an archive and does little good if your home or office is destroyed. Not only do you need backups, but it is critical to have multiple backups both off-site and on-site and in the case of an emergency. Redundancy, redundancy, redundancy… You simply can't have too much.

An archive should be made to separate media that you can pick up and take with you. This way, copies of your data can be kept off-site, such as in another building. This helps protect against disasters, which may obliterate the building where your computer is held.

Backups

Ideally the copies made onto backup media should be performed with a system that verifies the data. This is fundamental difference

between a backup and an archive. Most folks simply perform a finder copy, better known as drag and drop. These are very unreliable and permissions, preferences and other needed files may or may not copy this way. We personally like Retrospect from Dantz but there are other products as well. These products perform a bit for bit duplication and then verify that the data has been duplicated correctly.

The frequency of your 'backups' should be dictated by how much data you would like to lose if there is a problem on your machine. For example, if you enter a significant amount of data every day, you should be backing up every day. If you rarely enter new data, then backups once per week might be okay.

'Backups' should be tested. Make sure that you can read the backup you just wrote. Nothing is worse than having a disaster and discovering that your backups are unreadable for some reason or another. If you are burning CDs or DVDs, it is usually sufficient to have the burner program 'verify' the disk after it is written.

Of course, if you don't have a computer or power, you won't be able to access the data, but just knowing your personal and business documents are safe is reassuring. A good battery backup system is always a wise idea, but if power is out for an extended period of time even this will fail.

Emergency Power

In case of an emergency, you may or may not have access to power, phone service or the Internet, and the need for power is the foundation of maintaining communication. Power alternatives include extra batteries, conversion battery kits, power cords that hook up to a cigarette lighter, solar packs and manual power generators.

Preparation is the best defense against nature and other unforeseen disasters. While a personal bomb shelter might help you rest easily at night, there are more practical ways to protect your personal treasures. In the event of a catastrophe, take care of your family, friends, property and community. Knowing that you're prepared will let you do just that. Personal safety is always first, of course. But after that, it's insurance companies and state and federal agencies that bear the burden of helping families rebuild and replace material possessions.

Archiving Lightroom

Archiving is different than backing up during processing or in the field. An archive is duplicated bit for bit, verified for integrity duplicated for both on-site and off-site storage.

There are several backups available within Lightroom, but it is important to understand exactly what they do and more importantly what they don't do. When we first import files into Lightroom, the import dialog box offers a backup.

Import Backup

This backup causes confusion to many photographers. They assume that they have a full backup of the imported files, but in fact this backup only provides a backup of the exact structure of the files on the memory card with their original camera-generated names. So if you rename in the import dialog box, apply a metadata preset, or any develop preset or keywords, none of this will be available in the backup. This is really just a temporary insurance plan, should something go wrong with the import (Figure 14.3).

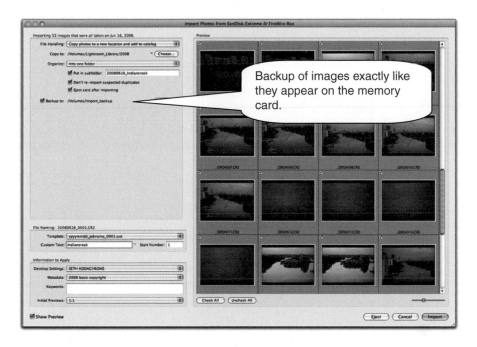

FIG 14.3

The Catalog Backup

The Catalog Backup in Lightroom's Catalog Preferences is a backup of the Catalog. While the preferences clearly say Catalog Backup, most photographers fail to recognize exactly what this means. It means exactly what it says. It is a backup of the Catalog. **It is not backing up any of the images associated with the catalog.** So if you have your catalog and your images on drive A and you have chosen to backup to drive B, the only backup occurring is a backup of the catalog, not the images. If drive A fails and this is where you had your images, you would have just lost all your images.

Additionally, there are choices for when to perform this Catalog Backup. They are all for time periods when Lightroom starts. Typically, when we are ready to use Lightroom we want to start using it. The last thing we want is to have to wait for a complete backup of the catalog, which could take hours. A better choice here would have been to perform a backup when the catalog is closed. We don't have Lightroom backup our catalog. We do the backup ourselves daily (Figure 14.4).

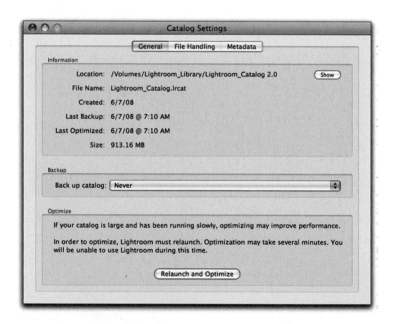

FIG 14.4 Catalog Backup

The D-65 Archive

We want to duplicate and backup our Images and our Lightroom Catalog. As we said earlier, the Lightroom Library and Catalog are held

on an internal terabyte drive with nothing else on it. We duplicate the Lightroom Library and Catalog on a second internal terabyte drive as well as two external drives, one of which goes off-site.

Media Choice for Archive

D-65 chooses hard drives as our main means of archiving for many reasons. Do you remember SyQuest drives? Eventually, they became obsolete. The same happened with the Zip format, optical drives and on and on. The only standard that has been around to stand the test of time is the hard drive. When a newer and faster drive comes out, it is easy to simply duplicate an entire drive. Many people make their main archive on CD, but there are many problems with CD. The average CD may only last for 3–10 years and that is a potential disaster for archiving. Further, if one has 20 gigs of data per photo shoot, there could easily be 50 CDs or more per shoot.

D-65 Drive Structure

As discussed in Chapter 4, D-65 chooses to have a large internal drive holding our images (Lightroom Library) and our Catalog. The structure of that drive looks like Figure 14.5.

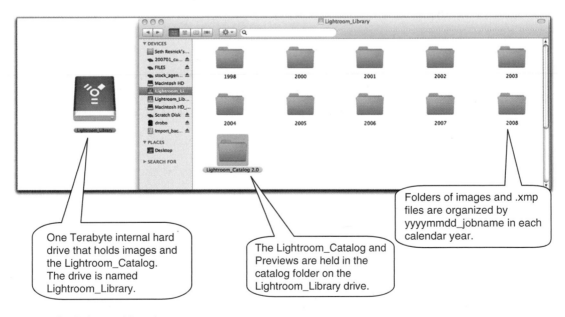

One Terabyte internal hard drive that holds images and the Lightroom_Catalog. The drive is named Lightroom_Library.

The Lightroom_Catalog and Previews are held in the catalog folder on the Lightroom_Library drive.

Folders of images and .xmp files are organized by yyyymmdd_jobname in each calendar year.

FIG 14.5 D65 Lightroom_Library drive structure

In each year folders are folders for each job named yyyymmdd_
jobname, and in each job folder are the raw files and
corresponding .xmp files as in Figure 14.6.

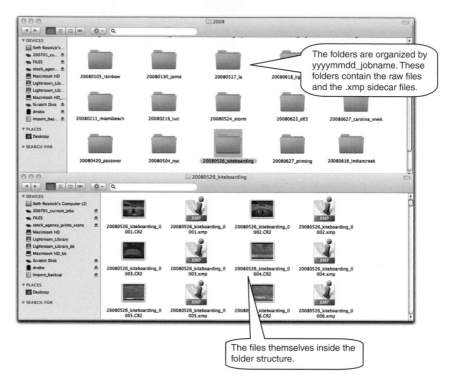

FIG 14.6

The Lightroom_Catalog folder contains two files, the Lightroom_
CatalogPreviews.lrdata and the Lightroom_Catalog.lrcat files
(Figures 14.7 and 8).

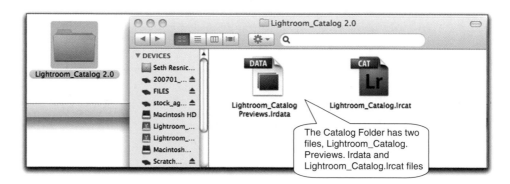

FIG 14.7

FIG 14.8 Internal Backup and Backup to a Drobo

Making the Backups

The Lightroom_Library gets duplicated to a second internal drive called Lightroom_Library_bk and that drive gets duplicated to a drobo. Even the Drobo gets duplicated to a second Drobo that gets stored off-site. *For detailed information on drobo see: http://www. Datarobotics.com.*

As we said earlier, we do not use drag and drop of finder copies as they are not very accurate. Instead, we use software specifically designed for archiving. We use Retrospect. *For detailed information on Retrospect see: http://www.emcinsignia.com/*

When we use Retrospect, we choose Duplicate and not Backup. The backup is proprietary. The duplicate choice is a bit for bit duplication with full verification of the data at the end. To use we simply choose a source and a destination (Figure 14.9).

FIG 14.9 Using Retrospect for Backup

Summary

Backup is important, but backup is not preservation. The goal of D-65 is to have an EXACT DUPLICATE of our catalog and all of our image files on multiple media in multiple locations. ARCHIVES should be made regularly because computers are not 100% reliable. Hard disks malfunction, viruses and worms corrupt data, and people can make simple mistakes such as deleting when they didn't mean to. Having an archive means you can recover from such things, with little if any data lost.

If you are a digital photographer, your data is the heart of your business. Not having an archive strategy in place means that a single malfunction can leave your business without any data, thus placing the future of the business in jeopardy.

Discussion Questions

(1) Q. Why have on-site and off-site backups of your data?

A. While basic computer backups are a good start, a backup is not necessarily an archive and does little good if your home or office is destroyed. Not only do you need backups but it is critical to have multiple backups both off-site and on-site and in the case of an emergency.

(2) Q. Why is it important to have at least one backup on portable media?

A. An archive should be made to separate media that you can pick up and take with you. This way, copies of your data can be kept off-site, such as in another building. This helps protect against disasters, which may obliterate the building where your computer is.

(3) Q. What are finder copies and what is the problem with them?

A. Most folks perform a finder copy, better known as drag and drop. These are very unreliable and permissions, preferences and other needed files may or may not copy this way. We personally like software called Retrospect from Dantz, but there are other products as well. These products perform a bit for bit duplication and then verify that the data has been duplicated correctly.

(4) Q. How often should you backup?

 A. The frequency of your 'backups' should be dictated by how much data you would like to lose if there is a problem on your machine. For example, if you enter a significant amount of data every day, you should be backing up every day. If you rarely enter new data, then backups once per week might be okay.

(5) Q. What is backed in Lightroom if you choose backup on import?

 A. This backup only provides a backup of the exact structure of the files on the memory card with their original camera-generated names. So if you rename in the import dialog box, apply a metadata preset, or any develop preset or keywords, none of this will be available in the backup. This is really just a temporary insurance plan should something go wrong with the import.

(6) Q. What is backed up if you choose backup in Lightroom's Catalog Preferences?

 A. It is only backing up the catalog itself. It is not backing up any of the images associated with the catalog. So if you have your catalog and your images on drive A and you have chosen to backup to drive B, the only backup occurring is a backup of the catalog not the images. If drive A fails and this is where you had your images, you would have just lost all your images.

(7) Q. A complete backup of Lightroom would include backing up what?

 A. An exact duplication of the Lightroom Catalog and all the image files associated with the catalog.

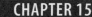

Importing and Exporting Catalogs and Synchronizing Your Laptop and Desktop

The question is:

> I use a Laptop in the field when shooting and a desktop at the studio/home for processing and management in Lightroom. If the 'main' Library and Catalog live on my 'main' computer's external drive in the studio/home, how do I sync the Catalog on my laptop or other computers with the 'main' Library and Catalog?

There are several ways to do this, and we will review them here. Most of them are rather confusing, but D-65 has found work-around solutions that work effortlessly and flawlessly. Your methodology for accomplishing this needed task will be dependent upon what you need to do on your files in the field.

D-65 Concepts for Syncing

Concept One

You maintain your archive on your studio or home desktop computer. You have a shoot on location, so you will be bringing a laptop and external hard drive on location with you. You may do some work on the files you capture in the field, but your main goal is simply to take the images you captured in the field and bring them back to the studio, placing the images from the field into the studio/home machine.

In this scenario, you don't need to bring or care about bringing your entire archive of images with you on your shoot.

Solution for Concept One

(1) The easiest and most reliable way to accomplish this is to bring a laptop and a hard drive on location. For absolute protection, we like to bring two or three external drives on location, duplicating the contents to all three drives just to protect against drive failure or theft or any other unforeseen circumstance.

(2) Ideally reformat the hard drive before the trip. We usually take LaCie Rugged drives or SmartDiskFireLite drives, but any decent portable drive will do.

(3) Before we leave, we create a new Lightroom catalog on the freshly reformatted drive. We name the catalog yyyymmdd_ Lightroom_Catalog. Refer to Chapter 4, for creating a new catalog.

(4) We shoot the job(s) on location and import to the portable drive into a folder named yyyymmdd_jobname. Our external drive will then have a Lightroom catalog and a folder of images from that job.

(5) We tweak our files in the field and apply metadata and keywords, edit out ones we don't want, rank and essentially accomplish as much as we can.

(6) Verify that, in Lightroom's Catalog Settings>Metadata, you have checked Automatically Write Changes into XMP. If you don't have that checked in your Catalog Settings, after you are done tweaking all your files, select them all in the Library Module grid mode and choose Save Metadata to File (Command S).

(7) We return home and plug the external drive into our main computer at the studio or at home.

(8) We start Lightroom on the main computer and choose Import from the lower left-hand corner of the Library Module. We select the folder to import.

(9) The Import Photos dialog box will pop up (**Figure 15.1**).

FIG 15.1 Import Dialog Box

- **File Handling:** Choose Copy photos to a new location and add to catalog.
- **Copy to:** The location that all of our image files reside, our Lightroom_Library hard drive on our main computer. In our case, it will be /Volumes/Lightroom_Library/2008.
- **Organize:** By original folders.
- Don't reimport suspected duplicates.
- **File Naming:** Template Filename – because we named the files in the field.
- **Information to Apply:** None, because we have applied Develop Settings, Metadata and Keywords in the field.
- Choose 1:1 Initial Previews because we always want 1:1 previews.

(10) The files are imported, and all material is now on our main drive. The portable drive can be reformatted and readied for the next location shoot.

Concept Two

You maintain your archive on your studio or home desktop. You are leaving for a location shoot and want to bring your entire

catalog and images from studio/home with you. You do not plan on working on any old images, but you want the material with you just in case. You have a shoot on location, so you will be bringing a laptop and external hard drive with you. You may do some work on the files you capture in the field, and your goal is to add these images to your existing catalog that you took with you in the field. When you return to the home or office, you want to update the catalog at home with the material you captured in the field.

Solution for Concept Two

(1) The easiest and most reliable way to accomplish this is to bring a laptop and an external hard drive that is large enough to hold the entire Lightroom catalog and image files and can be reformatted on location. For absolute protection, we like to bring two or three drives on location, duplicating the contents to all three drives just to protect against drive failure, theft or any other unforeseen circumstance.

(2) Ideally reformat the hard drive you are bringing on location before the trip. We usually take use a large 750-GB Seagate or 1-TB Seagate external drive. This drive is reformatted so that there is nothing on it, and it is given the same name as our main drive at home. We color code them differently. We do this so that file paths will be exactly the same. If we had different named drives for location, our files could lose their paths, and rather than pointing each folder to the right drive, this is an easier solution (**Figure 15.2**).

The drive for location is given a different icon, but the name of the drive is exactly the same name as that of the main drive.

FIG 15.2

(3) Before we leave, we copy our Lightroom_Catalog and folders of images from our main Lightroom_Library to the external drive we are taking on location. Ideally, we accomplish this using Retrospect or other backup software (**Figure 15.3**).

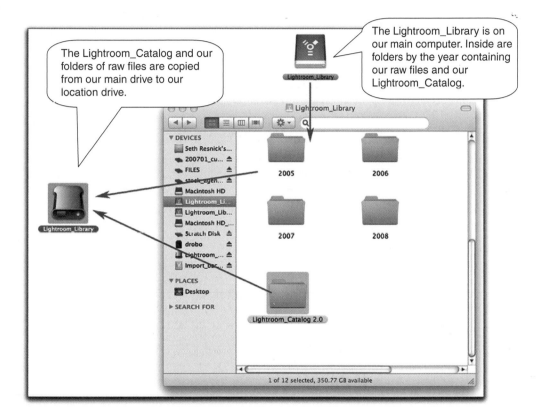

The Lightroom_Catalog and our folders of raw files are copied from our main drive to our location drive.

The Lightroom_Library is on our main computer. Inside are folders by the year containing our raw files and our Lightroom_Catalog.

FIG 15.3

(4) We shoot our job and import to the portable drive into the 2008 folder. The job is named yyyymmdd_jobname. In **Figure 15.4**, on page 308 we have imported files into a folder named 20080622_denver.

(5) We tweak our files in the field and apply metadata and keywords, edit out ones we don't want, rank and essentially accomplish as much as we can.

(6) Verify that, in Lightroom's Catalog Settings, you have either checked Automatically Write Changes into XMP or, after you are done tweaking all your files, selected all of them

FIG 15.4 2008 Folders in Lightroom_Library

FIG 15.5 Folder showing raw files
and sidecar.xmp files

and chosen Save Metadata to File (Command S). **Figure 15.5** shows the 20080622_denver folder with all the raw files and corresponding .xmp files.

(7) We return home and plug the external drive into our main computer at the studio or at home.

(8) We start Lightroom on the main computer and choose Import from the lower left-hand corner of the Library Module. We select the folder to import.

(9) The Import Photos dialog box will pop up (**Figure 15.6**).

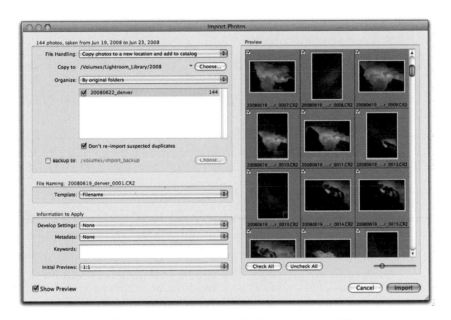

FIG 15.6 Import Dialog Box

- **File Handling:** Choose Copy photos to a new location and add to catalog.
- **Copy to:** The location that all of our image files reside, our Lightroom_Library hard drive on our main computer. In our case, it will be /Volumes/Lightroom_Library/2008.
- **Organize:** By original folders.
- Don't reimport suspected duplicates.
- **File Naming:** Template Filename – because we named the files in the field.
- **Information to Apply:** None, because we have applied Develop Settings, Metadata and Keywords in the field.
- Choose 1:1 Initial Previews because we always want 1:1 previews.

(10) The files are imported, and all material is now on our main drive. The portable drive can be reformatted and readied for the next location shoot.

Concept Three

You maintain your archive on your studio or home desktop. You are leaving for a location shoot and want to bring your entire catalog and images from studio/home with you. You plan on working on old images from the existing catalog, but you also want to add new material. You have a shoot on location, so you will be bringing a laptop and external hard drive on location with you. When you return to the studio/home, you want to update the catalog on your main computer with the material you captured in the field and with the material changed in the field. Now we must sync the field catalog and the studio/home catalog.

Solution for Concept Three

(1) The easiest and most reliable way to accomplish this is to bring a laptop and an external hard drive that is large enough to hold the Lightroom catalog and any image files that you want to bring on location.

(2) Ideally reformat the hard drive you are bringing on location before the trip. We usually take a 750-GB Seagate or 1-TB Seagate external drive. This drive is reformatted so that there is nothing on it and it is given the exact same name as our main drive at home. We color code them differently. We do this so that file paths will be exactly the same. If we had different named drives for location, our files could lose their paths, and rather than pointing each folder to the right drive, this is an easier solution.

(3) Before we leave for location, we copy our Lightroom_ Catalog and folders of images to the external drive. Ideally, we accomplish this using Retrospect or other backup software.

(4) We shoot our job and import to the portable drive into the 2008 folder. The job is named yyyymmdd_jobname. In **Figure 15.7**, we are on location and have shot some lightning images for a job. These images are imported into a folder called 20080618_lightning.

(5) We tweak our lightening files in the field and apply metadata and keywords, edit out ones we don't want, rank and essentially accomplish as much as we can.

FIG 15.7 Images are worked on on the road

(6) We also work on a second folder (**Figure 15.8**) and make changes to keywords, metadata and develop module, delete some images and rename the entire group. We are going to want to have these changes apply to our 'main' Lightroom Library and Catalog when we get home. We are going to want

FIG 15.8 Images are worked on on the road

to add the lightning as new material and replace or update the indiancreek folder at home with the changes made in the field.

(7) Verify that in Lightroom's Catalog Settings, you have either checked Automatically Write Changes into XMP or, after you are done tweaking all your files, selected all of them and chosen Save Metadata to File (Command S).

(8) Next we are going to select each folder of images that we worked on and export each as a catalog. First, we select 20080616_indiancreek, and then we select 20080618_lightning. We export them to our laptop's desktop or to the external drive. We export first to the laptop or desktop and then duplicate the catalog to an external drive(s) as a backup (Figures 15.9A–C).

(A)

(B)

(C)

FIG 15.9 A&B&C Exporting a Catalog

(9) We return to the studio/home and plug the external drive into our main computer. At this point, you can copy the exported catalog(s) and image files to your studio/home computer's desktop, or work off the external drive from location. In this demo, we moved the catalogs from the location laptop to our main desktop. We start Lightroom on the studio/home computer and choose from the Library Module File Menu>Import from Catalog. We navigate to our desktop where we have placed the indiancreekjob folder, which was altered in the field (**Figures 15.10A** and **B**).

(A)

(B)

FIG 15.10 A&B Importing a Catalog

FIG 15.11 Import Catalog Choices

FIG 15.12 Import Progress Bar

(10) Because these files exist on our studio/home computer, we get a dialog box asking us what we want to do. We choose to Replace Metadata, develop settings and negative files in order to update our catalog at home that we altered in the field (**Figure 15.11**).

(11) The indiancreek images that we altered on the field laptop computer are imported and the existing images on our office/home computer updated (**Figure 15.12**).

(12) We repeat this process, this time importing the lightening folder, which does not yet exist on our home/office computer. Notice that the Existing Photos dialog box is grayed out. Under File Handling, we choose Copy photos to a new location and add to catalog. We copy to the location, our Lightroom_Library, where all of our image files live on our main computer (**Figure 15.13**).

(13) The files from the lighteningjob and the old indiancreekjob have been imported, and all material now on our main computer is up to date.

FIG 15.13 Import from Catalog settings

Summary

You use Lightroom on a main computer and take a laptop on location. How you go about syncing the work done on your laptop on location to your main computer is a critical part of the workflow. There are several methods that will accomplish this task in Lightroom. The choice you make will be dependent on whether you are simply acquiring new information on location that you want to bring back to the main computer, or whether you are taking information from the main computer and working on that in the field and then syncing that information back to the main computer.

Discussion Questions

(1) Q. If you are just going on location and want to take a laptop and bring the new files you shot back to your main computer, is it necessary to export a catalog?

A. No, the easiest thing to do is make sure that the .xmp file is saved with the files on location and simply take the folder of images and .xmp and import to the main computer at home.

(2) Q. When is exporting and importing a catalog a necessary step?

A. If you take information from the main computer and make additional changes to those files on location and then you want to merge the changed information back into the main catalog, it is necessary to export a catalog from one computer and import the catalog into the existing catalog on the other computer.

Taking It Up a Notch – Advanced Lightroom

W hat is advanced to some is basic to others, but we are pretty sure that most of you will find that this chapter definitely takes it up a notch. We are going to explore a few of the advanced features that further the power of Lightroom, Edit in Photoshop and Post-Processing on Export.

Edit in Photoshop

The first feature to examine is Edit in Photoshop, or keyboard shortcut Command E. Lightroom provides the ability to go directly from a file in Lightroom into Photoshop, work on the file in Photoshop, and then to save the file with those changes back into Lightroom.

FIG 16.1 Raw file opened directly in
Photoshop and saved back to Lightroom

In **Figure 16.1** above we took a raw file from Lightroom with
Lightroom adjustments, 20080707_lightning_0004.CR2, and hit
Command E. This opens the file in Photoshop in a nondestructive
fashion, recognizing all of the Lightroom adjustments. We then
applied some Photoshop adjustments that we could not apply in
Lightroom to the file. We then close the file, and save changes and
it automatically saves an edited version of the file, as a TIF, next to
the original raw file in Lightroom's Library. The new filename for
the file from Photoshop then has the name, 20080707_lightning_
0004-Edit.TIF.

Edit in Photoshop: Merge to Panorama

You can even select multiple images in Lightroom and take
advantage of Photoshop Merge to Panorama, or Merge to HDR. For
this demo we are going to create a panorama of Miami Beach.

FIG 16.2 Choose raw images for panorama

1. We select eight raw files in the Library Module Grid Mode
 (**Figure 16.2**).
2. From the Library Module Photo menu, we select Edit In and
 drop down to Merge to Panorama in Photoshop (**Figure 16.3**).
3. The Photomerge dialog box opens and we select Auto for the
 layout and for source files we choose Files. We then choose OK
 (**Figure 16.4**).

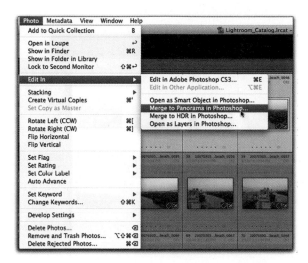

FIG 16.3 Merge to Panorama in Photoshop

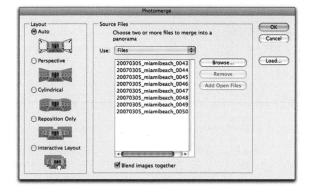

FIG 16.4 Selection of files in Photoshop for Panorama

FIG 16.5 Layers Blend based on Content

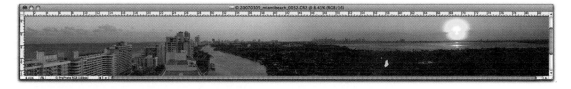

FIG 16.6 Final Panorama in Photoshop

4. The files are opened and the layers are blended together (**Figure 16.5**).
5. We have created a panorama of 200 plus degrees (**Figure 16.6**).

6. We choose save from the dialog box which will save this file right next to our original files in Lightroom (**Figures 16.7A** and **B**).
7. The file is rendered as a 502 MB tif file. If we check the dimensions of Photoshop, we can see we now have a panorama which is over 85 inches wide. How cool is that ☺ (**Figure 16.8**)

(A) (B)

FIG 16.7 Saving Panorama as a Tiff

FIG 16.8 Newly created image in
Lightroom

8. The newly created image is saved directly in Lightroom as a Tif, with the suffix Edit which of course can be changed if need be (**Figure 16.9**).

FIG 16.9

Now we could make nondestructive edits to this file in Lightroom and then if we choose Command E or Open in Photoshop we could take advantage of those nondestructive edits and again open the file in Photoshop. If we choose Command E we would get the following dialog (**Figure 16.10**).

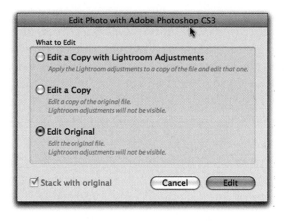

FIG 16.10 Edit Photo with Adobe
Photoshop CS3 Adjustments

Edit a Copy with Lightroom Adjustments: Edits a copy of the
original file with Lightroom adjustments visible.
Edit a Copy: Edits a copy of the original file without Lightroom
adjustments. This is not for raw files. It is for jpg, tif and psd only.
Edit Original: Edits the original file without Lightroom
adjustments. This is not for raw files. It is for jpg, tif and psd only.

Depending on how far you want to go with this file would depend on
your choice but it is important to understand the dialog nonetheless.

Post-Processing on Export with Actions for Power Processing
There are a number of options available under Post-Processing in
the Export Dialog Box. To really bump the workflow up a notch,
we customize this feature for our workflow. We write Photoshop
actions and have them execute on our images as we export them
from Lightroom. This truly integrates Lightroom and Photoshop
and speeds up workflow.

As a photographer how often do you find yourself working in
Photoshop doing repetitive tasks over and over again? If you are
like most folks the simple answer to this question is way too often.
Well, if you enjoy all that wasted time in Photoshop you have
no problems, but if you want to reduce your time in Photoshop
and get back to shooting there is a solution. Actions automate
repetitive tasks and are the key in taming workflow. An Action
allows you to automate your workflow and batch process your
files. An Action is a 'tape' recording of the steps needed to process
one image, which can be played back and applied to a group of
images. Learning how to write actions can help you get your life
back or at least some of the precious time.

Consider this scenario which was in fact a very real set of tasks we needed to accomplish this week. We had 400 raw files that we worked on in Lightroom and wanted to prepare them for a multimedia presentation. The requirements for the multimedia presentation were to have the images with a ¼ inch white frame and to have the images in sRGB at a resolution of 144. The verticals needed to be 768 tall and the horizontals needed to be 1024 wide.

If we were doing this one file at a time, we would likely still be working in Photoshop two days later. Instead, we were able to hit a keyboard shortcut, go to Starbucks and all the files were processed when we returned home, thanks to Post-Processing on Export with Actions.

Are Actions Part of Photoshop?

Some actions come with Photoshop and those are known as the default actions. You can also write your own actions or gather them from other sources. Actions are located in Photoshop's main menu under Window > Actions. Actions in the Actions palette are arranged in sets, each of which can contain one or more actions. To open an action set, click the right-pointing arrow to the left of the action set name. Now you'll see the list of actions in the set. This panel and Actions in general are not the most intuitive things in Photoshop. For example, after creating an action you will find that you can't save an individual action. You can only save a set of actions. Sets are sort of like holding pens that hold individual actions. For example you might have a retouching set and a processing set and a sharpening set. In each of these sets you might have many actions to accomplish different tasks.

The actions included in Photoshop are only a small example of what can be done with actions. You can write your own actions and can record commands like open, close and save as part of the action. In fact just about everything you can do in Photoshop is in fact actionable.

Before creating an action to perform a complex task (particularly if you're unsure exactly how to begin), search the web to see whether an action already exists to do the job. A good place to start looking is the Adobe Studio Exchange, which is a shared resource for many Photoshop tools. If you find an action you like you can load an action by opening the Actions Palette menu, choosing Load Actions, navigate to where you saved the action and select the .atn file, and click Load to load it. You can then play

the action by opening the actions set, selecting the action to play, and clicking the Play Selection button. Big note…You have to have an image open to play the action on.

Creating Your Own Action

Once you're comfortable with finding the actions and using them you can try and create your own custom actions.

For those who have written actions before the two common problems that folks run into when playing actions is having one image open up over and over again and/or having the action run and seemingly work but the finished images are nowhere to be found. Both of these are very common problems. The first happens when you have an image opened and start writing the action on that image. Then every time you run the action that same image will open over and over again.

The second problem of images disappearing occurs when you save the images in the action to a specific folder that has since been thrown out. Now the action runs and looks for that specific folder path which is now in the trash and thus the action runs perfectly but deposits all of the files in the trash and empties the trash. While both of these problems can be solved by checking the correct options in the Batch Dialog Box, there is still a much better way that eliminates almost all the problems associated with action writing.

We like to have our destinations designated by the action so we suggest that you create a folder on your desktop that is permanent destination for all your actions. We call our 'D65 Lab'. By having this permanent 'lab' on the desktop, all of the actions run to the same destination eliminating any problems with folders no longer in existence or disappearing files.

One further problem is that Lightroom doesn't really play actions. The good news is that you can turn an action into a Droplet and have the Droplet executed by Lightroom. Following is a demo on Post-Processing in Lightroom for our presentation scenario described earlier.

Before You Begin Writing the Following Action

1. Edit and Rank the images in the Lightroom (delete all out takes).
2. Verify that the images have been properly named, keywords added and that metadata has been applied.

3. Make sure that all developing is finished and the images are pretty much the way you want them.
4. Make sure that you have a destination folder for your actions. Ideally set up the folder with subfolders for all the processing you are going to do. For the action below I have a D65 LAB FOLDER and one subfolder inside, called multimedia.

We will write a simple action that will access your processed full-size jpgs located in your job folder (these jpegs would have processed during export from Lightroom) and will size them to a resolution of 144 with a .25 inch white border and deposit those into a folder called multimedia. The horizontals will be 1024 wide and the verticals will be 768 tall. All the metadata applied from Lightroom will be embedded in this new set of jpegs. Even your rankings will be there too!

Let's Write the Action

1. Make new folder on desktop called D65 Lab or 'white border for client x', or whatever you want to call it. We are creating a folder called D65 lab and inside that folder will be a folder called multimedia images (**Figures 16.11A** and **B**).

(A)

(B)

FIG 16.11 D65 Folder on Desktop

2. Process one raw file in Lightroom into a jpg at the following specs (see below).
 - Color Space is sRGB
 - Resolution at 144
 - Check Resize to Fit dimensions at 987 × 732

Because we are making a ¼ inch white border around the image, the image size is 987 × 732. When we add the border the final size will be 1024 × 768 (**Figure 16.12**).

FIG 16.12 Output size adjusted to 987 × 732

FIG 16.13 Actions Palette in Photoshop

3. Open the one jpg you just created in Photoshop.
4. Go to the Actions Palette in Photoshop, located under Window < Actions (**Figure 16.13**).

5. Using the fly-out arrow, create a new set called Lightroom Actions. You will put any action you write for Lightroom into this set (**Figures 16.14A** and **B**).

(A) (B)

FIG 16.14 Lightroom Actions Set

6. Highlight that set and choose create new action within that set (**Figure 16.15**).

FIG 16.15 New Action

7. Call it 'xxx action (i.e. whatever action you are writing)'.
8. Click record (**Figure 16.16**).

FIG 16.16 Record new Action

9. Go to image that is already open and from the Image Menu choose Canvas Size.
10. Type in .25 × .25 under width and height. Make sure Relative is checked, and the Canvas extension color is white.

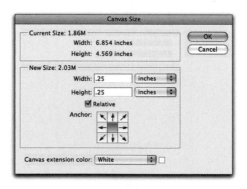

FIG 16.17A Adjusting Image Size

11. Choose OK (**Figures 16.17A** and **B**).
12. Go to the File Menu and choose Save As.

FIG 16.17B

13. Save As a jpg to the new 'multimedia' folder that you created in the D65 Lab on your desktop (**Figure 16.18**).

FIG 16.18 Save as JPG

14. The jpg options dialog box will appear. Choose 10 medium baseline standard and choose OK (**Figure 16.19**).

FIG 16.19 JPG Options

327

15. Close the image that is open in Photoshop (**Figure 16.20**).

FIG 16.20 Image is closed in Photoshop

16. Stop the Action from the Actions Palette (blue button at the bottom) (**Figure 16.21**).

FIG 16.21 Action is stopped

17. Now you need to convert the Action into a droplet.
18. Select Action called ¼ inch white border from the Actions Palette.

FIG 16.22 Droplet created from
Action in Photoshop

19. Go to File Menu > Automate > Create Droplet (**Figure 16.22**).

FIG 16.23 Saving Droplet to Light-
room Export Actions Folder

20. Check the two boxes in Create Droplet Dialog Box, Destination
 NONE (**Figure 16.23**).
21. Save the droplet in User > Library > Application Support >
 Adobe > Lightroom > Export Actions. For a PC the location
 is > Documents and Settings > UserName > Application
 Data > Adobe > Lightroom > Export Actions.

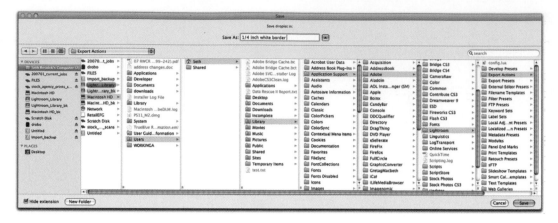

FIG 16.24 *Naming the Droplet*

22. Save Droplet and give it a name that makes sense, like ¼ white border (**Figure 16.24**).

To Run the Action/Droplet in Lightroom

1. Open Lightroom
2. Select the images that you want to export and process with this new droplet in the Library Module
3. Choose Export
4. Go through the Export Dialog box choosing the correct parameters
5. Under Post-Processing > After Export > choose droplet from the drop-down menu (**Figure 16.25**)

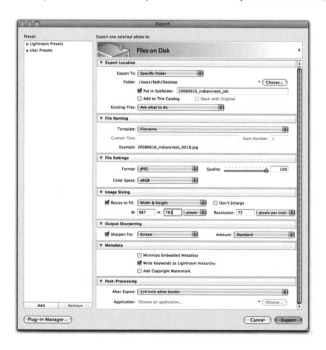

FIG 16.25 *Post Processing Dialog Box in Lightroom*

6. Click on Export
7. Your selected images will export to the correct specs and the droplet will run on them

Action Tips for Photoshop

Viewing an Action: Click an action's name to select it. Click the right-pointing fly-out menu arrow to the left of the name. You can now see every step of the action in detail.

Undoing an Action: To undo the effect of an action, click the History palette and step back through the commands individually until the image returns to the desired state.

Saving Actions: The new action will stay in the Actions palette even after Photoshop is closed and reopened. However, the action is not saved so you will lose it if Photoshop crashes. For this reason, you should save your actions. You can't save individual actions, only action sets – but you can create a set with only one action in it, if you want. If your action doesn't appear in the Actions palette, you can load it by loading the set in which the action is saved.

Editing an Action: The simplest way to edit an action is to open any image and then double click on the section of the action you want to edit. You can change anything in an action as long as you have an image opened. After making the changes be sure to also resave the set to make sure that the change is saved. You can remove a statement from an action by dragging it over the trashcan icon at the foot of the Actions palette. To add a step, click where it should appear in the action and click the Begin Recording button. Record the missing commands and, when you're done, click the Stop Playing/Recording button.

Adding a pause to an Action: Once you've created a few simple actions like the one we've just recorded, you may encounter a situation in which you want the ability to interact with the action. When you're running the action, for example, you may want to resize the image at some point in the process. To open a dialog box while an action is running and have it pause until a choice is made, use the Insert Menu Item option on the Actions Palette menu. This option lets you force a dialog box to open at a defined point in the action so that you can make a selection from it.

Stopping and Restarting an Action: Another handy tool to use in an action is a stop. To add a stop, you select Insert

Stop from the Actions Palette menu. A stop allows you to display a short message, which appears in a small dialog box as the action is played. You can use this feature to type a brief description of the action or to give brief instructions about the steps in the action.

If you're using a stop just to provide a brief message – and if you don't want to stop the action from playing – check the Allow Continue checkbox.

As an example of when you may want a stop suppose, you need to crop the image before continuing and you won't know ahead of time what portion to crop. Choose Insert Stop, and type a message indicating that you should now crop the image and reminding you to continue with the action from the following statement when the crop is complete. Disable the Allow Continue checkbox and continue recording the action.

When the action is played, you'll be prompted to crop the image and advised to continue playing the action after you've done the cropping. Crop the image; then, to continue playing the action, click the statement following the stop in the action and click Play Selection to play from that statement forward.

Adding User Control: When you record an operation that includes parameters of some kind, the Actions palette records the exact parameters that you enter at the time you make the recording. If you'd rather enter parameters for a given step on-the-fly, while the Action executes, check the Toggle Dialog On/Off switch next to the appropriate step in the Actions palette. This will cause the action to pause and display its dialog rather than automatically entering the values you used when the Action was created. These checkmarks can be turned on and off and are used to toggle steps inside the action. If they are checked, the step will be played when the action is run. If they are unchecked, the action will skip over these steps when the action is played. This provides for greater flexibility when you use an action.

F-Keys: Assign F-Keys on your computer to actions, so that you can simply hit the key and the entire action is run.

Button Mode: This will convert your Action palette into a list of usable buttons. You can separate all your actions out by their color. However, this mode is not very functional, as you cannot edit or change your actions while in button mode.

Saving Actions as a Text File to Print out For Reference: You

can save actions as a text file to examine the steps involved or to print. In the Actions palette, highlight the Action set you want to save, then hold down Ctrl + Alt (Windows) or Command + Option (Mac) while selecting Save Actions from the Actions Palette menu. You will get a text file containing all the commands and settings contained in the action set. Note that the text file cannot be converted back to an action so it is not suitable for transferring or backing up actions.

Insert Path: This command is only available when a path (or shape) is selected. Use it to insert the selected path into the selected action (below the active step) as a series of anchor and handle coordinates. Set your ruler units to percentage before using this command. This will ensure that the path is sized and positioned relative to the canvas size. Otherwise, the path may appear too large, or completely outside the canvas boundaries.

Clear All Actions: As the name implies, this command removes all actions (and sets) from the Actions palette.

Selecting Noncontiguous Action Steps: Select noncontiguous action steps using the Shift key. Use the Ctrl key to range select contiguous action steps. You may then delete, duplicate or even play the selected steps! However, this only works within the current action.

Short Cut Delete: Alt-click the Delete button (on the Actions palette) to delete the selected item without confirmation. This is equivalent to dragging the desired item onto the Delete button.

Even though operations performed in the Actions palette may not be undone using the Edit » Undo command or the History, you can undo/redo the last operation (and only the last operation) by pressing Ctrl + Z.

Summary

Lightroom provides the ability to go directly from Lightroom into Photoshop and then to save those changes back to Lightroom. This means that you can take advantage of tasks like Photomerge and Merge to HDR directly out of Lightroom. Further you can use the power of nondestructive editing in Lightroom which would otherwise be destructive in Photoshop. You can even write actions in Photoshop and save them as Droplets and play those directly out of Lightroom.

Discussion Questions

(1) Q. Can you make a panorama in Lightroom?

A. No not directly, but you can select a group of images and export directly from Lightroom into Photoshop's Photomerge and then save the newly created panoramic directly back into Lightroom.

(2) Q. What does Edit a Copy With Lightroom Adjustments mean?

A. When editing a file from Lightroom in Photoshop, you will Edit a copy of the original file with Lightroom adjustments visible.

(3) Q. Can you edit a copy of a proprietary raw or DNG file?

A. No. Edit a Copy is not for any raw file. It is for jpg, tif and psd only.

(4) Q. Can you execute an action directly from Lightroom?

A. No. Actions can't play out of Lightroom. They can only play out of Photoshop, but an action can be saved as a Droplet and the Droplet can be saved in Lightroom's Export Actions Preset Folder which will allow the Droplet to be played from Lightroom automatically after export.

Digital Dictionary

A/D Converter (Analog/Digital Converter)

One of the most important components of the digital camera is the A/D converter. The digital sensor is composed of cells that are light sensitive. The cells capture photons and the image is composited based on the luminance or intensity of the light. More light equals more information. The cell converts light to voltage and generates voltage directly proportional to the intensity of the light.

The voltage is regulated by the A/D converter and the voltage is divided into sections. On one end there is black and the other end is white. As the bit depth increases, there is more separation of values, which provides smoother ranges in light density. Hence, a 14-bit capture is better than a 12-bit capture.

Anti-Aliasing

Many digital cameras incorporate infrared blocking filters. Manufacturers use an anti-aliasing that prevents high-frequency image signals from hitting the sensor, which could create artifacting and moiré with some images. The anti-aliasing filter softens the detail, which is why all digital files need some degree of capture sharpening.

Aspect Ratio

It is the ratio of horizontal to vertical dimensions of an image. A 35 mm slide frame is of the ratio 3:2.

Artifacting

It is the evil enemy to digital photographers. Essentially, it amounts to distortion or breaking up the pixel from a variety of reasons. Artifacting can originate from heavy compression as in JPEG or from interference or noise from the sensor or even optics themselves. When artifacting occurs, the image appears to lose definition and may look chunky.

One of the most common reasons for artifacting in digital files is compression and recompression that occurs when using JPEGs.

A JPEG is lossy compression by definition. Significant and random data are thrown away when saving a JPEG. Anytime a user sees the JPEG quality box in Photoshop, there will be data loss when the image is saved. Even something as simple as changing the name of an open JPEG will produce data loss. Essentially when using JPEG you are losing the original and that can be a major problem. A significant factor in using the JPEG format is to understand that information is lost when a file is compressed.

Thus, if a JPEG image is opened and altered in any ways, then saved as a JPEG again, a certain amount of information is lost. If this process is repeated over and over again you will eventually lose all the pixels. The loss that occurs is cumulative. JPEG compression is particularly susceptible to artifacts because the sharp edge detail inherent to JPEG will show the artifacting against large light areas in an image. JPEG also produces enhanced artifacting when noise is introduced into an image because the noise is added data meaning that even more information has to be thrown away in the compression process.

Oversharpening will also produce artifacting. This is why we like to undersharpen rather than oversharpen. You can always add additional sharpening, but removing artifacting is nearly impossible.

Photographers looking for the best-quality and long-term archiving won't shoot in the JPEG format and will only use JPEGs for low-end usage. The loss of quality that occurs with JPEG compression is the result of artifacts from the loss of data in the compression algorithm.

AWB (Automatic White Balance)

Digital cameras perceive a white subject by adjusting the balance to the ambient light surrounding the subject. The cameras can be set for a custom white balance or to automate the white balance. When the camera is set to automate the white balance, it is auto white balancing.

Bit Depth

Each pixel contains bits. The total amount of bits in each pixel defines the bit depth. The tonal range or color range of the image is a correlation to the bit depth. The greater the bit depth, the greater the tonal range or palette of colors.

A bit depth of 8 can display only 256 shades of gray or color. A bit depth of 16 can display 65,536 different colors and a bit depth of 24 can display 16,777,216 colors.

A color image is typically represented by a bit depth ranging from 8 to 24 or higher. With a 24-bit image, the bits are often divided into three groupings, red, green and blue. Each color is composed of 8 bits, which together equal a 24-bit image. The calculations to determine how many colors are represented by a given bit depth are as follows:

1 bit (2^1) = 2 colors or shades
2 bits (2^2) = 4 colors or shades
3 bits (2^3) = 8 colors or shades
4 bits (2^4) = 16 colors or shades
8 bits (2^8) = 256 colors or shades
16 bits (2^{16}) = 65,536 colors or shades
24 bits (2^{24}) = 16.7 colors or shades

Blooming

The sensor on a digital camera acts much like the way a sponge reacts with water. When a dry sponge touches water, it absorbs the water and that process continues until at some point the sponge is holding all the water it can hold. The sponge becomes oversaturated and begins to drip water. The digital camera sensor (CCD/CMOS) also has a limit as to how much charge it can store. When the sensor can hold no more charge it begins to bleed or overflow the charge from an oversaturated pixel to another one on the sensor. This is known as blooming. It is more predominant in CCD sensors. Blooming is most visible in photos that contain regions that are clearly overexposed. These regions may have color fringes that can appear anywhere in the photo. The fringes have the same color in every direction. Some manufacturers have incorporated a drain-like mechanism next to each row of pixels to allow the overflow charge to drain away without altering the surrounding pixels. These drains are known as antiblooming gates.

Blooming is likely to occur when the luminance exceeds the capacity of the light-sensitive cells or diodes in the brightest area of the shot. Essentially, the charges will overflow into adjacent sections and causing high charges in the corresponding image pixels. To avoid this condition be careful in very extreme exposures

where bright-edged subjects appear against a black-edged background or darker subjects against a very bright background.

Brightness

It is the value of a pixel within a digital image. The value is defined numerically from 0 (black) to 255 (white).

Byte

One byte is a group of 8 bits. Each bit is either a 1 or a 0. Each group of 8 bits becomes a language to the computer. It all begins here. The bit and the byte are the birthplace of the digital language problems. Now you know why the rest of the terminology of digital is so confusing.

> Okay let us try and make a little sense out of this. The byte '01000001' means the capital letter A. The byte '01000010' means the capital letter B. The byte '01000110' means the capital letter C.

The name D-65 is 4 bytes long. The byte is a unit of information. One byte can also represent a value from 0 to 255. One end of the scale is either 0 defining pure black and the other is white or 255.

Capture

Film is to the film-based camera what capture is to a digital camera.

Card Reader

It is a device that allows your computer to directly read flash memory cards or Microdrives. Typically, to the computer via a Firewire or USB cable, it provides the tool to transfer the images from a card to the CCD.

CCD (Charged-Coupled Device)

It is a light-sensitive chip or sensor. Sensors for digital cameras are typically either CCD or CMOS (Complementary Metal Oxide Semiconductor). Conventionally, CCD was the predominant image pickup device, the workhorse engine of digital cameras. Ironically they are analog devices. The digitization occurs when the charged electrons are converted to digital via the A/D converter.

The CCD has thousands of tiny cells on the sensor that act like little containers or holding tanks. The dynamic range of the sensor is determined by the depth of the little holding tank. The deeper the tank, the greater the dynamic range.

CCDs are not color devices per say. Rather they are grayscale and create color using an RGBG color filter known as a Color Filter Array.

Chromatic Aberration

A lens has different index of refraction for different wavelengths. This causes the rays of light to pass through different focal points based on wavelength much like a rainbow. Simple lenses will refract light as a function of wavelength. The shorter wavelengths (blue) are refracted more than long wavelengths (reds). This is known as Chromatic Aberration. Achromatic camera lenses are designed to help correct this discrepancy. Chromatic aberration is the inability of a lens to focus all colors to the same point. This red light is bent less by its passage through glass than blue light. The effect is always worse the more curved the surfaces are and is usually worse toward the periphery of a digital image. Chromatic aberration is tough to deal with and the best answer to dealing with the problem is to try and prevent it from occurring.

CMOS (Complementary Metal Oxide Semiconductor)

The CMOS sensor really began to be noticed when Canon introduced this sensor into the D-30 camera. The CMOS sensors use both negative and positive circuits. CMOS require less power than the traditional CCD because only one circuit is on at any given time.

There are some other significant advantages with CMOS. The CMOS sensors are relatively of low cost to produce. Further, there is a significant advantage of the data-scanning method of a CMOS sensor.

A CCD sensor scans consecutively, like a human wave from one person to the next and the process of amplification occurs at the end of the wave. On the other hand, a CMOS sensor is provided with one amplifier per pixel. Therefore, it can perform signal amplification on a per-pixel basis. This allows data to be scanned faster and with less energy consumption.

CIE

The International Commission on Illumination (www.cie.co.at). Founded in 1920, CIE is an authority on lighting and is recognized by ISO (International Standards Organization). The International Standardization body developed a way to assign numbers to every color visible to the human eye – L^*a^*b – CIELAB.

CMM (Color Management Module)
It is a software that translates color information from one profile to another. Adobe Color Engine (ACE) is a CMM.

CMS (Color Management System)
It is a collection of color engines, ICC profiles, color settings and other bits and pieces to manage color.

Color Space

A collection of possible colors that can be created by a specific technique or device is the Color Space. ProPhoto RGB is a very wide space that can hold all the colors that the camera is capable of capturing. CMYK color space includes only those colors created by using the four process color inks (Cyan, Magenta, Yellow and Black).

Compact Flash Cards (CF Cards)

Compact Flash cards are storage devices. They are the 'film' of a digital camera. They are designed so that information is retained even after a termination of power, which allows the card to be removed from the camera. The cards contain no moving parts and are extremely rugged, providing much greater protection of data than conventional magnetic disk drives. They are still susceptible to corruption problems and both the cards and microdrives are typically the weak link in a digital system.

Compression

Some of today's digital cameras produce files sizes that are enormous. The Canon 1Ds Mark III, for example, can produce a 120 meg 16-bit file. One option for very large files is compression that can reduce the file size. That said, unfortunately, there is also a significant trade-off in quality and in reality the loss of an original when shooting with some compressed formats.

During compression, data are eliminated or saved in a reduced form, shrinking a file's size. There are two forms of compression – lossless and lossy.

Lossless compression: It is as the name states without data loss. The file compresses but decompresses an image to its original state, so there is no loss of quality.

Lossy compression: This process reduces file size but also degrades image quality. The most common form of lossy compression is JPEG. If your camera lets you choose an image format or compression ratio you should always choose those that give you the highest quality. If you decide later that you can use a smaller image or greater compression, you can do so to a copy of the image using a photo-editing program. If you shoot the image at a lower quality setting, you can never really improve it much or get a large, sharp print if you want one.

CRW

It is the raw CCD file format used by Canon digital cameras.

Demosaicing

In order to keep costs low, many digital cameras use a single image detector. A Color Filter Array (CFA) is used to cover the detector. The detector samples the intensity of just one of the many color channels.

In order to recover full-color images from a CFA-based detector, a method is needed to calculate the values of the other color channels of each pixel. Demosaicing is the term applied to the process of interpolating these colors.

Dot Gain

The Spot Channels default dot gain for press is usually 20%. Dot gain refers to the amount of spread of the 'dot' or drop of ink on a given paper stock. Coated papers (gloss) produce little dot gain. Uncoated papers absorb more ink and consequently have more spreading or dot gain.

DPI (Dots per Inch)

It is a measurement value used to describe either the resolution of a display screen or the output resolution of a printer. Do

not confuse with PPI (pixels per inch). Dots and pixels are very different. There is no correlation between the resolution of digital data (ppi) and the resolution of a printed image (dpi). DPI only refers to the printer.

DRAM (Dynamic Random Access Memory)

It is a type of memory that is lost when the power is turned off.

Dynamic Range

It is a measurement of the range between the brightest and darkest parts of an image. More dynamic range results in finer gradations being preserved. Scenes with a very large difference in dynamic range may be beyond the capability of a digital camera and may even be beyond the capability of the human eye.

EXIF (Exchangeable Image File Format)

The EXIF format is a JEIDA (Japan Electronic Industry Development Association) standard. The concept of EXIF was to embed certain digital information during capture, including a host of exposure parameters, and camera functions. Unfortunately, the groups that designed and specified the schema had their own agendas, which up until this point, seem to have excluded photographers. To have EXIF or any additional schema reach broad adoption and acceptance, the creators of digital images need to be brought into the process of designing and specifying what metadata can be used for. Further, the camera manufacturers are actually going to have to talk to one another in order to have these standards become universal.

XMP Schema

XMP (Extensible Metadata Platform) establishes a common metadata framework to standardize the creation, processing and interchange of document metadata across publishing workflows. XMP defines a standard, uniform way for applications to describe and store the metadata of files. XMP is designed specifically for describing files that is easily parsed, understood and written by a wide variety of applications. XMP was invented by Adobe. All Adobe products mark the files they create with XMP metadata, and many other applications can read this data.

File Info

At this point in time, the primary image metadata schema has been 'File Info', which is nonimage data embedded within Photoshop image files. Originally employed by the newspaper industry, IPTC (International Press and Telecommunications Council) metadata contains only a few fields of limited text used to help organize and distribute photographic images for newspaper publishing. 'File Info', which is the Photoshop implementation of the IPTC specification plus additional data fields, defines both the storage format as well as the actual metadata. Text fields in the current specification include but are not limited to Caption, Caption Writer, Headline, Special Instructions, Keywords, Category, Supplemental Categories, Urgency, Byline, Byline Title, Credit, Source, Object Name, Date Created, City, Province-State, Country Name, Original Transmission Reference, Preserve Additional Information. Mark as Copyrighted, and URL are additional fields beyond the IPTC specification.

The File Info fields allow for both digital asset management and digital rights management. Surprisingly, a large number of Photographers don't even realize these metadata fields already exist. Photographers routinely send out digital images without even marking them as Copyrighted or embedding simple contact information. When they dealt with film they always placed their names and copyrights on the slide mounts but fail to realize that this same concept is available with digital files.

Firewire

It is officially known as the IEEE 1394 protocol. A high-speed data transfer interface.

Gamut

The range of colors that is available in an image. This plays a special importance in digital photography. The total range of colors that will be reproduced by a color model may be less or greater than the color one perceives when shooting an image. The actual range of colors achievable is called its gamut. A color is said to be 'out-of-gamut' when its position in one device's color space cannot be directly translated into another device's color space.

Gigabyte (GB)

One gigabyte equals 1000 megabytes. The actual value is 1,073,741,824 bytes (1024 megabytes). Not long ago a gigabyte of storage was a lifetime of digital information. Digital photography has certainly changed all that. With some cameras producing files over 125 megabytes in size, it is not at all uncommon for a photographer to need 10–20 gigabytes of space for one photo shoot.

Histogram

Many digital cameras incorporate a histogram as part of the camera software, which is displayed on the camera LCD (Liquid Crystal Display). This graph is an essential tool for the digital photographer. Understanding histograms will allow you to create better digital captures. The histogram identifies both the contrast and dynamic range of an image. The histogram shows a scale of 0–255 with 0 being black and 255 being white. The scale reads from left to right. More and more cameras let you view histograms on the camera's monitor. The histogram allows careful evaluation of the tonal range within an image.

The horizontal axis of the histogram represents the range of brightness from 0 (black) on the left to 255 (white) on the right. Visualize the axis as 256 possible values to hold all the pixels within an image. The horizontal axis of a histogram in a camera essentially represents the camera's maximum potential dynamic range.

The vertical axis represents the number of pixels at each point of the horizontal axis. The higher the line coming up from the horizontal axis, the more pixels there are at that level of brightness.

To read the histogram, you look at the distribution of pixels. An image that uses the entire dynamic range of the camera will have a reasonable number of pixels at every level of brightness.

Whether a particular histogram is good or bad depends on what you are trying to show in an image.

Not every image is going to have pure black and pure white. The histogram will allow you to adjust the range from blackest shadow to the whitest highlights. These points are known as the black point and white point.

Hue

It is the term used to describe the entire range of colors of an image. The hue is the shades of all colors present. An image with different shades of yellow has a similar hue.

ICC Profile

A set of standard guidelines for color management in the imaging world. When a device is profiled it is referring to this standard. Color profiles simply let one piece of hardware or software 'know' how another device or image created its colors and how they should be interpreted or reproduced.

Interpolation

An image may need to be increased or reduced from its actual resolution. There are many complex algorithms used to achieve optimum results. Software programs can enlarge image resolution beyond the actual resolution by adding extra pixels using complex mathematic calculations. Digital captures do not contain grain in the same way as film-based images. With film, the silver halide particles are infinitely variable but with digital captures the pixels have no grain. Hence, it is possible to interpolate a digital capture to a much greater extent than a film-based image. Traditionally, Photoshop has used Bicubic and Bilinear Interpolation but with the release of Photoshop CS and Adobe Camera Raw, the digital photographer has newer and more precise interpolations algorithms available.

ISO

The speed or specific light-sensitivity of a camera is rated by ISO numbers such as 100, 400, 800, 1000, etc. The higher the number, the more sensitive it is to light. With film, the higher the ASA the more grain is present. With digital captures, the higher the ISO the more noise is present. Noise is much more offensive than grain. As a general rule, the digital photographer is usually better off using the optimum ISO for the camera whenever feasible.

JPEG (Joint Photographic Experts Group)

It is a lossy compression, simply meaning that information is compressed and some is thrown away with its use. JPEG images loose quality each time they are saved, closed and then reopened.

While JPEGs are probably the most common format that people encounter, they are also the prime reason that people tend to believe that digital does not have the same quality as film. The quality of a JPEG deteriorates every time there is anything done to the file. The tendency when using any image format is to repeatedly close, open and resave, as part of the normal workflow. JPEG suffers because every time you open one of these files, and then save it again, the image is compressed. As you go through a series of saves and reopens, the image becomes more and more degraded and will eventually just about disappear after enough changes to the file. When a JPEG is altered, the image on the screen won't reflect the compression unless you close the file and then open the saved version.

Luminance

The luminance of a color is the perceived brightness. A good way to think about luminance is to think about a transparency on a light table with bulbs of varying wattage. The color of the transparency remains the same but depending on the intensity of the light the perceived color will change.

Metadata

By simple definition, 'Metadata' is data about data. For our purposes, Metadata is all information that describes or yields information about an image. There are many types of metadata, including XMP, EXIF and File Information.

Megapixel

Quite literally this means millions of pixels. Thus, an 11 megapixel camera is an 11 million pixel camera. The higher the effective resolution, the higher the quality of the picture that can be recorded. While it is important to pay attention to megapixels, it can also create some confusion. Some manufacturers capture at one resolution and interpolate the file up. This can be very confusing and an interpolated file is likely to be of lesser quality than a noninterpolated file.

Moiré

The term moiré effect generally refers to a geometrical optical interference formed when two two-dimensional meshes of a

similar pattern overlap. If you look at two chain link fences in the sunlight, one in front of the other you will notice a pattern of color that looks like a mirage. Moiré often produces a colored checkerboard or rainbow pattern.

Moiré patterns are problematic because they degrade quality and are generally hard to eliminate in digital images. Consider a scene containing a light-dark striped pattern like a dress shirt. Moiré is best explained using the concept of frequency. Image frequency is the rate of change of pixel brightness values across the image. In a low-frequency image, pixel values do not change much (or change very slowly) from one pixel to the next. If the pixel values change very rapidly, the image is said to be high frequency.

The sensor on a digital camera records the image by sampling at regular intervals. In the case of a low-frequency input scene there is no problem; the sensor records the image and accurately renders the image. Now consider a scene that contains brightness values that quickly change to dark values like a stripe dress shirt with blue and white. When a high-frequency image like this falls on the same sensor, it's sampled incorrectly because the scene information is changing too rapidly. The moiré effect will occur only at certain frequencies. Where it actually occurs depends on both the image frequency and the sensor frequency. Sometimes this moiré effect is false. When images are reduced on a screen, they can appear to have a moiré effect but when viewed at 100% the pattern disappears. Before attempting to fix any moiré pattern, make sure you are viewing the image at 100%.

NEF (Nikon Electronic Format)

It is Raw image data file format used by the Nikon digital cameras.

Noise

Essentially, noise is a level of interference. It is a level of electronic error in the final image from a digital camera. Noise is directly related to how well the CCD or CMOS chip functions. Visible noise in a digital image is often affected by many factors, such as long exposure, high ISO and temperature (high worse, low better). As a general rule each camera has an optimum ISO and shooting at that ISO will help to reduce noise. Noise is compared by many to grain, but grain can have a positive effect on the mood of an image

whereas noise generally ruins an image. Some cameras exhibit almost no noise and some a lot and all the time.

Noise tends to affect certain color channels more than others. It is usually most noticeable in the green and blue channel. This is because a typical digital camera sensor (CCD/CMOS) is more sensitive to certain primary colors than others. The blue and green channel is often amplified. Noise is also associated and increased with JPEG compression. In fact, it can even produce hues and lines not in the original image. Noise looks like grainy areas of red, green and blue pixels. Some cameras have built-in noise reduction but most of the time there are better ways to deal with noise than within camera software. As a general rule, the best way to deal with noise is to try and prevent it from occurring in the first place.

Pixel

It is the unit for comprising digital images. The pixel is the atom in the digital world. They are the individual imaging elements of a CCD or CMOS sensor and the individual output point of a display device. This is what is typically meant by resolution. Pixel comes from a word meaning 'picture element'.

PNG (Portable Network Graphics)

It is a lossless format that is recognized by the World Wide Web consortium, and supported by all recent web browsers. In PNG images lossless quality is high but the size is significantly larger than JPEG images which are smaller because they are lossy.

PPI (Pixels per Inch)

PPI refers to the number of pixels viewable on a screen. There is no correlation between the resolution of digital data (ppi) and the resolution of a printed image (dpi). A dot is a droplet of ink on paper and a pixel is a ray of light on your monitor. There is a lot of confusion over PPI and DPI.

A pixel is a ray of light on your monitor; a pixel is superior to a dot because it has a luminosity. A pixel can be 100% bright or a pixel can be 50% bright. Luminosity is similar to a dimmer switch on a light. The monitor controls each pixel in much the same way as a dimmer switch.

Profiling

After a device is calibrated, it is profiled and called characterizing – records how close a device comes to matching an objective standard for color reproduction.

RAW

The RAW format is all of the information captured from the image sensor without first processing it. The RAW format records color and other information that is applied during processing to enhance color accuracy and other aspects of image quality. When it comes to digital, RAW is the golden rule. It is the only way to gain the full quality and control to produce the best final image. Using a raw file converter such as ACR (Adobe Camera Raw) allows color space and exposure to be accurately controlled. Since one has the original file with the raw file, it is also always possible to go back and reprocess with different set of standards. For example, an original raw file could be processed as if it were shot with tungsten lighting or with daylight lighting. This is unlike a JPEG image where data are permanently changed or deleted during processing in the camera and can never be recovered. RAW files have other advantages. Their files are approximately 60% smaller than uncompressed TIFF files with the same number of pixels.

Resolution

The quality of a digital capture depends in part on its resolution that essentially is the number of pixels per millimeter in the image. The official definition of the term 'resolution' is the joint effect of spatial resolution and brightness resolution; commonly, however, the word is used to refer to spatial resolution alone. The higher the resolution, the greater the detail in the image (and the larger the file). For computers and digital cameras, resolution is measured in pixels per inch (ppi).

RGB

RGB means Red, Green and Blue – the primary colors from which all other colors are derived. The additive reproduction process mixes various amounts of red, green and blue to produce other colors. Combining one of these additive colors primary colors with another produces the additive secondary colors cyan, magenta and yellow. Combining all three produces white.

Saturation

It is the degree to which a color is undiluted by white light. If any color is saturated 100%, it lacks any white light. If a color has 0 saturation, it is a shade of gray. Saturation measures the amount of gray in a color. When the color lacks any gray impurity, it will seem more intense and vivid.

TIFF (Tag Image File Format)

It may be the most widely accepted image format. It is the choice for most designers. It is also a source of confusion. Some cameras call their raw formats TIF, which most assume as a TIFF. TIFF is a popular format because it uses a lossless compression. The problem is that the format has been altered by so many people that there are now 50 or more flavors and not all are recognizable by programs. The TIF format in some cameras is actually a raw format and one needs to be very careful not to confuse the two.

UV Filter (Ultra Violet Filter)

This is an Ultra Violet absorbing filter that helps overcome the abundance of blue in outdoor photographs. Not really necessary in digital photography because while film is very sensitive to UV, digital is very sensitive to Infra Red.

White Balance

It refers to adjusting the relative brightness of the red, green and blue components so that the brightest object in the image appears white. This gets confusing because most types of illumination appear white to our eyes but digital sensors and film are not as versatile as humans. The actual color of light can vary significantly. Fluorescent light appears green and tungsten light appears orange and metal halide and sodium vapor produce even more dramatic results. However, even the various times of day and direct or indirect sunlight produce color temperature differences.

Working Space

Gamut of image's color model, which is restricted by device profile. CMYK images have a working space defined by CMYK profile. RGB images are defined by RGB profile.

Index

A

Aberration Panel, 191
Active image cell, 125
Adobe Bridge, 43
Adobe Camera Raw, 34
Adobe Photoshop CS3, 56–57
Adobe's Camera Raw, 28
Adobe98 space, 33, 35–36
Advanced features, in Lightroom
 action tips for photoshop, 331–333
 custom actions, 323–330
 edit in photoshop, 317–322
81A filter, 7
Alt-click key, 89
Alt key on the plus sign, 96
+/− and control keys, 78
Angle, in slideshow, 223
Application Color Management, 243
Architecture, of Lightroom
 custom workspaces, 78–79
 filmstrip, 75
 keyboard shortcuts, 76–78
 modules, 73
 panels, 74
 presets, 79–81
 toolbar, 74
Archiving
 backups, 293–294
 catalog backup, 296
 D-65 archive, 296–297
 D-65 drive structure, 297–298
 developing backups, 299
 duplicate backups in multiple places, 293
 emergency power, 294
 import backup, 295
 Lightroom, 295
 media choice for, 297
Auto button, 172–173
Auto Contrast, 16
Auto Hide & Show, 79
Auto Levels, 16
Auto Sync, 214–215
AWB mode, 5

B

Background Color, 225
Backups, 19, *see also* Archiving

16-bit images, 13–17
16-bit printing, 240
8-bit RGB images, 13–17
256 (8 bits), concept of, 13–17
65,536 (16 bits), concept of, 13–17
B key, 87–88
Blacks, 170–172
Blue-filtered elements, 10
Blue/yellow color fringing, 191
Bridge, 44
Brightness Slider, 172
Brown Tone, 182

C

Camera Matching profiles, 194
Camera Raw Cache Settings, 59
Canon cameras, 19
Canon 1DS Mark III, 45
Capture One, 34
Capture One by Phase One, 28
Cast Shadow, 221
Catalog panel, 86–87
CatalogPreviews.lrdata, 298
Check box, 105
Chomix ColorThink, 38
Chromatic Aberration, 191–192
Clarity, 173–174
Cloning tool, 153–155
CMYK color space, 36–37
Collection panel, 92–96
 library module, 92–96
 print module, 233
Color balance, 7
Color Management, 240–241
ColorMatch space, 33
Color Picker, 220
Color spaces, for digital
 for client delivery, 37–38
 ColorMatch, 36
 four types, 33
 ideal working space for digital
 photographers, 35
 and interpolation of pixel, 34
 profile conversion and assignment, 39–40
 profile of printer and, 34
 and profiles in workflow, 36–37
 ProPhoto, 37, 38–39

Color spaces, for digital (*continued*)
 and raw digital capture, 34–35
 for web, 35–36
Command E. Lightroom, 317
Command U, 173
Compare Mode, 120
Compare View, 118
Contrast Slider, 172
Cool Tone, 182
Copy/Paste Buttons, 103, 112
 for synchronizing, 214
Crème de la crème, 28
Crop overlay and straighten tool,
 150–151
CSS Galleries, 253
Curves adjustment, 16
Customizing, slideshow toolbar, 226
Custom printer profiles, 244
Custom workspaces, 78–79

D
D-65 archive, 296–297
Darks, 177
D65.com, 67
D-65 drive structure, 297–298
Default Adobe settings, 215
Detail Matte, 255
Detail Slider, 187
Develop module
 Basic Panel, 164–168
 Before/After view, 148
 Camera Calibration Panel, 193–195
 cloning and healing tools, 153–154
 crop overlay and straighten tool,
 150–151
 Detail Panel, 182–192
 flagging, an image as a Pick or as Rejected, 148
 forward or backwards button, 148
 histogram, 148–149
 Histogram Panel, 148–149
 History Panel, 199
 HSL/Color/Grayscale Panel, 178–182
 Impromptu Slideshow, 148
 labels, 148
 localized adjustments, 150
 localized corrections adjustment brush, 159–163
 localized corrections graduated filter, 156–159
 Loupe view, 148
 Presence Panel, 173–176
 Presets Panel, 195–198
 ranking, 148
 red eye reduction tool, 152

 remove spots tool, 153, 155
 Snapshots Panel, 199–200
 Split Toning Panel, 182
 straighten tool and the straighten tool
 slider, 151
 Tone Curve Panel, 176–178
 Tone Panel, 168–173
 toolbar, 147
 Vignettes Panel, 192–193
 zoom fit, 148
Digital dictionary, 335–350
Digital Negative (DNG), 26–27, 29, 263–264
Digital shooting, elements of
 backups, 19
 bit images, 13–17
 editing, 3–4
 exposure for digital capture, 12–13
 filters, 17–18
 histograms, 7–12
 memory cards, 1–3
 optimum ISO setting, 4–5
 physical work environment, 18–19
 white balance, 5–7
Discard previews, 64
D key, 78
D-65 Lightroom workflow
 adding keywords and additional metadata, 277
 applying Develop Setting, 270
 backup of the imported files, 265
 color correcting, 279
 creation of web gallery, 280
 editing, 274–277
 exporting of files, 280–290
 file handling, 263–264
 file naming, 265–269
 importing of images, 262–269
 initial preview, 273
 keywords, 273
 Metadata Preset, 270–272
 preview, 273–274
 raw files, 261
 renaming of images, 277–279
Double click, 77
Draft Mode Printing, 231, 238–239
Drag Keywords, 103
D-65 recommendations, 2–5, 11–12, 25, 36–37, 45,
 47
 Library Module, 88, 89, 97, 108
 print, 238
 suggested starting point, for sharpening, 188–189
 for synchronizing settings, 304–315
 for user preset, 196

Drop-down menu, of navigator panel, 85
D-65's Lightroom_Library, 47–48

E

Edge Masking, 188
Editing, in camera, 3–4
Edit in Photoshop, 317
Edit menu, 133
Effect Slider, 150
Emergency power, 294
Epson & Canon printers, 35, 37
Epson K3 inks, 242
Epson Premium Glossy, 242
Epson Premium Luster, 242
Epson Stylus Pro 3800, 243
Export, 117
Export PDF button, 227
Exposure, for digital capture, 12
Exposure Slider, 168–169
Extensible Metadata Platform (XMP), 30

F

FAT16 file structure, 3
FAT32 file structure, 3
File menu, 132
Fill Light Slider, 170
Filmstrip, 60, 75, 125
Filtering, 130–131
Filters, 17–18
F key, 77
Flagging, of an image as a Pick or as Rejected, 148
Flags, 123–125
Flash memory cards, 2
Flash memory chip suppliers, 2
Folder panel, 88, 90–91
Formatting, of memory cards, 3
Forward and backward buttons, 128–130
FTP transfer settings, 257
Full-Screen Workspace, 79

G

Gamma, of raw camera files, 40, 146
32-gig card, 2
G key, 78
Graduated Filter, 150
Gray card, 12
Grayscale Panel, 181–182
Green-filtered elements, 10
Grid View, 118

H

Hard drive, *see* Memory cards
Help menu, 140

Highlight Recovery, 169
Highlights, 176
Histograms, 7–11, 97, 177
 on the back of the LCD, 11–12
HTML Galleries, 253
Hue Sliders, 178–179

I

Identity Plate, 237
ImagenomicNoiseware, 190
Import, 117
 backup for archiving, 295
 to desktop/laptop, 304–315
 D-65 Lightroom workflow
 backup, 265
 library module, 117
 preferences, Lightroom, 54–57
Import Photos dialog box, 305
Impromptu Slideshow, 125, 148
International Press Telecommunications Council
 (IPTC), 30
ISO/camera specific preset on import, 97

J

Jardine, George, 50–51
Javascript Galleries, 253
Jay Maisel red, 13
Joint Photographic Experts Group (JPEG)
 format, 30

K

Keyboard shortcuts, 76–78, 114
Keyword Filter, 100
Keywording Tips, 101
Keyword list panel, 98–113
Keywords, with synonyms and export
 options, 100
Keyword Set Panel, 102
Keyword tags, 102
Kodachrome, 10
Kodachrome adjustment tool, 174

L

Labels, 123–125, 148
LaCie Rugged drives, 304
Landscape Preset Applied, 185
LCD on the cameras, 11
Lens Vignetting, 192
Lexar, 2
Library filter, 113–116
Library menu, 134

Library Module
 catalog panel, 86–87
 collection panel, 92–96
 D-65 recommendations, 88–89, 97, 108
 edit menu, 133
 export, 117
 file menu, 132
 filmstrip, 125–126
 filtering, 130–131
 folders panel, 88, 90–91
 forward and backward buttons, 128–130
 help menu, 140–141
 histogram, 97
 import, 117
 impromptu slideshow, 125
 keywording in, 97–98
 keyword list panel, 98–113
 library filter, 113–116
 library menu, 134
 library right-side panels, 96
 library toolbar, 118–121
 main menus, 131–132
 metadata menu, 136–137
 multiple monitors, 127–128
 navigator panel, 85–86
 overview, 83
 photo menu, 134–136
 quick collection, 86–87
 quick develop panel, 97
 rotation and advancement, 125
 sort direction and sort criteria, 123
 spray can, 122
 stars, flags and labels, 123–125
 target Collection, 87–88
 thumbnail slider and active image cell, 125
 use in workflow while 'On the Road,' 92
 view menu, 137–139
 volume browser, 89–92
 window, 84–85
 window menu, 140
Library Module toolbar, 74
Library right-side panels, 96
Library toolbar, 118–121
Lifespan, of memory cards, 3
Lighting digital capture, 12
20080707_lightning_0004.CR2, 318
Lightroom, 28, 34–35, 40, *see also* Preferences,
 Lightroom
 card catalog concept, 45
 catalog location, 45–47
 components, 44–45
 creation of Catalog, 49–50

 default location, 44, 48
 as digital asset management system, 91
 external hard drive and, 44
 Lightroom_Catalog, 47–49
 pros and cons, 44
 uses, 43
 using more than one Catalog, 50–51
Lightroom 2.0, 150
Lightroom_Catalog.lrcat, 44–45
Lightroom_Catalog.lrcat files, 298
Lightroom_CatalogPreviews.lrdata, 44
Lightroom histogram, 9
Lightroom_Library_bk, 47, 299
Lightroom Library hard drive, 83–84
Lights, 176
L key, 78
Localized corrections adjustment brush, 159–163
Localized corrections graduated filter, 156–159
Loupe View, 118, 148
Luminance channel, 190
Luminance Sliders, 179
Luminance Smoothing Slider, 189

M
Main menus, 131–132
Maisel, Jay, 9–10
Masking, 188
Memory cards, 1–2
 lifespan, 3
Memory Card Speed, 2
Metadata menu, 136–137
Metadata Tips, 109–110
Microdrives, 2
Modules, 73
Move forward or backwards buttons, 148
Multiple monitors, 127–128

N
Navigator panel, 85–86
Noise reduction, 4, 189–190
Noiseware, 5
Nondestructive edit, 146–147

O
Offset, 223
Opacity, 223
Operating systems, evolution of, 27
Optimum ISO setting, 4

P
Panel End Markers, 59
Panels, 74

Parametric edit, 146–147
'perfect' histogram, 8
Photo Info, 237
Photo menu, 134–136
Photoshop, 85
 using, 15–17
Photoshop format (PSD), 30
Physical working environment, 18–19
Picture Package, 234
Pixel Genius PhotoKit Sharpener, 240, 256
Point Curve Tool, 178
' poor ' histogram, 8
Portfolio Collection, 88
Portrait Preset, 184
Post-Crop vignette, 192
Preferences, Lightroom
 64-Bit Processing, 67–68
 Camera Raw Cache Settings, 59
 catalog settings, 60–66
 discard previews, 64
 D-65 recommendations, 54, 55
 external editors, 56–57
 file handling, 58–59
 File Handling Catalog Settings, 62–64
 file name generation, 58–59
 general, 54
 Identity Plate Setup, 66–68
 import, 55–56
 interface, 59–60
 Metadata Catalog Settings, 64–66
 optimization of catalog, 62
 presets, 55
 preview quality, 63–64
 reading of metadata, 58
Premium Luster Photo Paper, 243
Presets, 79–81
Preview, in Browser, 257–259
Previous button, 214
Print Module
 Collections panel, 233
 Guides panel, 236
 image settings panel, 236
 layout engine panel, 234–235
 layout panel, 236
 make a print, 242–248
 Overlays Panel, 236–238
 page setup & print settings buttons, 234
 Print Button, 241
 Print Job Panel, 238–241
 Template Browser panel, 232–233
Print resolution, 240
Print Sharpening, 240

ProPhoto color space, 33, 35–38
ProPhoto RGB, 146

Q
Quick collection, 86–87
Quick Describe view, 107
Quick develop panel, 97

R
Radius, in slideshow, 223
Radius Workflow, 186
Ranking, an image, 148
Raw digital file, 10
RAW files, 11
RAW formats, 29
RAW mode shoot, 12, 23–26
 Digital Negative, or .dng, 28–29
 and DNG, 26–27
 file formats, 27–31
 and operating systems, 27
Recovery Slider, 169
Red/cyan color fringing, 191
Red eye reduction tool, 152–153
Relative Colormetric, 241
Remove Spots Button, 153, 155
Reset button, 214
Retrospect, 299
Rotation and advancement, 125

S
Samsung, 2
SanDisk, 2
Saturation, 174
Saturation Sliders, 179
Science Faction, 95
Screen size and toolbar, 74
Seagate external drive, 306
Sensors, 10, 34
Sepia tone, 182
Set Default, 215
Seth Kodachrome, 196
Shadows, 177
Sharpening, 185–186
Sharpening Default for Lightroom, 183
Sharpening Panel, 182–184
Shift-Tab key, 76
Sidecar .xmp files, 91
Slideshow Module
 backdrop panel, 224–225
 creation of, 218
 export PDF button, 227–228

Slideshow Module (*continued*)
 layout panel, 222
 Options panel, 220–222
 overlays panel, 223
 playback panel, 226
 slideshow toolbar, 226
 Template Browser, 219–220
 titles panel, 225
Smart Collections, 95–96
SmartDiskFireLite drives, 304
Snapshot Function, 199
Sort direction and sort criteria, 123
Spot Healing Tool, 153–155
Spray can, 122
Spray Can Tool, 103, 105
Spraying Metadata, 112
sRGB space, 33, 35–36, 39
Stars, 123–125
Stock Agencies, 95
Straighten tool and the straighten tool slider,
 151–152
Stroke Border, 220
Suggested Keywords, 105
Survey Mode, 118, 121
Sync Button, 214
Synchronize folders, 91
Synchronizing settings
 adjusting an image, 210–212
 D-65 concepts for, 304–315
 between multiple images, 213–214
 options, 214–215
Sync keywords, 103
Sync Metadata Button, 111–112
Syncs, 79

T
Tab key, 76
Tagged-Image File Format (TIFF, TIF), 24, 29
Target Collection, 87–88
Targeted Adjustment Tool, 177
Temperature Slider, 165
Template Browser
 for print, 232–233
 for slide show, 219–220
 Web Module, 253
Terabyte drive, 47
Thumbnail slider, 125
TIFF standard, 57
Tint Slider, 165

T key, 74
Tonal values, 10
Tone Curve Controls tool, 176
Toolbar, 74
Toshiba, 2
Transparencies, shooting of, 11
Treatment Panel, 164

U
U.S. Web Coated (SWOP)v2, 40

V
Velvia adjustment tool, 174
Vibrance, 174
Vibrancy, 12
View menu, 137–139
Visual guides, 222
Volume browser, 89–92

W
Warm Tone, 182
Web Module
 Appearance Panel, 255–256
 Color Palette Panel, 255
 creating a web gallery, 252–253
 Engine Panel, 253
 Export/Upload, 257
 features, 251–252
 Image Info Panel, 256
 Output Settings Panel, 256
 preview, 257–259
 Site Info Panel, 254
 Template Browser and Preview Panels, 253
 Upload Settings, 256
White balance, 5–6, 164
White Balance Selector Tool, 165, 210
White Balance tool, 6
White Balance Toolbar Options, 165–166
Window menu, 140
WorkbookStock, 94
Workflow Shortcuts in the Basic Panel, 166
Workflow while 'On the Road,' use of, 92
Working space, for digital, 35

X
XHTML Galleries, 253
XMP metadata, 98
XMP sidecar files, 65
X-Rite ColorChecker, 6–7, 167, 194